HISTORIC PHOTOS OF
GREATER
MIAMI

TEXT AND CAPTIONS BY SETH H. BRAMSON

TURNER
PUBLISHING COMPANY
NASHVILLE, TENNESSEE PADUCAH, KENTUCKY

Miami Beach's oceanfront looking north from 18th Street has yet to be developed in this 1914 photograph.

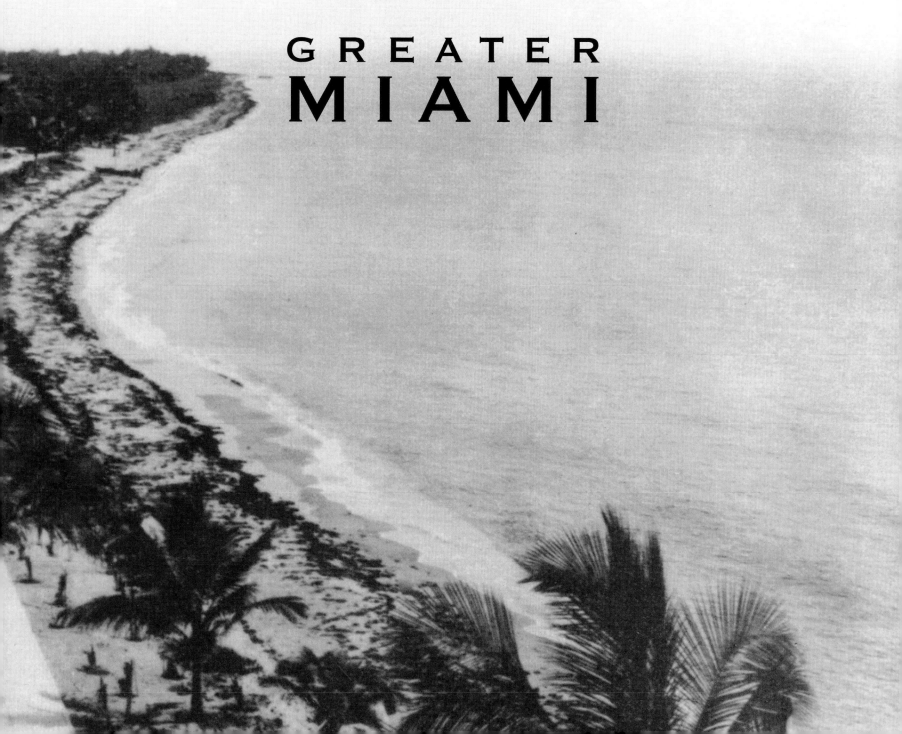

HISTORIC PHOTOS OF

GREATER
MIAMI

Turner Publishing Company
200 4th Avenue North • Suite 950 412 Broadway • P.O. Box 3101
Nashville, Tennessee 37219 Paducah, Kentucky 42002-3101
(615) 255-2665 (270) 443-0121

www.turnerpublishing.com

Library of Congress Control Number: 2006937032

ISBN-13: 978-1-59652-320-3
ISBN: 1-59652-320-4

Printed in the United States of America

07 08 09 10 11 12 13 14 15—0 9 8 7 6 5 4 3 2

CONTENTS

It is 1899 and the view is north from the Royal Palm grounds, with the
Elser Pier at the foot of Twelfth (later Flagler) Street shown at right, and
the Florida East Coast dock farther north, also on the right.

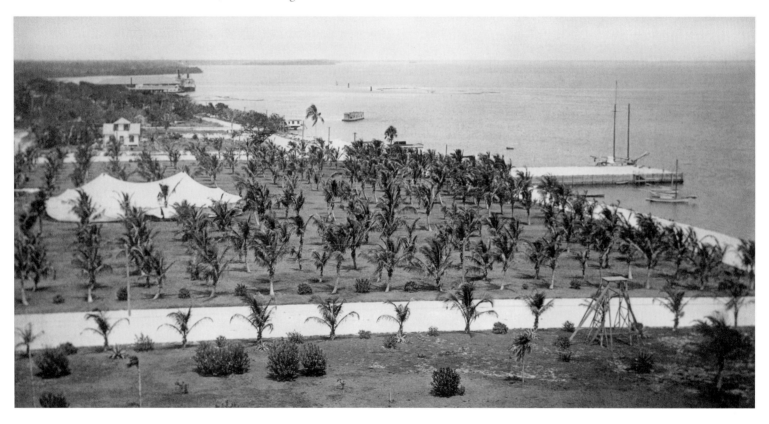

ACKNOWLEDGMENTS

This volume, *Historic Photos of Greater Miami,* is the result of the cooperation and efforts of many individuals and organizations. It is with great thanks that we acknowledge in particular the generous assistance of the State Archives of Florida.

We would also like to thank the following individuals for valuable contributions and assistance in making this work possible:

N. Adam Watson, Photographic Archivist, State Archives of Florida

Seth H. Bramson, our writer

PREFACE

Miami has thousands of historic photographs that reside in archives, both locally and nationally. This book began with the observation that, while those photographs are of great interest to many, they are not easily accessible. During a time when Miami is looking ahead and evaluating its future course, many people are asking, How do we treat the past? These decisions affect every aspect of the city—architecture, public spaces, commerce, infrastructure—and these, in turn, affect the way that people live their lives. This book seeks to provide easy access to a valuable, objective look into the history of Miami.

The power of photographs is that they are less subjective than words in their treatment of history. Although the photographer can make decisions regarding subject matter and how to capture and present it, photographs do not provide the breadth of interpretation that text does. For this reason, they offer an original, untainted perspective that allows the viewer to interpret and observe.

This project represents countless hours of review and research. The researchers and writer have reviewed thousands of photographs in numerous archives. We greatly appreciate the generous assistance of the individuals and organizations listed in the acknowledgments of this work, without whom this project could not have been completed.

The goal in publishing this work is to provide broader access to this set of extraordinary photographs that seek to inspire, provide perspective, and evoke insight that might assist people who are responsible for determining Miami's future. In addition, the book seeks to preserve the past with adequate respect and reverence.

With the exception of touching up imperfections caused by the damage of time and cropping where necessary, no other changes have been made. The focus and clarity of many images is limited to the technology and the ability of the photographer at the time they were taken.

The work is divided into eras. Beginning with some of the earliest known photographs of Miami, the first section records photographs through the end of the nineteenth century to the beginning of the twentieth. The second section spans

1911 to the 1930s. Section Three covers the World War II era and postwar years. Section Four spans the 1950s and the final section the 1960s. In each of these sections we have made an effort to capture various aspects of life through our selection of photographs. People, commerce, transportation, infrastructure, religious institutions, and educational institutions have been included to provide a broad perspective.

We encourage readers to reflect as they go walking in Miami, strolling through the city, its parks, and its neighborhoods. It is the publisher's hope that in utilizing this work, longtime residents will learn something new and that new residents will gain a perspective on where Miami has been, so that each can contribute to its future.

Todd Bottorff, Publisher

The beauty of the Miami River at the time of the arrival of the pioneers was almost indescribable. This view gives the reader a view of the still-pristine waterway.

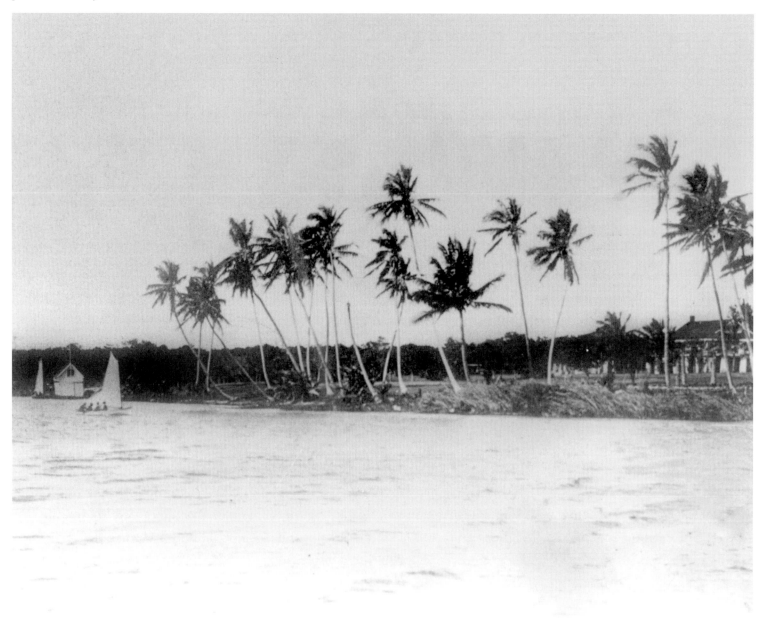

BIRTH AND THE RAIL CONNECTION

(1800s–1910)

The story of the Magic City is a story that began in the paleo-Indian era, when tribes such as the Timucuans and the Calusa, who left precious few artifacts, roamed the region around the shores of Biscayne Bay. Its origin as an American metropolis picks up with the arrival of people such as Julia Tuttle—the famed "Mother of Miami"—and William Brickell, along with others such as John Sewell and Isadore Cohen, all of whom found themselves fascinated with the beauty of the still virgin area—a pristine river and magnificent and open bay, the river so clean it could be sipped, the bay so clean that the fish and shellfish caught there were safe to eat.

On April 15, 1896, the first train—a construction train—arrived in what would become Miami on July 28 of the same year, and one week later, on April 22, the first passenger train stopped. The Royal Palm Hotel would open on December 31.

Julia Tuttle died in 1898, never getting to see the city she created begin its meteoric growth. With the formation of a chamber of commerce and the increase in Florida East Coast Railway passenger and freight services, that growth was just beginning.

Street paving got underway and ferry service was started across Biscayne Bay to Ocean Beach, not much more than a sandbar at the time, but today a little place called "Miami Beach."

Stores opened and names such as Frank Budge (hardware), Roddy Burdine (dry goods) and J. N. and J. E. Lummus (real estate) added their imprint to the city of the Brickells, Tuttles, Sewells, and Cohens as the community began to thrive and prosper.

John S. Collins and his son-in-law, Thomas Pancoast, had purchased the Ocean Beach property of Ezra Osborne and Elnathan T. Field and were developing a short-lived avocado plantation. Real estate prices began slowly to increase and the city of Miami began expanding north, south, and west, constricted on the east only by Biscayne Bay.

In infancy, Miami had advanced from crawling to walking and the steps were getting longer almost by the day.

Old Fort Dallas was the original Seminole Indian wars post, first occupied by the army in 1836, and closed and reoccupied several times, finally being sold to Julia Tuttle, who made it her home. The original Seminole Club Hotel is on the right.

One of the great names of Miami history is that of the Stoneman family, gathered for a portrait here around 1893. Holding his baby daughter in the back row is Frank Stoneman, who would become the owner of the Miami Herald newspaper in its early years. This daughter, Marjory Stoneman Douglas, would grow up to become one of the leaders in the fight to save the Everglades.

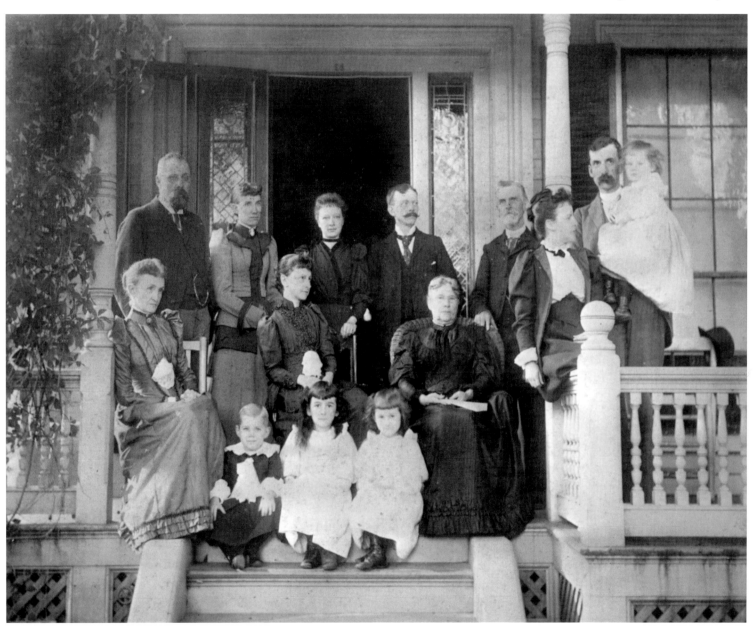

Even in the earliest days, the call of the Magic City (not yet known by that sobriquet) was irresistible. In a dwelling less than ideal this family strives to become part of the emerging community.

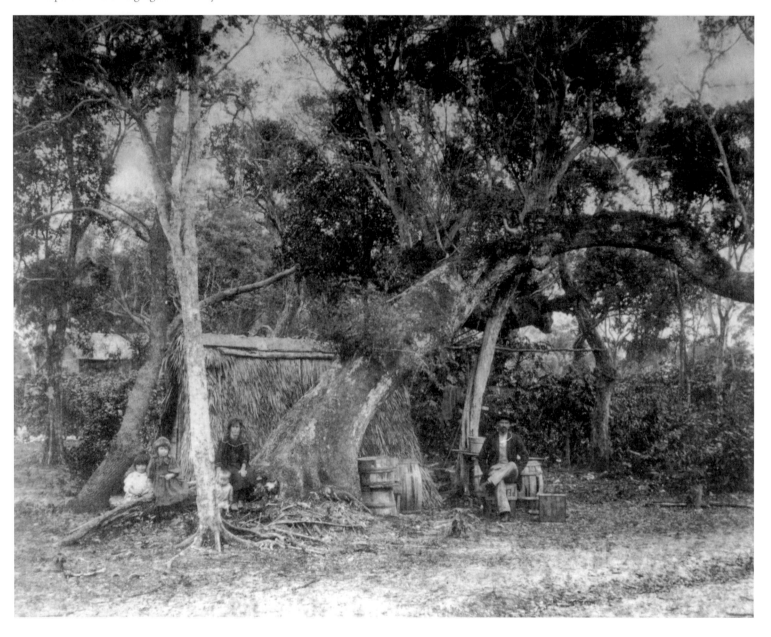

Photographed in 1896, the original Bank of Bay Biscayne is shown here. Richard Brown, president of the bank, is believed to be the person on the right.

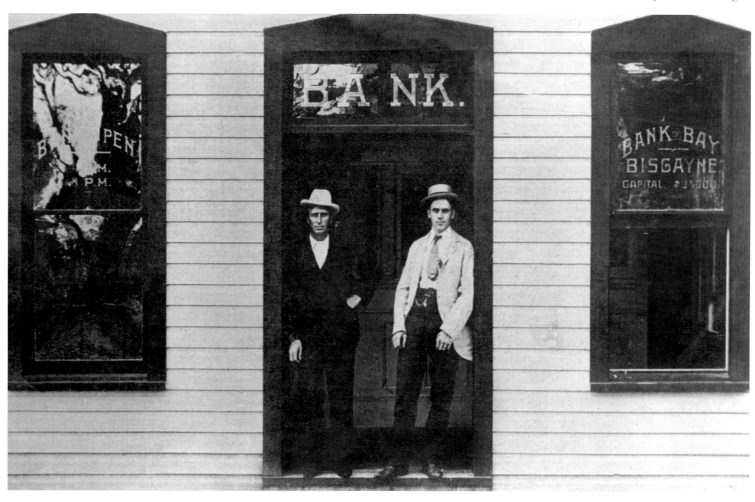

The breaking of ground for the fabled Royal Palm Hotel was a momentous occasion. On March 15, 1896, one month before the arrival of the first Florida East Coast Railway train, five pioneer Miamians—from left to right, Everest G. Sewell, T. L. Townley, John Sewell, C. T. McCrimmon, and J. E. Lummus—pose for a photograph commemorating the groundbreaking.

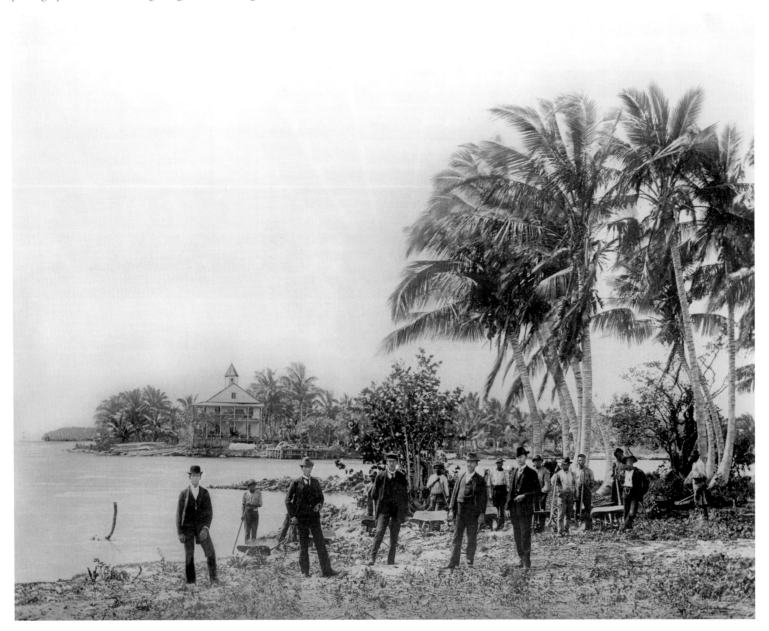

Julia Tuttle was a teetotaler and originally tried to make Miami a "dry" city, without much success. She was able, however, to organize religious gatherings. This very rare photo shows what is believed to be Miami's first revival or tent meeting, held sometime during 1896. The location is thought to be at 12th Street and Avenue C, today's Flagler Street and Northeast First Avenue.

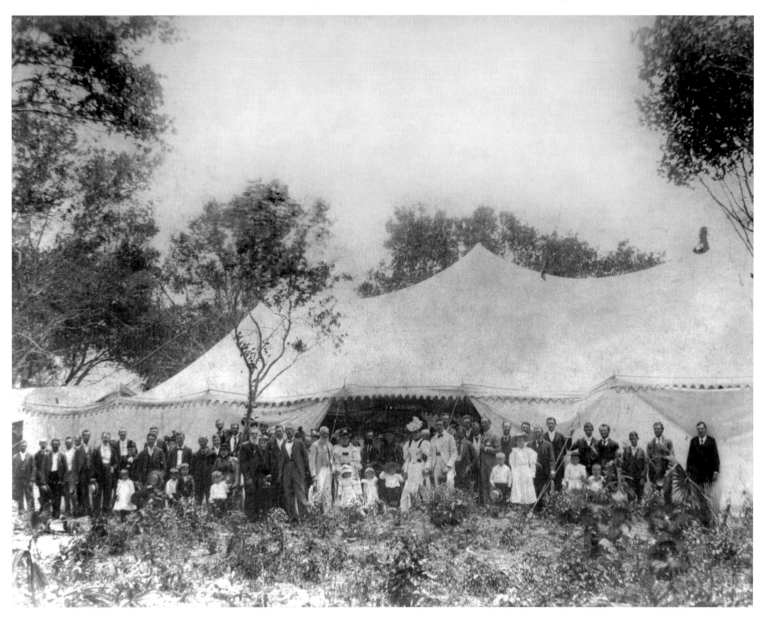

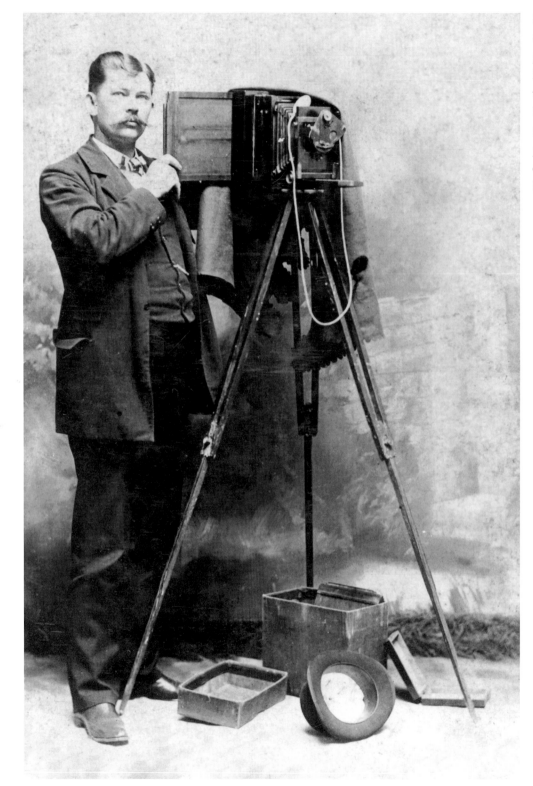

P. John Coates was one of Miami's pioneer photographers. He may have been associated with the Hand's Photographic Studio, the largest of the early photo and portrait emporiums in the newly birthed city.

Given the shape of the building and the sign on the left side, this is probably the original studio of photographer Coates, but is perhaps his home as well.

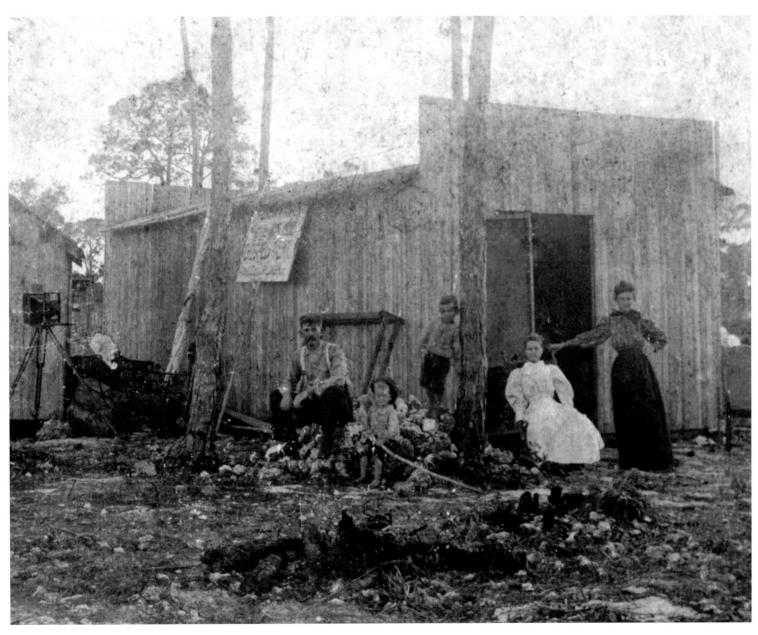

The C. Cone blacksmith shop, Miami's first, was on Avenue D, today's Miami Avenue, and stood next to the T. N. Gautier grocery and grain store. Mrs. Gautier's boarding house, one of Miami's earliest, is on the second floor. It appears that the trench being dug may be the sewer line for the Royal Palm Hotel.

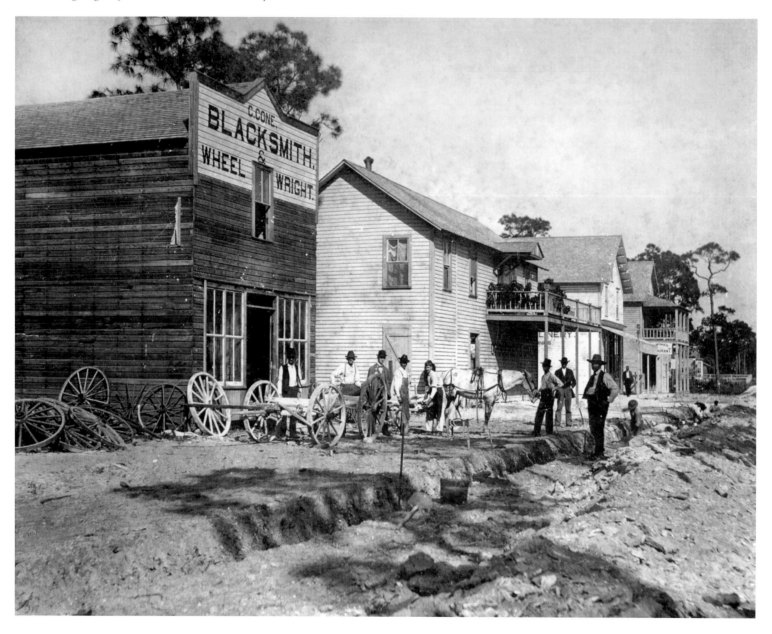

Although unidentified, this group of dandies likely poses on a Sunday at Julia Tuttle's hotel in Miami. It is probable that they were Flagler employees involved in the construction of the Florida East Coast Railway facilities and the Royal Palm Hotel.

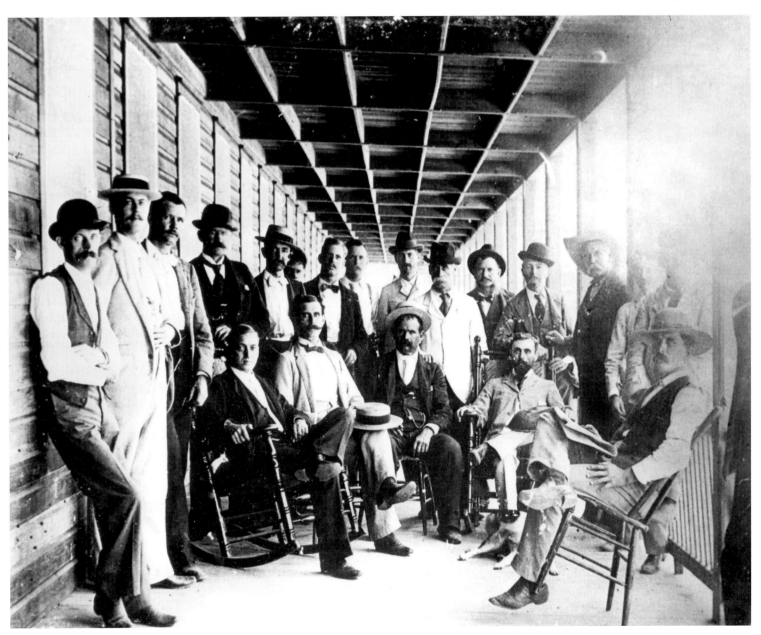

Compared with the Miami of today, it is almost unbelievable that this scene of a group of people shows them at what was then the area of 12th Street and Avenue D, today's Flagler Street and Miami Avenue.

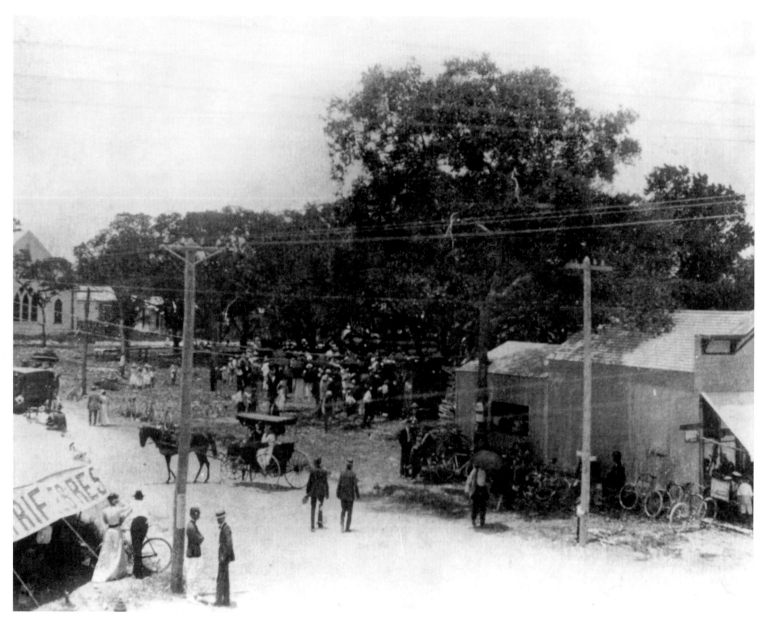

A group of Flagler workmen in the Miami "wilderness" pose for the
camera some time during 1896.

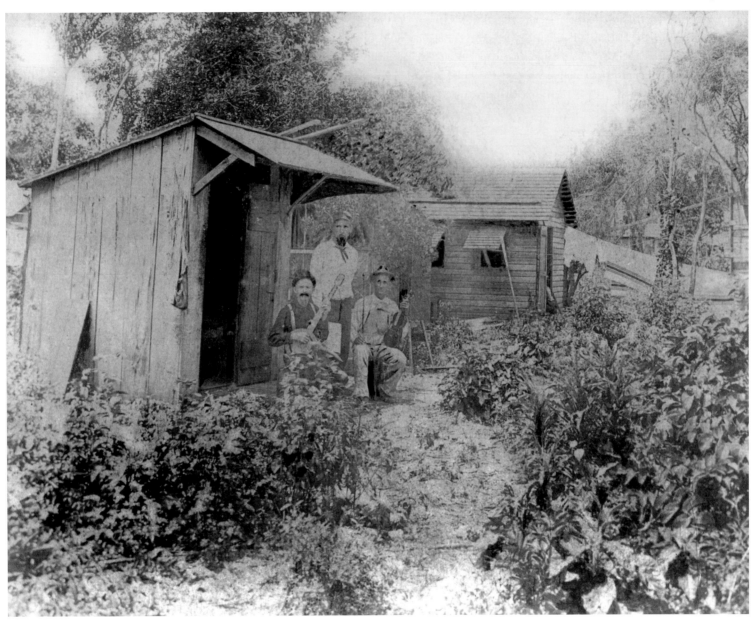

Life in early Miami was lived on the water as well as on the land. In this view are several of the commercial boats as well as houseboats.

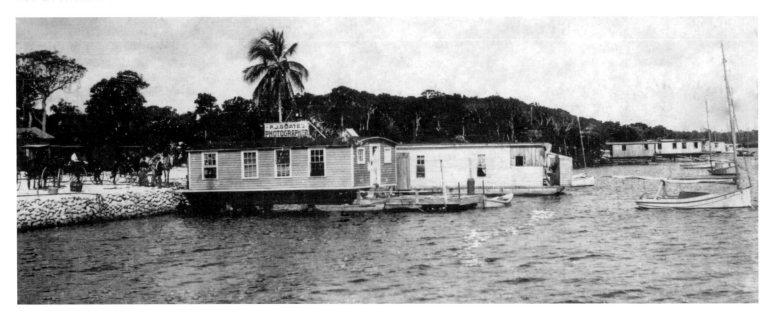

The Pollock family at home in 1897, at 10th Street and Avenue C, today's Northeast Second Street and First Avenue. Homesites, at $25 a lot, were cheaper north of the city limits!

Wooden commercial buildings, many of which would burn in the several fires that reshaped early Miami, are shown here on 11th Street, today's Northeast 1st Street, just west of Avenue D (Miami Avenue).

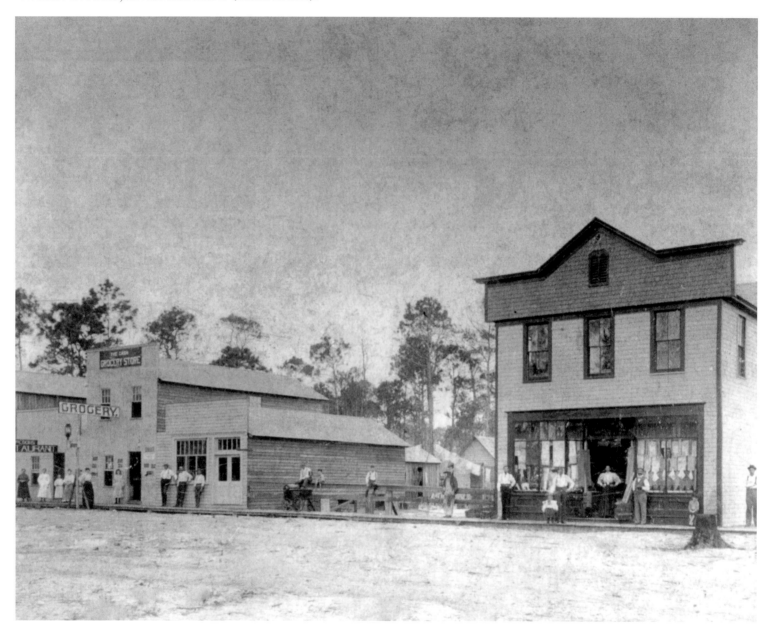

Likely Avenue D, just north of 12th St., this view shows, among other businesses, John Sewell's Shoe Store (Miami's first store, Sewell claimed), Reilly's real estate office, a tailor shop, a pool and billiard parlor, and Raulerson Brothers Meat Market.

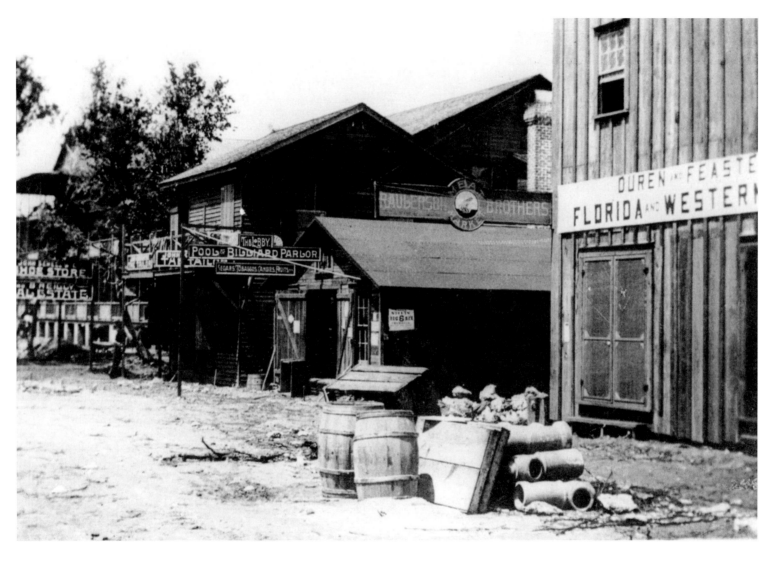

From P. John Coates comes this marvelous view of a coaching party departing from the Royal Palm Hotel for Arch Creek, the site of the natural bridge (now a protected preserve) in today's North Miami. It was approximately a 30-mile round trip—making a long day for the excursionists.

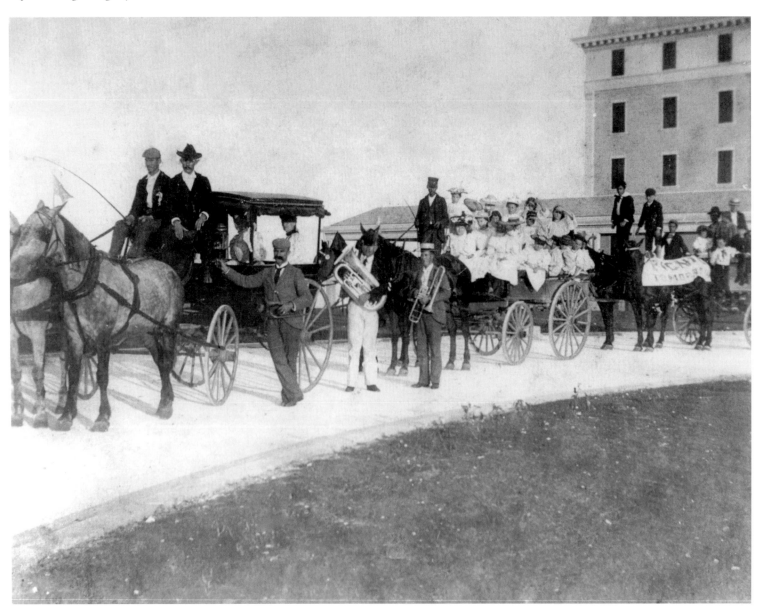

Pictured here at the early Florida East Coast Steamship Company dock (just north of the road access to today's Port of Miami) are the S. S. *Miami,* at left, which made the "run" to Nassau in the winter season, and the *City of Key West,* at right, the Miami–Key West boat.

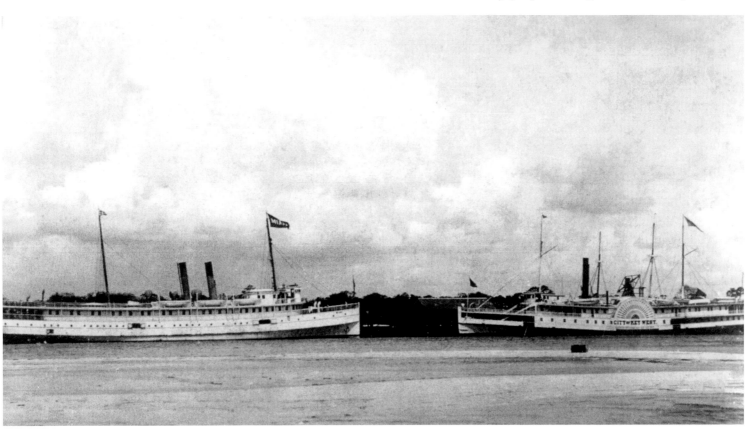

Whether prospective buyers, sellers, or kibitzers, this group gathered on the
Kingsley Real Estate office porch appears to be rough and ready.

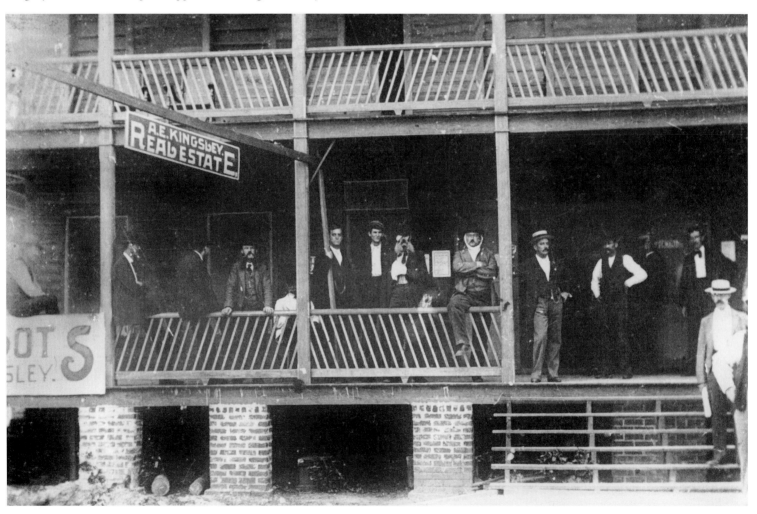

During the summer the Florida East Coast Hotel Company kept the Royal Palm Hotel swimming pool open and attended, for use by the locals. Brave young swains of the day, to impress their lady loves, would climb the ladder in the back corner and dive from the roof into the pool.

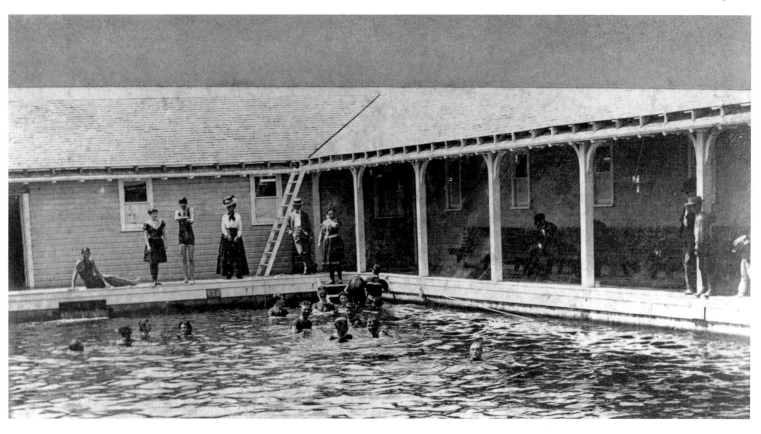

From the night it opened (New Years Eve, 1896) until it was badly damaged by the September 1926 hurricane, the Royal Palm Hotel was *the* social and entertainment center of the city. Lunch or dinner in the hotel's dining room was a guaranteed treat.

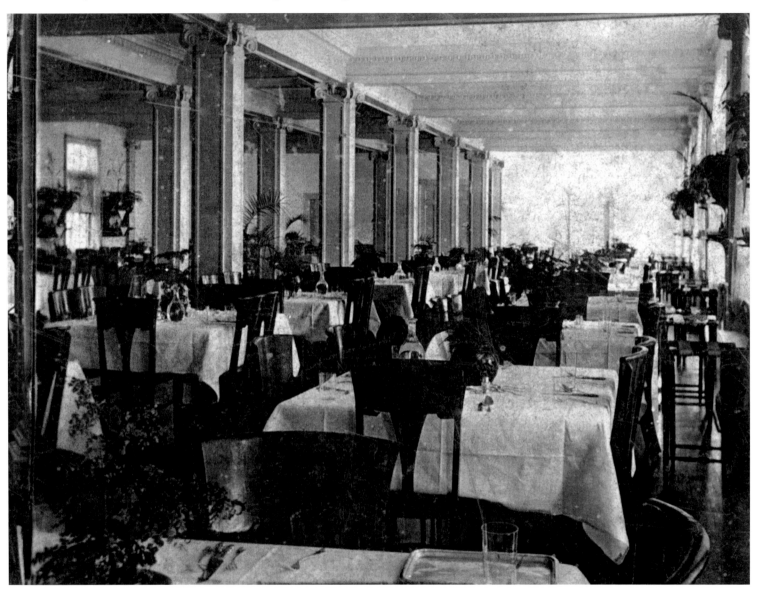

During the Spanish American War and later wars, Miami would serve as an encampment and training ground for those preparing to go overseas. The enlistees in view here are lined up for drill in Royal Palm Park, in front of the famed hotel.

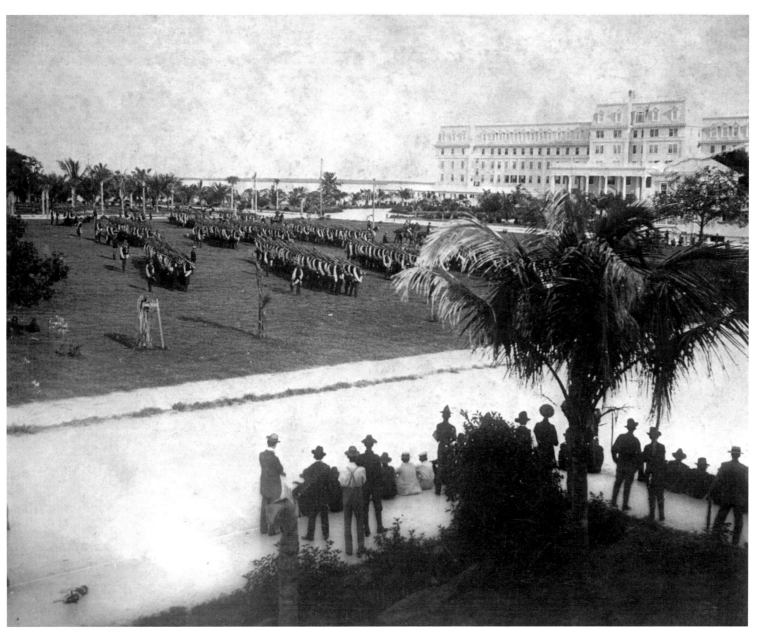

In this view north toward the Royal Palm Hotel, the Florida East Coast Steamship Company's *City of Key West* is in the channel heading south en route to Key West.

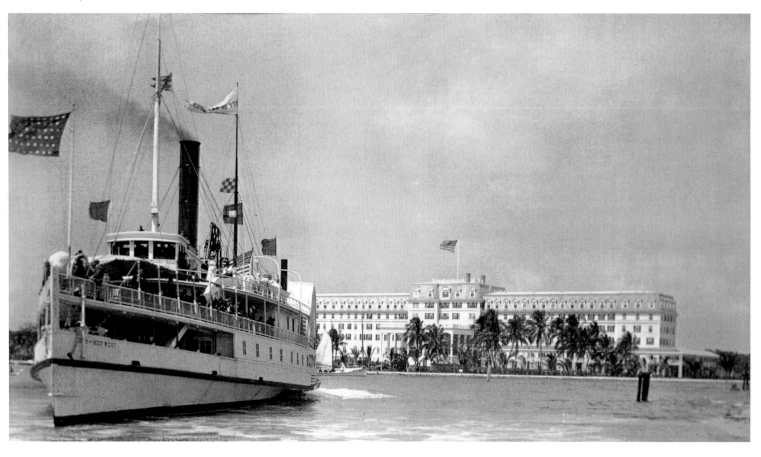

From 1897 until 1926, if it didn't happen at the Royal Palm—it didn't happen. Golf for women did happen there and in this image a group is taking practice swings, likely just before departing for the Florida East Coast Country Club, where Jackson Memorial Hospital and the Government Center stand today.

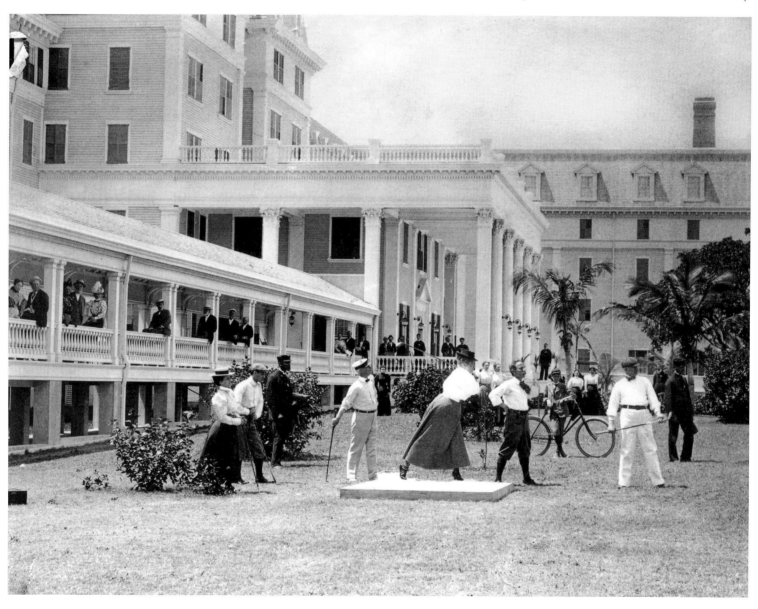

In this view, west on Twelfth Street from Avenue C, it can be noted that a city is beginning to develop. Sewell's, owned by the brothers of the same name and claimed by them to be "Miami's first store," is clearly visible across what would later become Flagler Street.

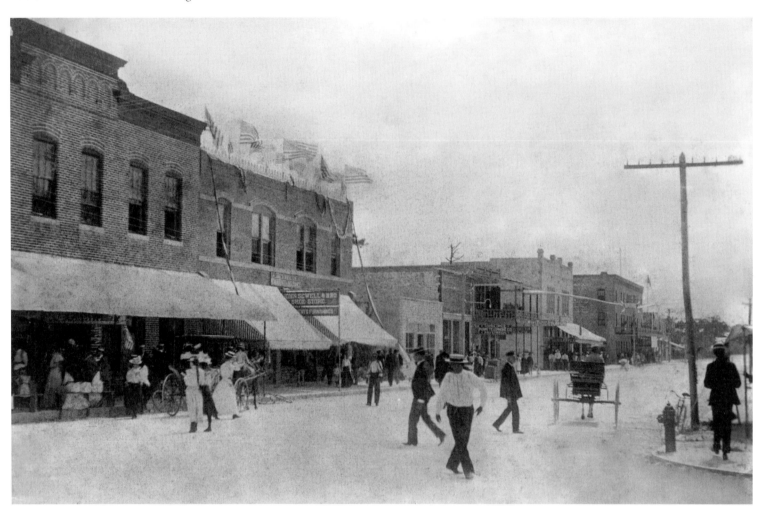

A view east on Twelfth Street shows the Halcyon Hotel in the left background. The Halcyon, on Avenue B (later Northeast Second Avenue), would be razed in the late 1930s and supplanted by the duPont Building, which still anchors the northwest corner of Northeast Second Avenue and Flagler Street.

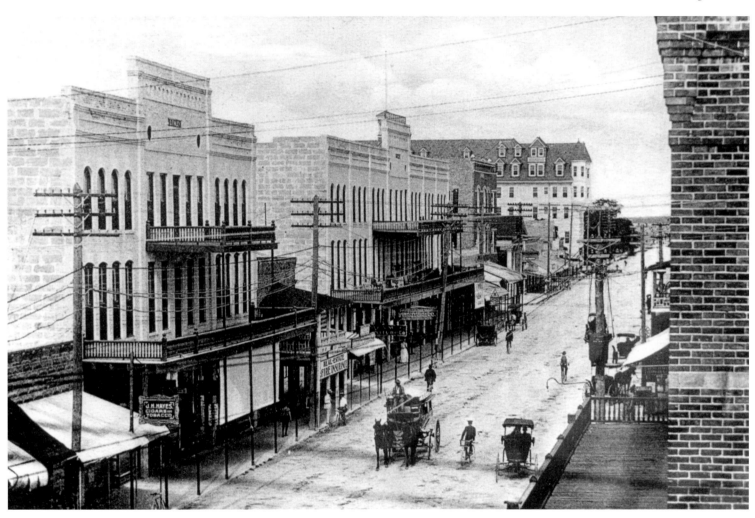

Views of business interiors are always rare and this one exceptionally so, as it may be one of the few known images of the Wilson & Flye Grocery Store interior on Avenue D (today's Miami Avenue) between 13th and 14th streets (today's Southwest First and Second streets).

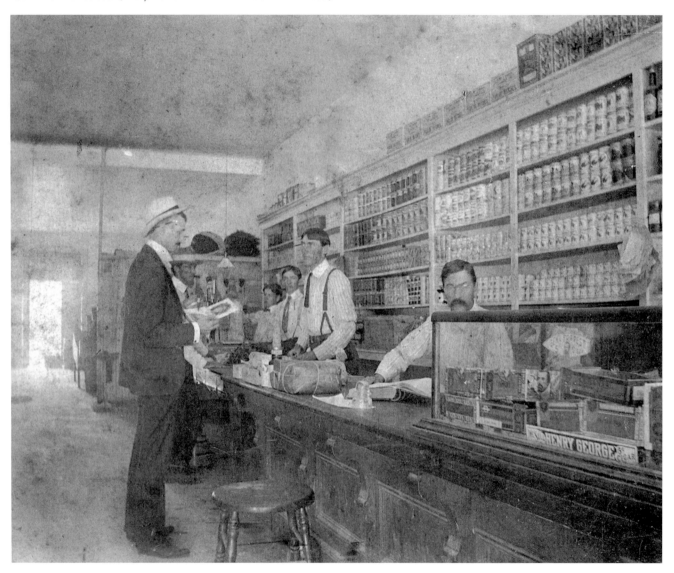

Reputedly the second hotel to be built in the Biscayne Bay region, the Bay View Hotel (preceded only by the Peacock Inn) was constructed by Cornelia Keys at Lemon City (Miami's first boat dock) in 1892 and moved to Miami by barge in 1899.

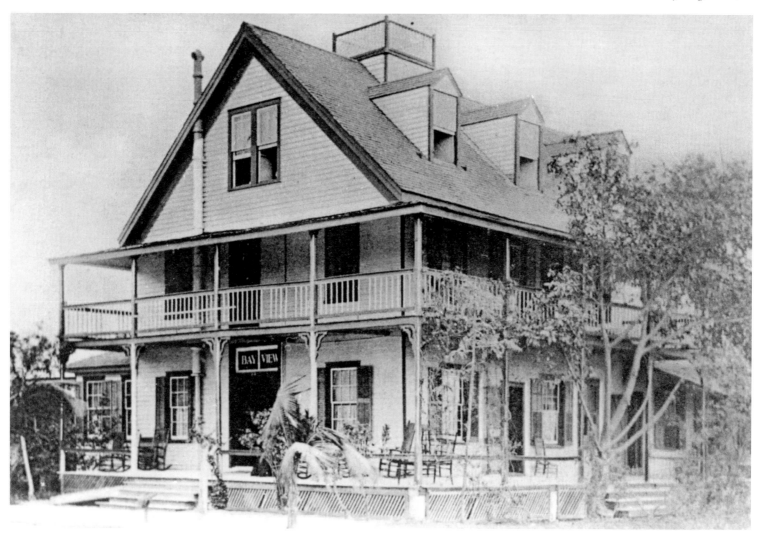

This early image shows Seminoles in their dugout canoes on the Miami River, likely near Musa Isle.

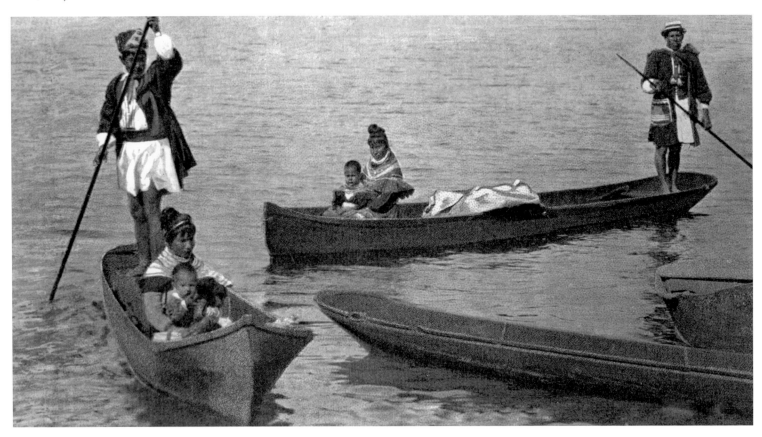

Newsboys for the predecessor of the *Miami Herald* promote the *Miami Evening Record* as they distribute newspapers from their mule-drawn wagon.

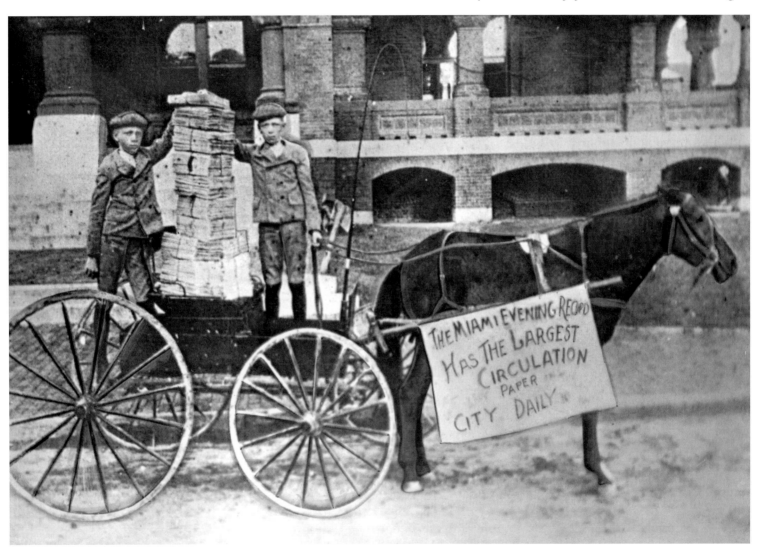

One of Miami's original churches, First Presbyterian stands at its
original location on 12th Street near the Boulevard (later Biscayne
Boulevard) in 1903.

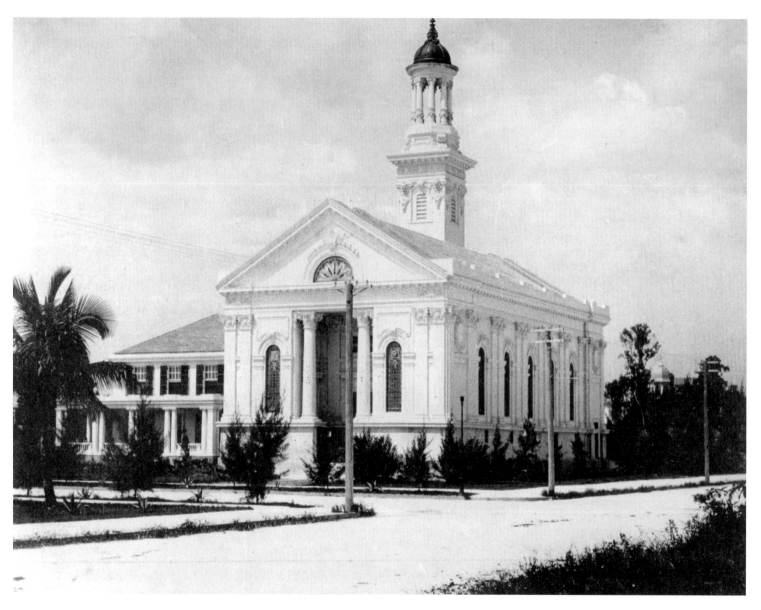

Following the 1902 fire that burned down the wooden building on the northeast corner of 12th Street and Avenue D, Frank T. Budge rebuilt his store, which was located on that corner, facing Burdine's, for many years.

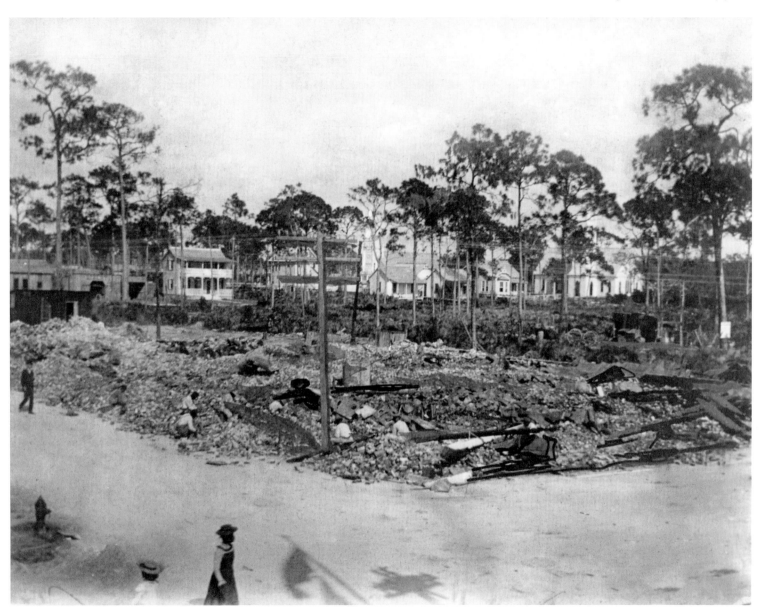

In this view east on 12th Street, around 1902, the Halcyon Hotel's turrets are just visible at left in the distance. Too early to be the work of famed Miami photographer G. W. Romer, this image may have been a Hand Studios photo.

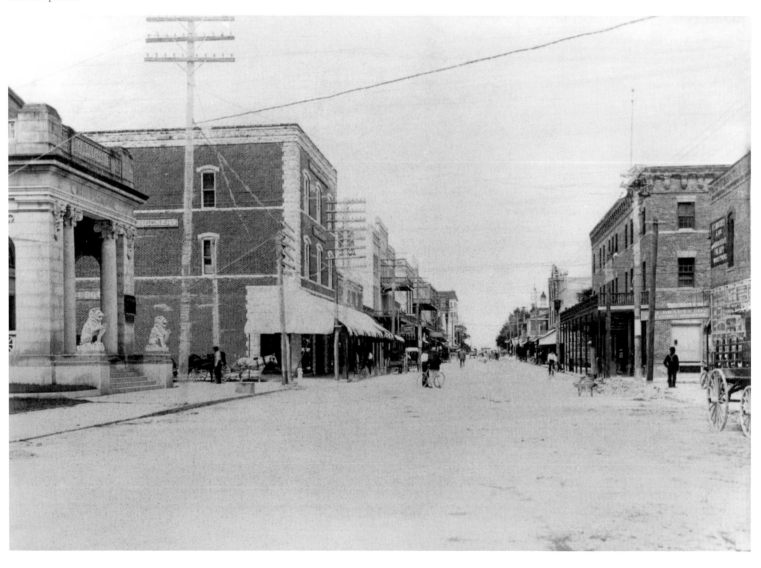

Another view of the Wilson and Flye Grocery with a Mr. Campbell at left, Roy Burgess, center, and J. L. Wilson at right.

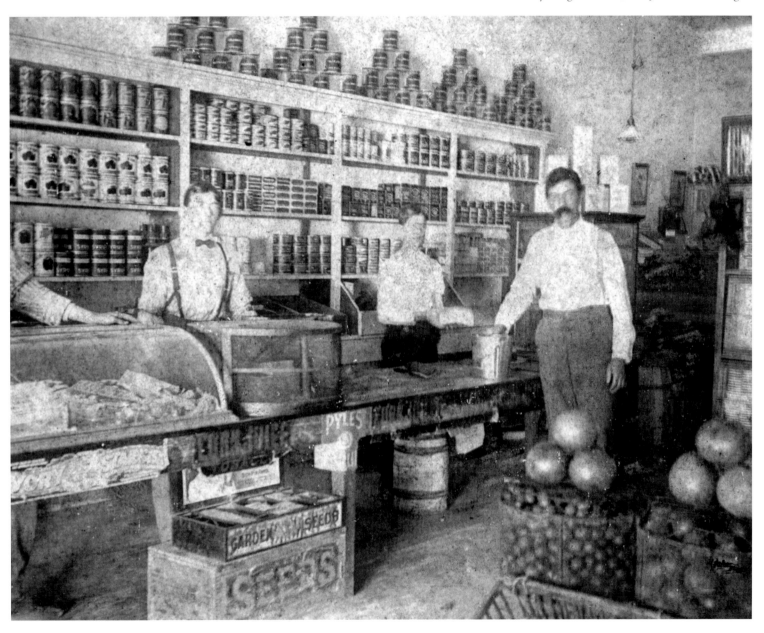

Mrs. Charles Mann, with her daughter, Louise, is shown in front of their Miami home with a group of Seminoles. This is an unusual and seldom found group portrait of the people who called early Miami home.

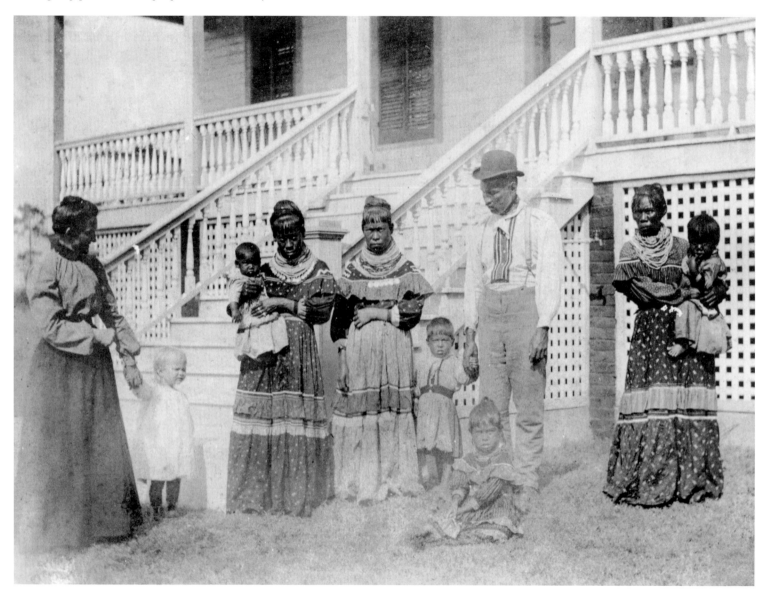

The Dade County Courthouse (not the first) just after its 1904 completion. Located on 12th Street, just east of the Florida East Coast Railway, it would be succeeded by the current courthouse, which was built over and around it. Following completion of the newest, the older courthouse was demolished.

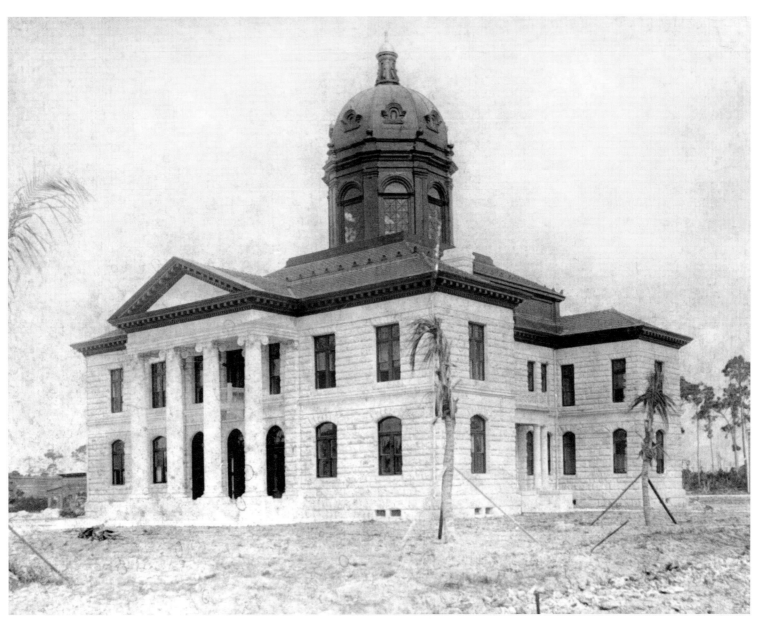

The clearing of what would become Lincoln Road was an arduous task. Eventually the street would be known as "the Fifth Avenue of the South." Today it is the north end of what is known as "SoBe," and is frequented by Miami Beach's swinging jet set.

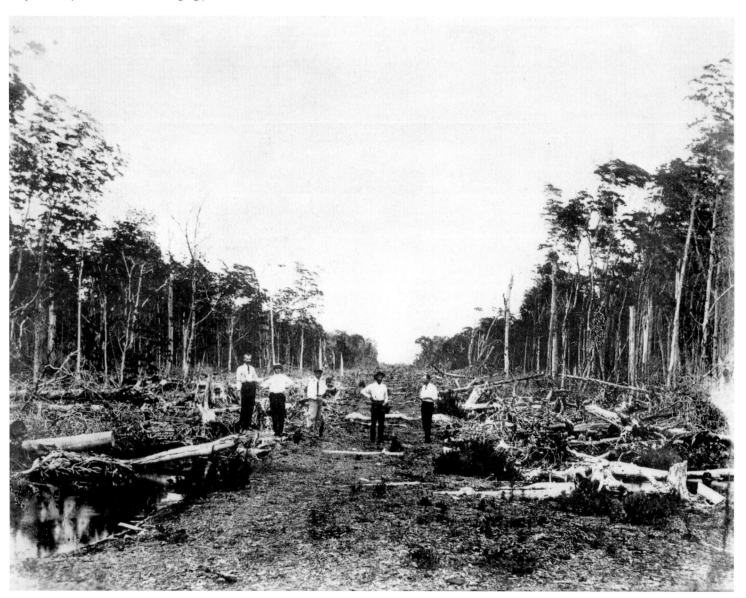

A view of Avenue C (today's Northeast and Southeast First Avenue) shows the street as a lovely, tree-lined thoroughfare. The avenue of today retains none of its original features.

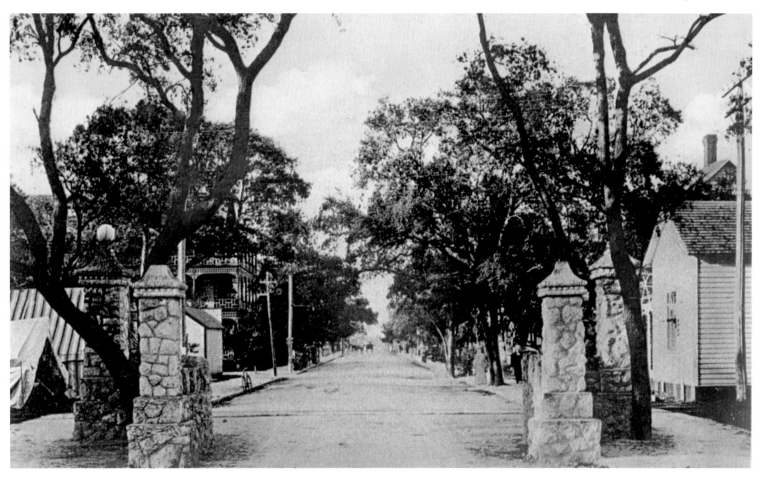

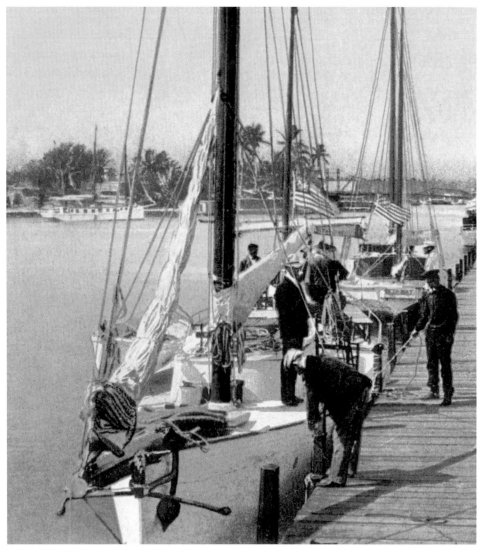

This 1905 photograph shows sailboats tied up at one of the Miami River piers. Even then the river was a bustling commercial waterway.

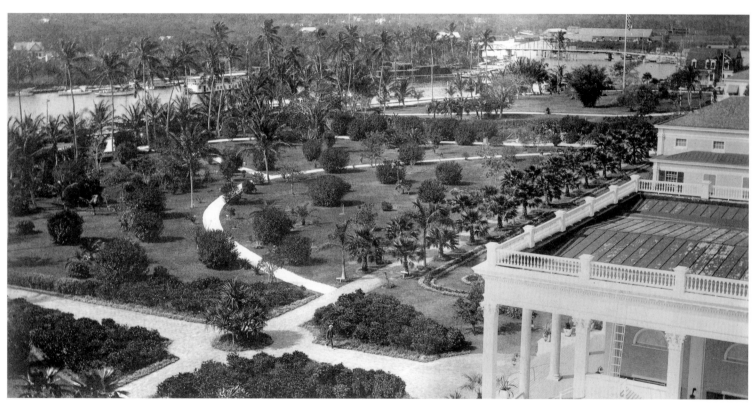

From the roof of the Royal Palm Hotel, this vista includes the Miami River, the
Avenue D bridge in the background, and the hotel's beautiful rear garden area.

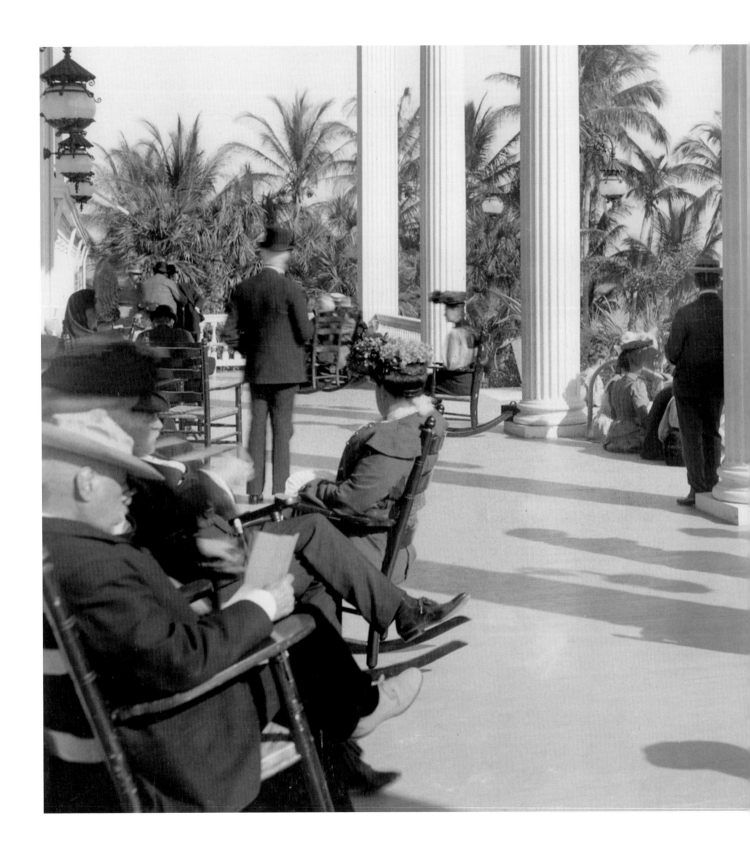

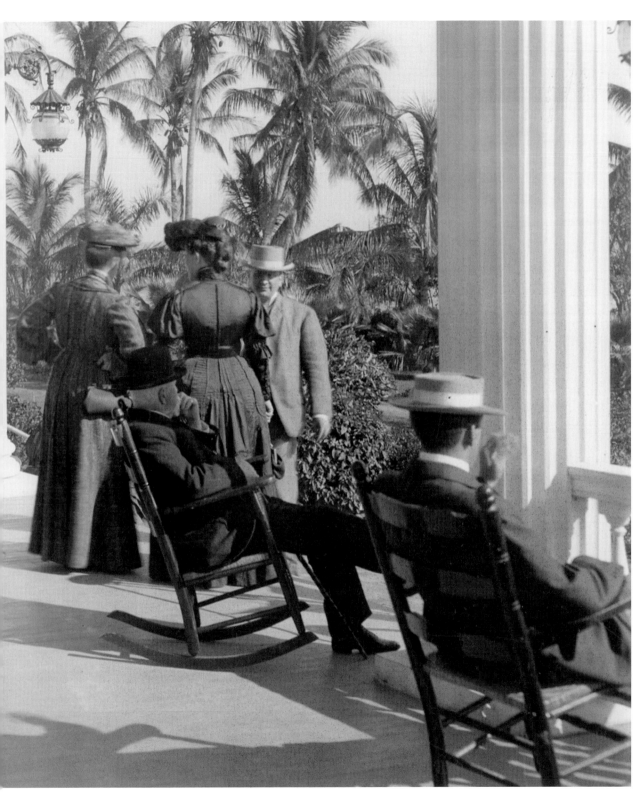

A lovely and pleasant afternoon was capped off with a visit with friends on the veranda of the Royal Palm. The hotel was part of the Florida East Coast Hotel Company chain, owned by railroad magnate Henry Flagler, and opened on December 31, 1896.

"W & H" stood for Wilson and Huddleston. The *20th Century*, shown here, was the "run" boat they used to meet fishing boats approaching the various docks. The captain would then negotiate with the fishing boat captains for the purchase of the catch.

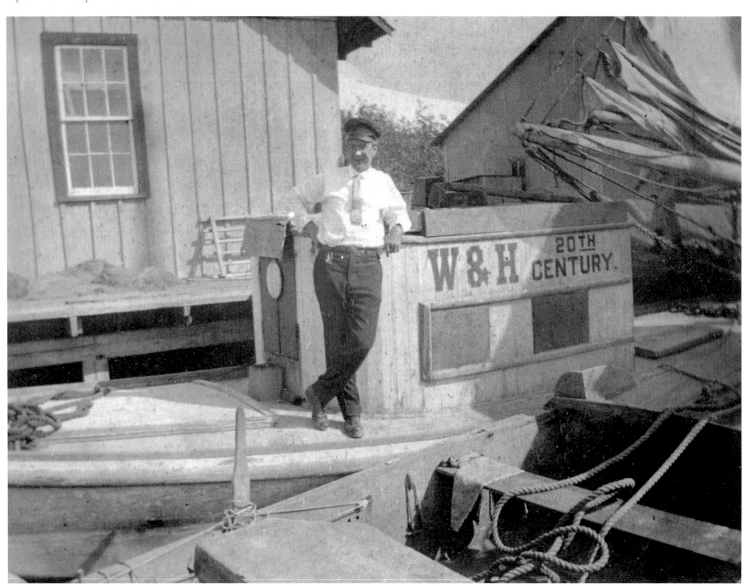

In this view east from behind the Royal Palm Hotel, a two-stack steamer plies the river, and Ocean Beach, later to become Miami Beach, is visible in the far distance. The hotel stands at left.

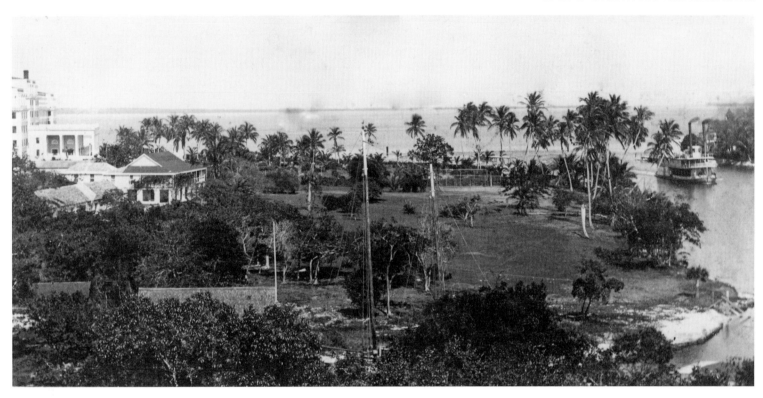

Like that of the Royal Palm, Halcyon Hotel memorabilia is a delicacy, at the top of the "food chain" among Miami history buffs who collect it. A stunning and ornate property, the hotel faced Avenue B (Northeast Second Avenue) with its south end facing Flagler Street. This photograph was taken in January 1906.

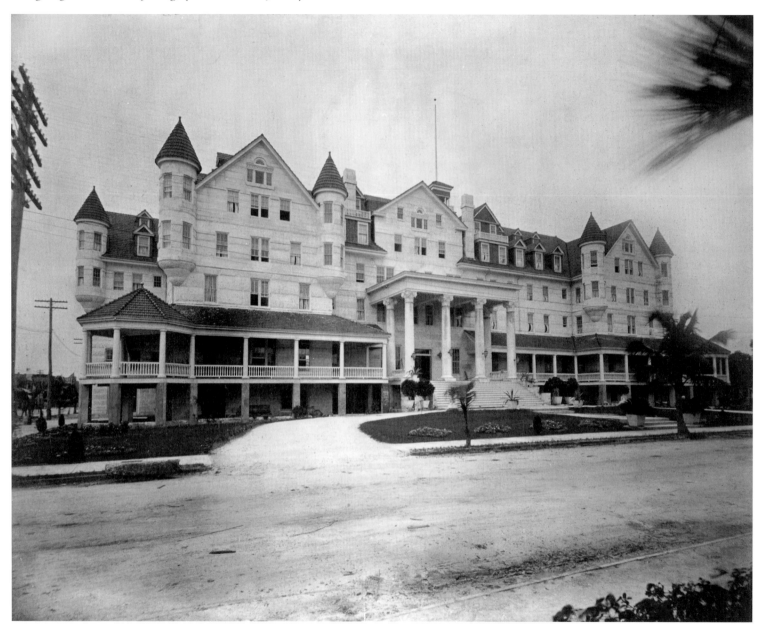

Pictured here is one of the Ft. Dallas
buildings, around 1908, ten years after
"the Mother of Miami" Julia Tuttle's death.

The John Quinn Company of Miami was one of the contractors whose job it was to drain the Everglades. In this view a Buckeye Traction Ditcher Company trench digger is hard at work excavating a drainage ditch to aid in the process.

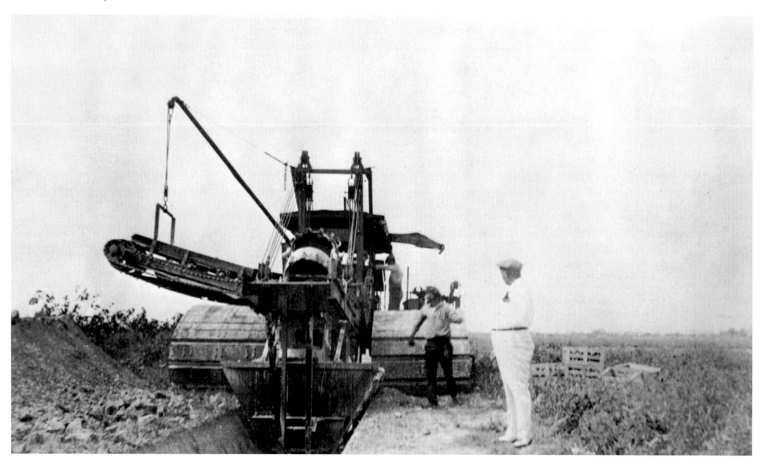

It was cause for celebration when, in 1908, the first automobile trip from Jacksonville to Miami was successfully completed. ("How" is still a mystery!) Shown here at the entrance to the Royal Palm Hotel, the group must have cleaned up themselves and the car prior to being photographed.

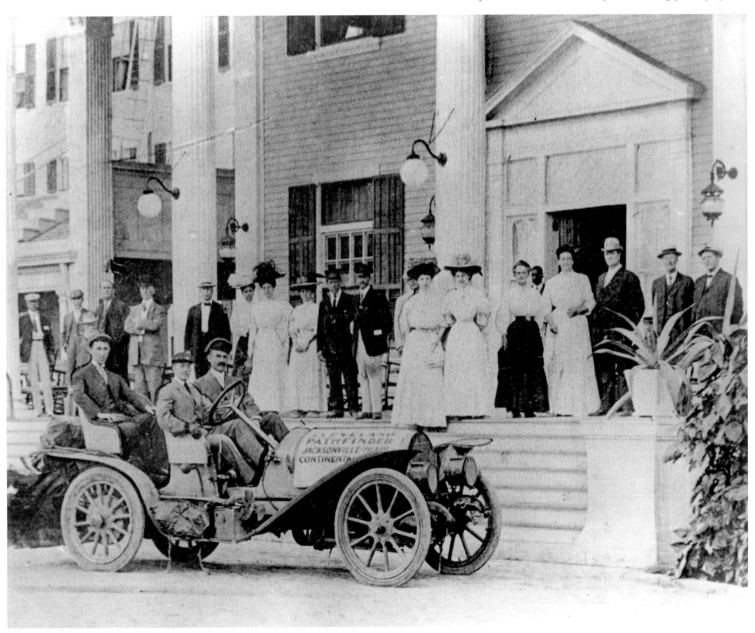

The Brickell family home, with William B. Brickell seated on the veranda, is shown here. Mr. Brickell was in Dade County as early as 1878, according to a tax collection book for that year, which records Brickell's payment of about $4 in county property taxes.

With his hands on the reins of the lead fire wagon, Henry R. Chase, later Miami fire chief and a Dade County sheriff, is shown here. In 1909, the year the picture was taken, the city fire department was only a few years away from motorization.

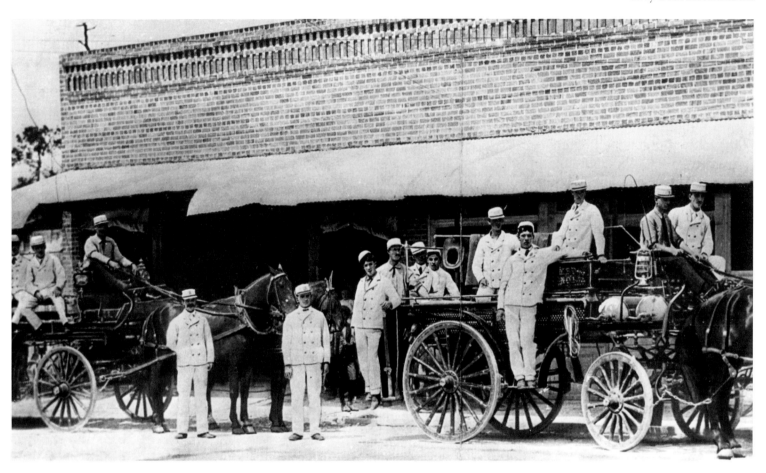

Fulford would, in 1931, become North Miami Beach, taking over part
of Sunny Isles, but in this photograph from around 1910, the center of
community life was its school. Fulford School, with students and teachers,
is shown here in all its one-room glory.

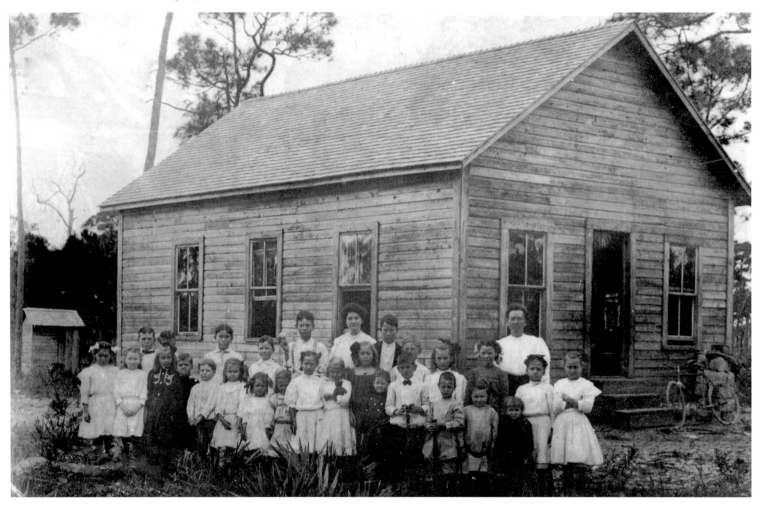

Out for a ride in the family carriage! It is believed that the couple is Mr. and Mrs. Everest (Ev) Sewell, he the brother of Flagler's construction boss, John Sewell. Both Sewells were instrumental in the early development of the Magic City.

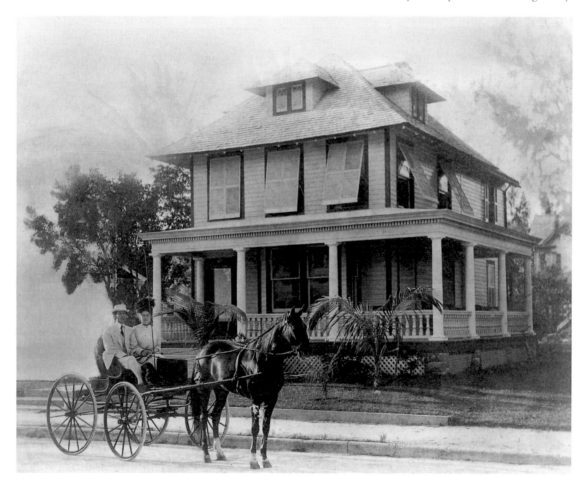

Miami's earliest streetcar line was electrically powered and ran on 12th Street from around 1905 until approximately 1907. Shown here in front of the Red Cross Pharmacy, the trolley is approaching the Bank of Bay Biscayne, the columned building on the right.

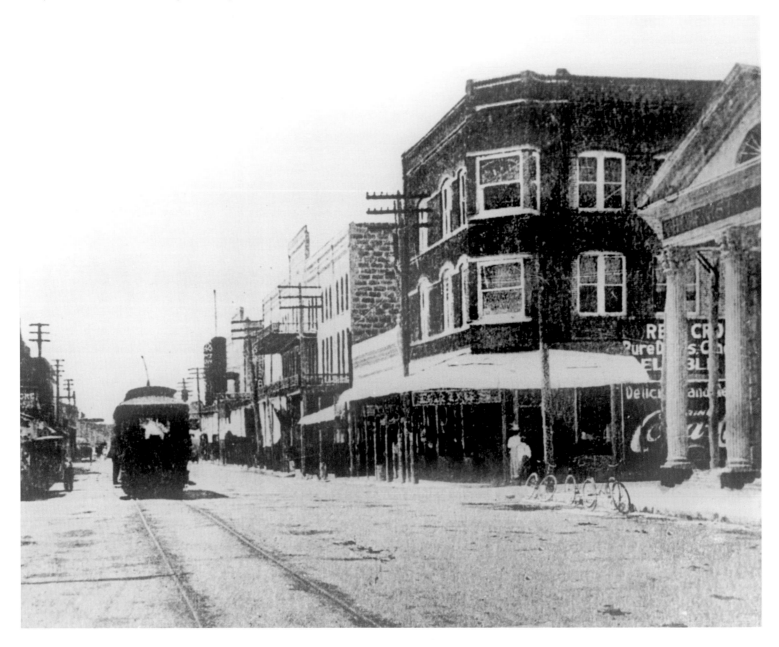

WAR AND REAL ESTATE BOOM

(1911–1930s)

It was an exciting time for Miami, as the fabled Key West Extension of the Florida East Coast Railway was at the high point of its construction, and Miami was the jumping-off point. The opening of a line to Key West in 1912 would bring Miami a new FEC depot, and the old one, located at 6th Street (today's Northeast Sixth Street) and the Boulevard, would close early in December 1912. The new station opened just north of 12th Street on Avenue E (today's Northwest First Avenue). Passenger trains no longer had to back in to the old station and could operate through to Key West without delay.

World War I began in Europe in 1914 and as it became evident that the U.S. would eventually have to go "over there," the tempo of military activity in Miami began to increase, with several new facilities, including a base at Dinner Key, opening.

In 1913 the Collins Bridge to Ocean Beach opened, and two years later, Ocean Beach would be incorporated as the Town of Miami Beach, becoming a city two years after that. Carl Fisher, who had lent the money to John S. Collins and his son-in-law Thomas Pancoast to complete the bridge, would become the dominant figure in Miami Beach's history, eventually carving a great city from jungle.

Miami began to push its boundaries in every direction and Cocoanut Grove (spelled with the "a") incorporated as a separate municipality. Communities throughout the county were growing and towns such as Arch Creek (later North Miami) and places such as Sunny Isles, to be developed by Harvey Baker Graves, were coming into existence.

With the end of World War I, servicemen and their families flocked to south Florida. The advertising of the FEC Railway, promoting "the Magic City" (a moniker now in use since at least 1915), was seized on by the Chamber of Commerce, helping to persuade thousands of people from all over America to come to Miami by whatever means they could.

The great Florida boom began in the early 1920s with Miami, Miami Beach, Coral Gables, and environs leading the way. Nothing short of unbelievable, developments sprang up overnight, lots changed hands ten, twelve, fifteen times in one day, fortunes were made in hours, and an epochal era of city building began. Led by Carl Fisher, George E. Merrick (Coral

Gables), Harvey Baker Graves (Sunny Isles), Emrys and Ellen Harris (the Shoreland Company—Miami Shores), and a good few others, Miami and its suburbs exploded with growth.

All of this growth came to a crashing halt early in 1926 when the four-masted schooner *Prinz Valdemar* overturned at the mouth of Miami harbor's turning basin, blocking all ships from entering or leaving. Followed shortly thereafter by the FEC's embargo of itself for being unable to clear the harbor and move traffic, the land boom began to fall apart. Adding to the trouble, the hurricane of September 17 and 18, 1926, was harbinger of the Great Depression that would begin in the rest of the nation three years later.

Although upbeat following the hurricane, business continued to decline, and even with the opening of new hotels on Biscayne Boulevard and the completion of the trolley line to Miami Beach, the "bust" had hit—and hit hard. Business sputtered, George Merrick and the City of Coral Gables declared bankruptcy, and in 1931 the FEC Railway was placed in receivership. The Labor Day, 1935, hurricane destroyed 40 miles of the great Key West Extension, leading to the abandonment of all tracks below Florida City, the community farthest south on the mainland.

Not being a manufacturing or industrial city, Miami felt the depression to a far lesser extent than most of the rest of the nation. "Bread lines" were rare and both the aviation and the hotel industry on Miami Beach experienced growth. Pan American Airways extended its routes, Eastern Air Transport became Eastern Air Lines and increased its service to Miami, the FEC Railway, on six different days during the 1935-36 season, operated seven sections of the famous all-Pullman sleeping car train, the "Florida Special," and, in 1938, the Seaboard Air Line Railway brought the first streamlined, air-conditioned train, the "Silver Meteor," to Miami.

Coral Gables, although suffering the effects of the depression, nonetheless refused to lower its zoning and building standards, a decision which has paid off many times over the years. And on Miami Beach a building boom of hotels, centered on the art deco style of architecture, would employ a large number of people. Throughout the 30s, bad as the depression was, Miami and its suburbs never ceased promoting life in sunny Florida, helping Miami to continue growing, albeit at a reduced rate, during the decade.

Early Miami was bucolic, and the water was its greatest attraction. The Miami River was the centerpiece for recreational activities in the young city and sailboating was enjoyed year-round.

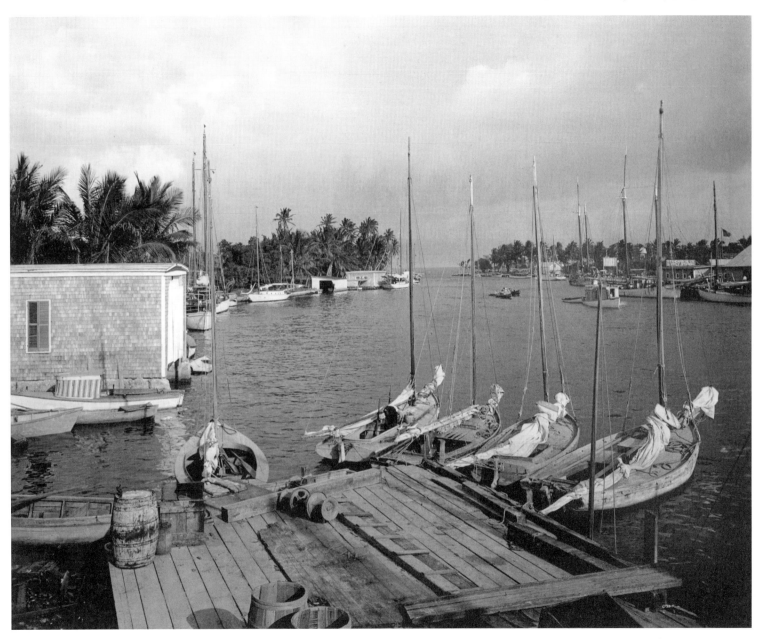

There were, at several locations along the western reaches of the Miami River, what were known as "observation towers," and tours were sold which included a boat trip to one of the towers. The Car Dale Tower was, for a good few years, considered to be a "high point" in any tourist's exploration of early Miami.

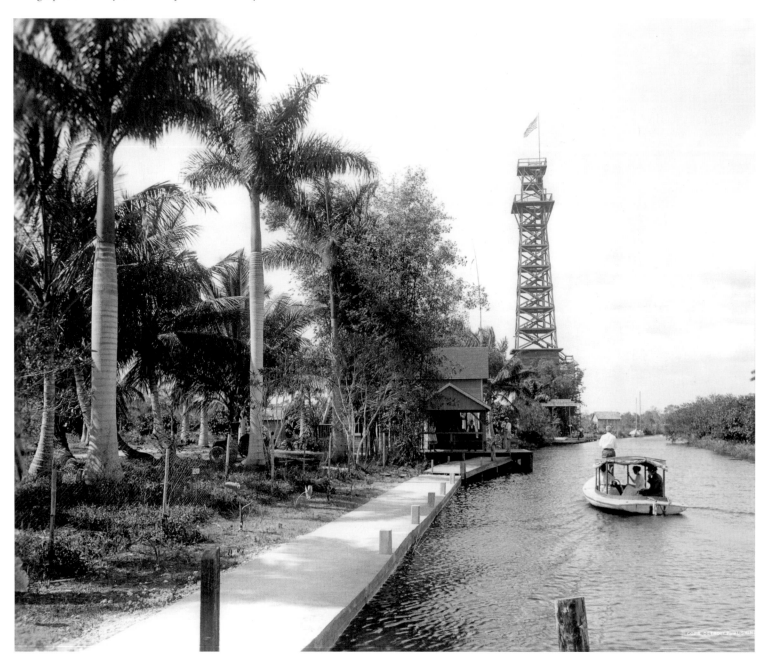

In 1912 aviation was just beginning to attract the nation's attention. The first commercial airline in America operated in Florida the following year. The Curtiss hydroplane shown here in Biscayne Bay was the first look most Miamians had at any "flying machine."

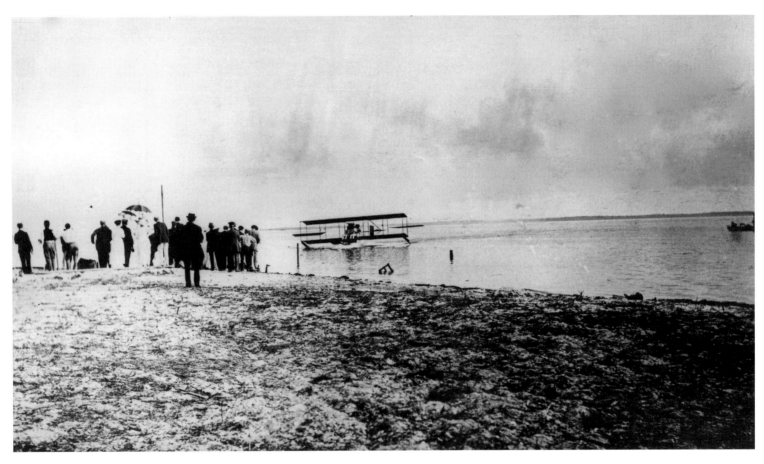

The famed aviator Glenn Curtiss would fall in love with Miami, and would be forever identified with the area, building both Miami Springs and Opa Locka. He is shown here in front of his hydroplane with pilot instructor Charles C. Witmer in 1912.

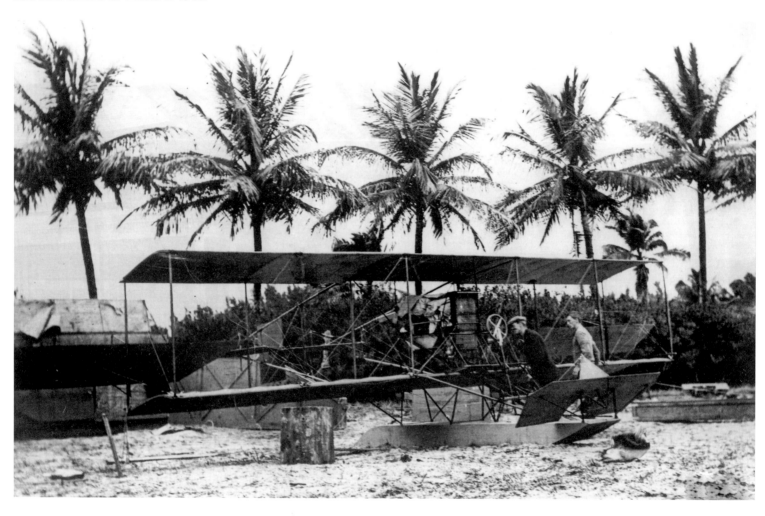

The predecessor of the Orange Bowl parade was the great Pageant Day parade held on 12th, later Flagler Street. Even before this parade, the city held yearly celebrations which included decorated floats. In 1912, photographer G. W. Romer captured this image of the float of A. B. Hurst of Little River Arrowroot Starch. Mr. and Mrs. Hurst themselves sit in the front seats.

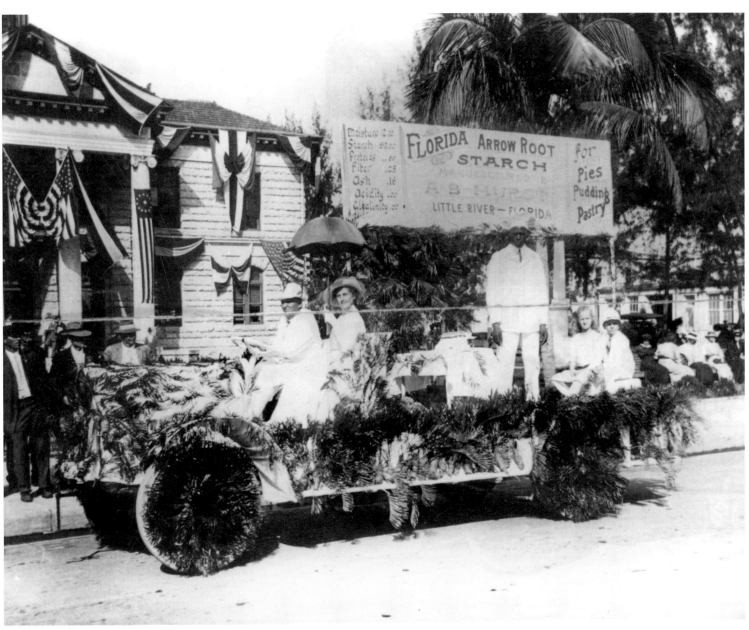

Helen Lummus hoists the first flag at the Ocean Beach (later Miami Beach) realty office on March 17, 1913. J. N. or J. E. Lummus is likely standing to Helen's right. The Lummus Brothers donated Miami Beach's famous oceanfront park and beach to the city.

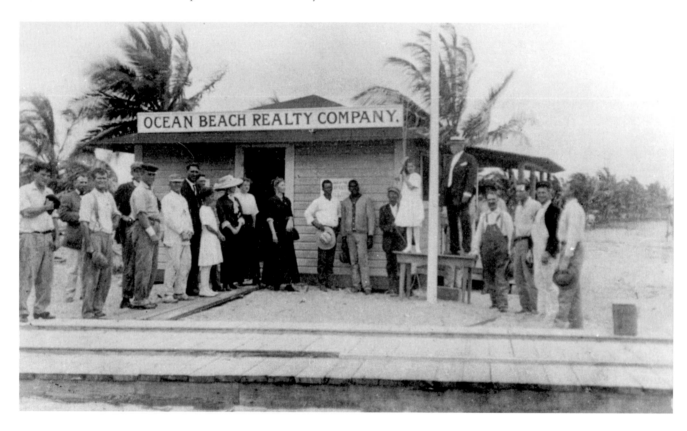

Blanck's Department Store was at 9th Street (today's Northeast and Northwest Third Street) and Avenue D (Miami Avenue). Shown here, from left, are Charlie Higgs, a porter and tailor, Jennie Ripa Blanck, P. G. Blanck, a salesman and a saleswoman whose names are unknown, and a Mr. Hendry. The Ripa family would become prominent hat makers in Miami and their store downtown would remain open until the late 1960s.

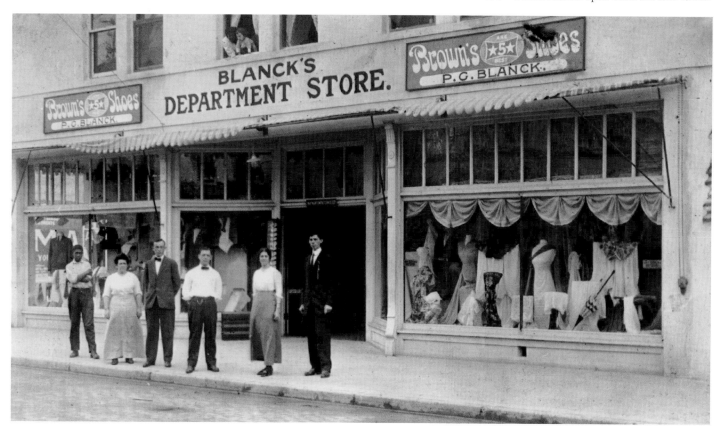

Miami High School, 1912. In the third row, far-right end, is Earl D. Wilson, who would become prominent in Miami politics. Miami High was the city's first public high school and recently celebrated its 100th anniversary.

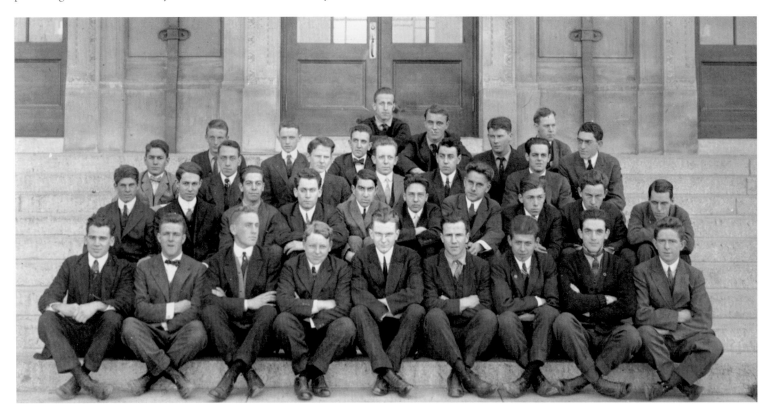

Carl G. Fisher, prior to coming to Florida, built the Indianapolis Motor Speedway
and sold his Prest-o-Lite Company for millions. Shown here on October 25, 1915,
he had just completed the first Chicago to Miami motorcade.

Royal Palm Park, in front of the hotel of the same name, was a great Miami gathering spot for many years. The failure of the city or county to take possession of it when the 1926 hurricane closed the hotel is a good example of shortsightedness in Miami's civic leadership. This tent is the temporary quarters of park custodian Charles A. Mosier, shown here with his family in 1916.

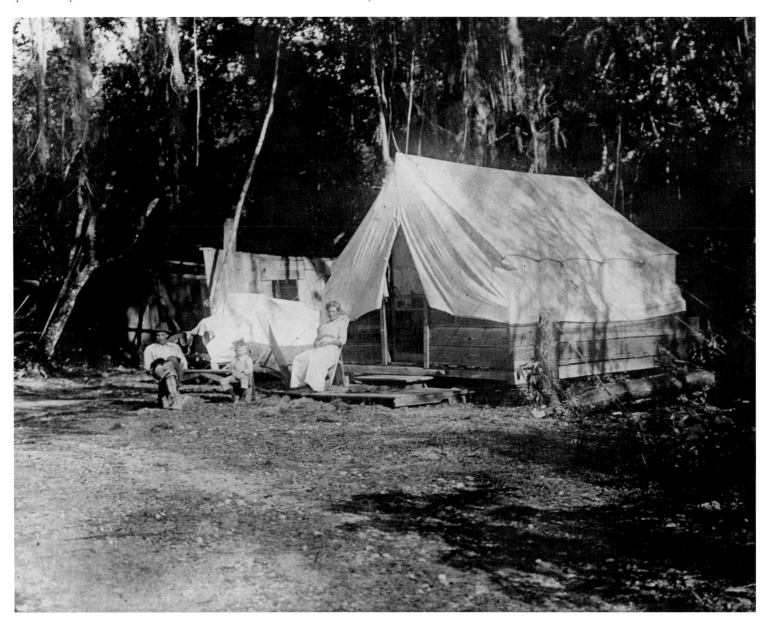

Captain Charles Thompson, shown at far left, garnered national fame when he caught a huge whale shark, mounted it on a railroad flat car, and took it on tour through much of the country. Standing dockside at the Royal Palm Hotel on January 10, 1915, group members proudly display sharks caught on their fishing trip.

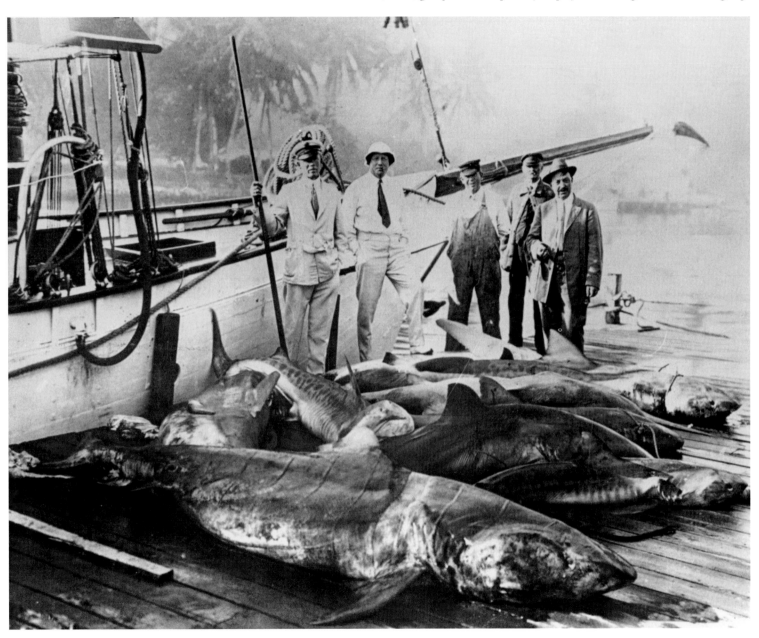

Located on 12th Street and Avenue B (Northeast Second Avenue) the
Hippodrome Theater was one of the city's first vaudeville and movie houses.
Pictured here on May 22, 1917, the building exists in memory only,
through photos like this one.

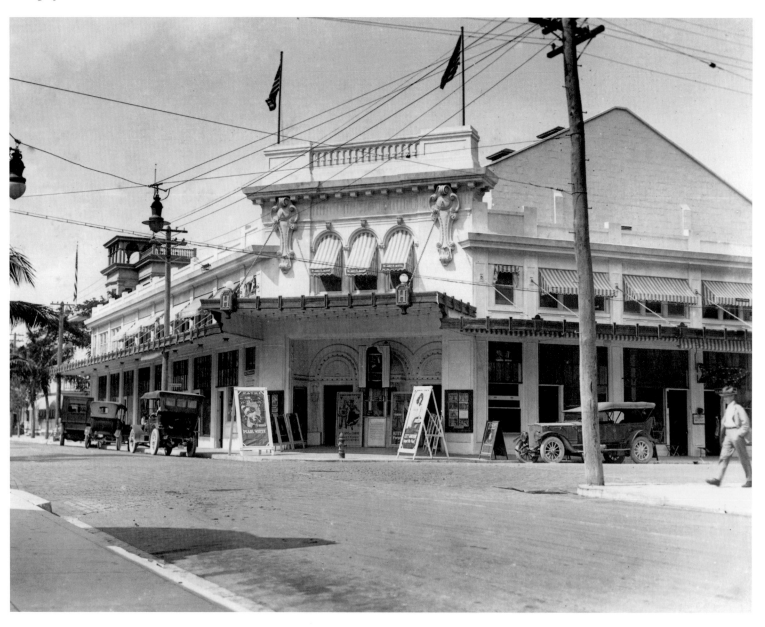

There are few names in the history of south Florida as widely recognized as that of Carl Fisher. Shown here nattily attired for the 1916 Biscayne Bay regatta, Fisher's greatest triumphs still lay several years in the future.

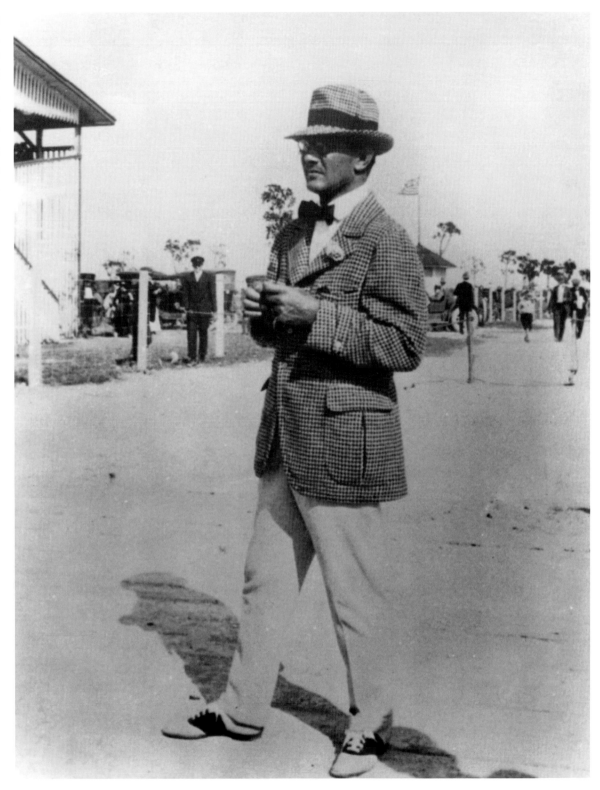

In the early years of the twentieth century, some believed that Miami should and would be the home of motion picture making. Several studios opened with high hopes, none of them lasting through the Depression. Among them was Field Feature Film Company, which, here in August 1915, poses a group of its actors and employees in front of the south Avenue D studio.

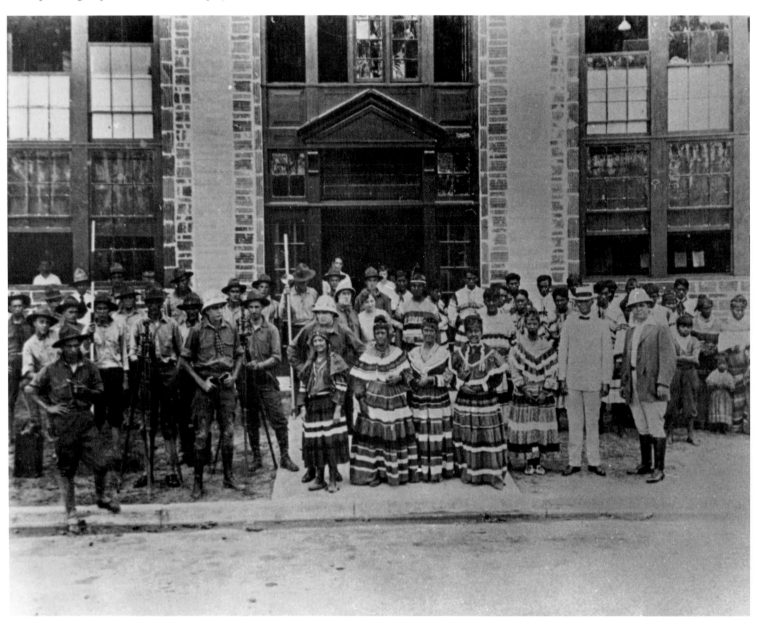

From left, Dr. Charles Torrey Simpson, John Soar, and Paul Matthaus carry saw cabbage palms through the Everglades to add to their plant collections. It is likely that this photograph was taken no farther west than today's Northwest 27th Avenue.

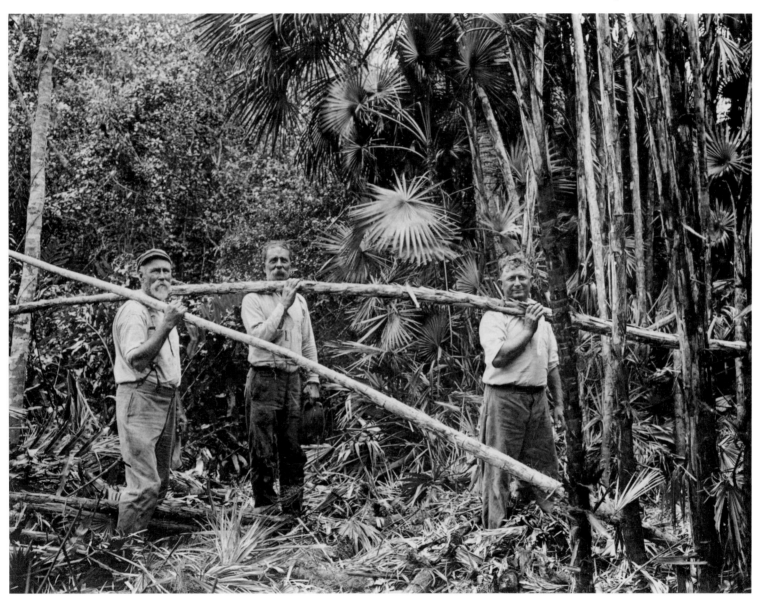

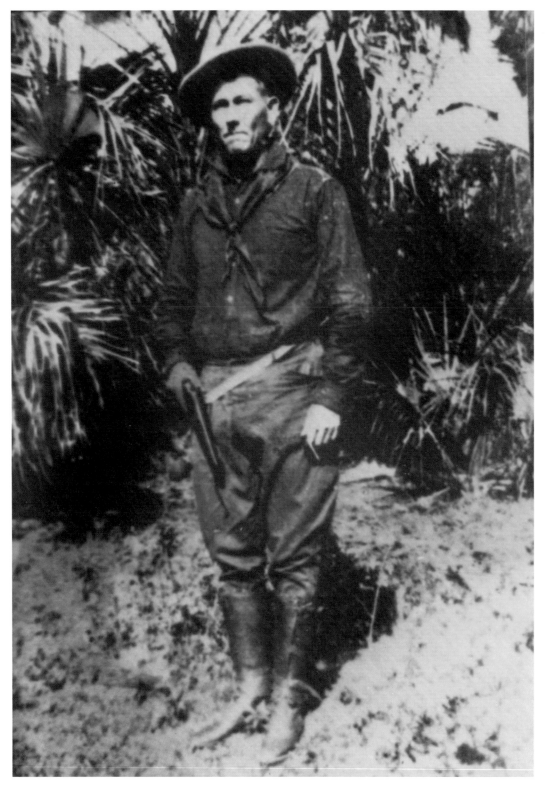

Randall Henderson was an early Miami law enforcement officer. His brothers, Allen B. and William Z., were shot and killed in pursuit of the "Rice gang," which had perpetrated the robbery of the Bank of Homestead on September 15, 1916, the first bank holdup in Dade County's history.

For many years, Elser's Pier sat at the foot of 12th and later Flagler Street. An amusement pier, dances and social events were held there on a regular basis, and the ferries to Ocean Beach left from the Elser Pier docks.

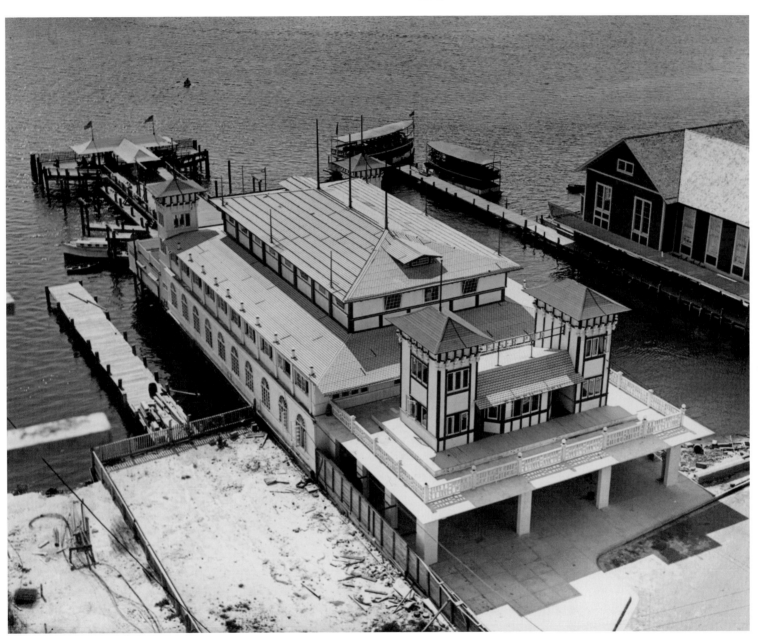

Passing the Airdome on east 12th Street, the Knights Templar parade in
one of the city's early pre–Orange Bowl parade pageants.

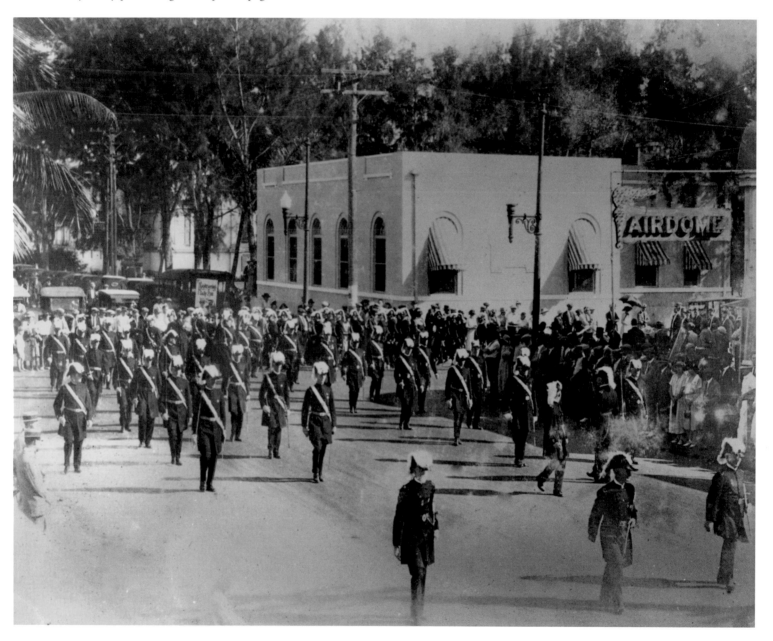

The magnitude of change in and to the Magic City following this May 22, 1917, photograph is almost inconceivable. Taken from the top of the Ralston Building, the view east on 11th Street (Northeast First Street today) shows the Collins Bridge at left and a Biscayne Bay wholly devoid of artificial islands.

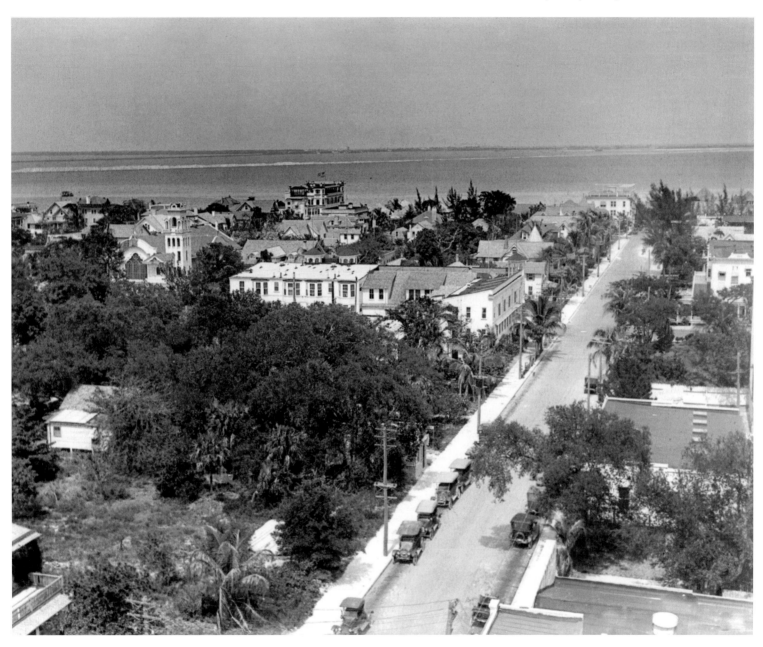

Shown from the left inside the Dade County Security Company in 1919,
May Davidson, Sears Shearston, Harold Hill, another Mr. Shearston, and
J. L. Hill stare uncomfortably at the camera.

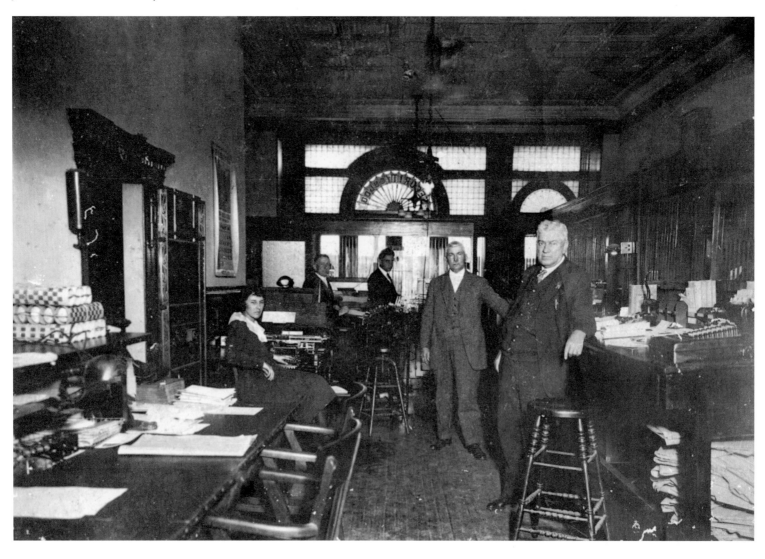

Shown west of Avenue D on Flagler Street, this is one of the finest pictures ever made depicting the situation when creosote-treated wooden blocks were used to pave Miami's early streets. With each heavy rain, the blocks would rise, rendering the streets unusable. The practice of wooden block paving ended shortly after the photo was taken in 1918.

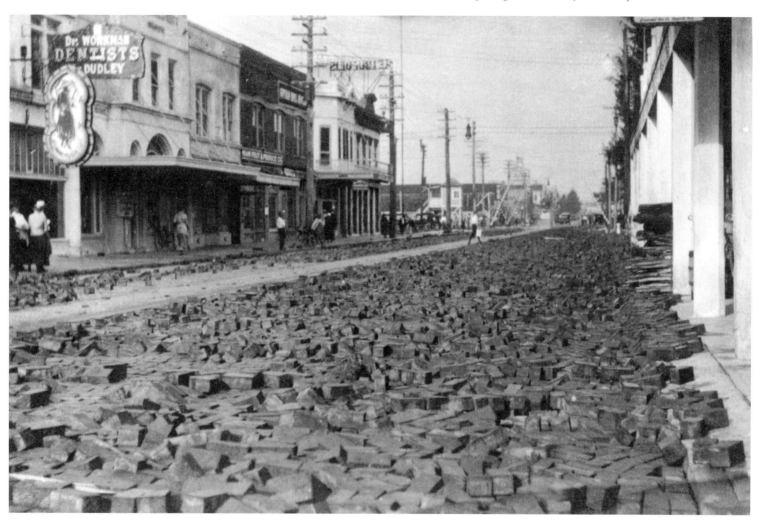

The *Shinnecock,* being used here as a hospital ship for World War I wounded, was owned by the Long Island Railroad and leased seasonally by the Flagler System–owned P and O Steamship Company for Miami-Nassau and Key West–Havana service.

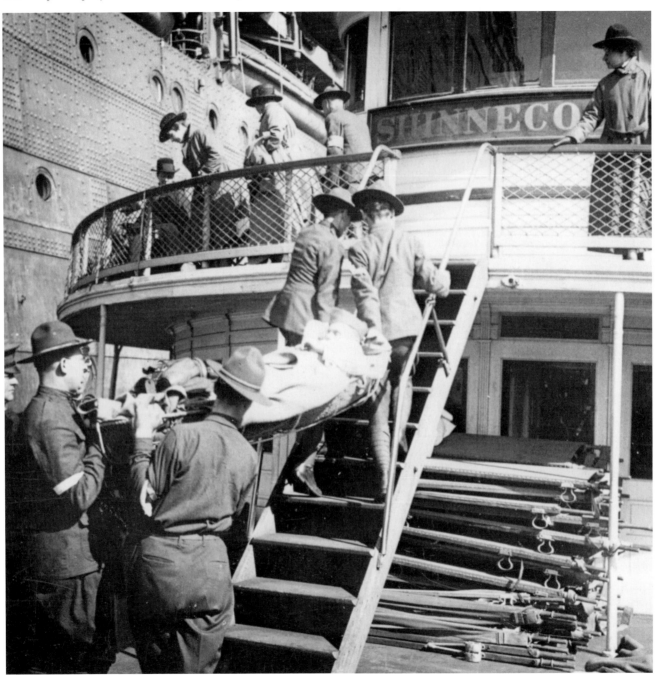

The navy is marching on 12th Street in a Victory Loan parade on May 10, 1919, to celebrate the end of World War I. Scenes like this one were repeated throughout Miami and Miami Beach during World War II as thousands of troops, sailors, and airmen trained in the sunshine prior to being shipped overseas.

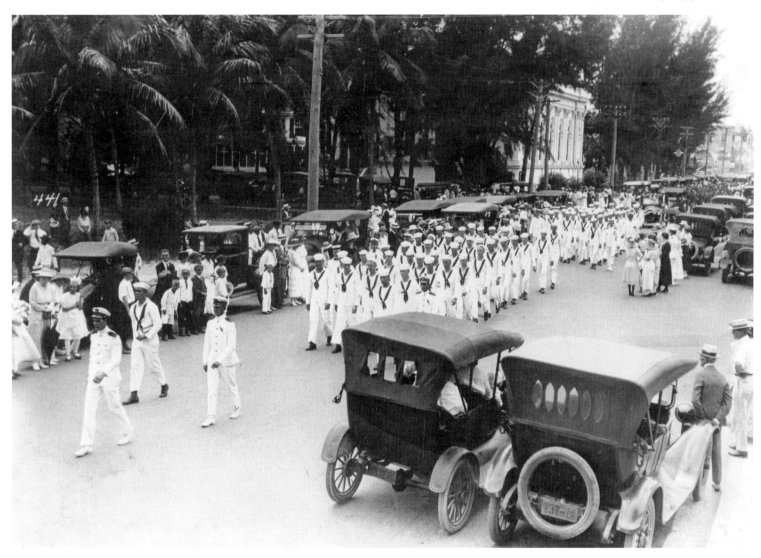

With Royal Palm Park on the right, the army contingent "shows its stuff" in the Victory Loan Parade of May 10, 1919, celebrating the end of World War I.

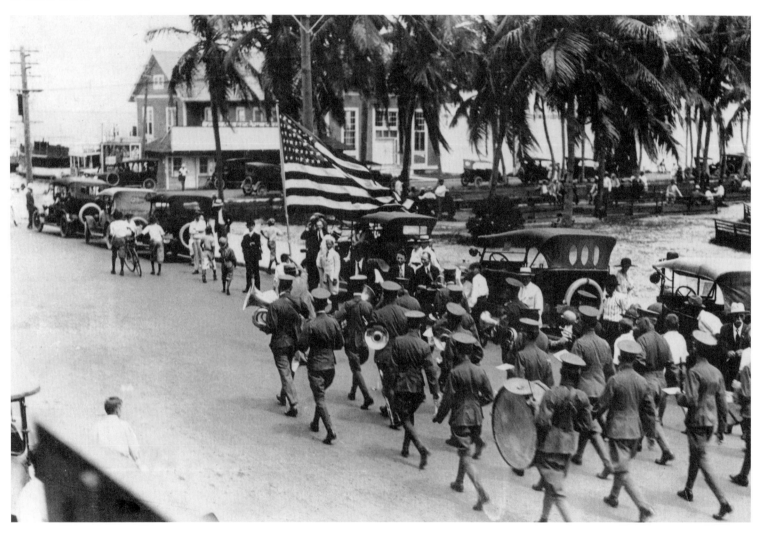

Photographed sometime in the early 1920s, this view, west on Flagler Street, shows a Coral Gables trolley in the center of the street, cars parked at the curb, and Sewell's, Kress, and Burdine's stores on the left.

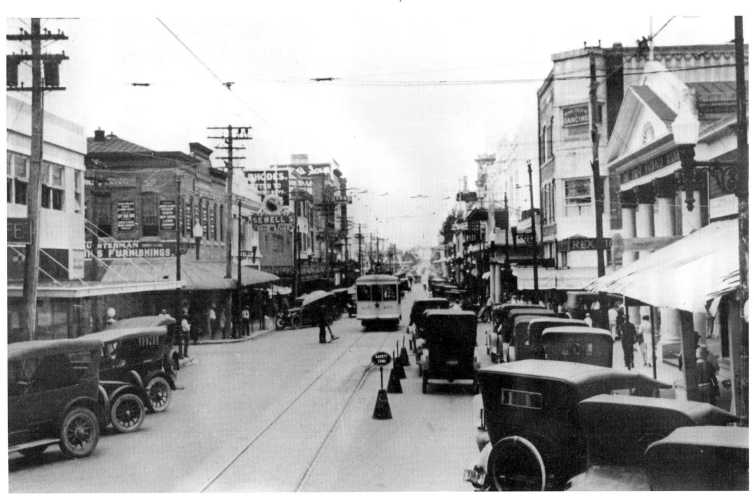

From the early teens Florida was home to the "grapefruit league," the spring training home of most of the major and minor league baseball teams and the epicenter of pre-season baseball activity. Here, on March 16, 1920, the legendary Babe Ruth, just after joining the Yankees, is taking his turn at bat, possibly at Miami Field, later the site of the Orange Bowl.

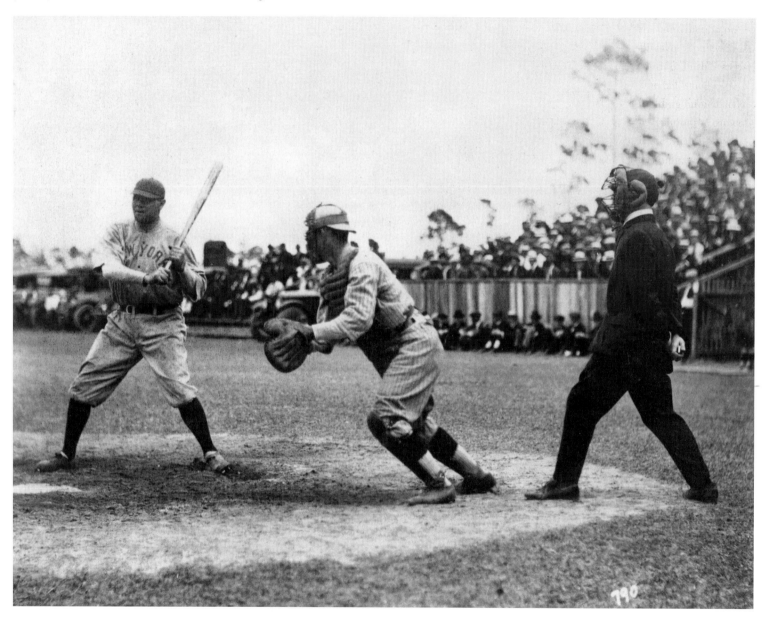

For the 1920 Palm Fest parade (predecessor to the Orange Bowl parade), the City of Miami Beach decked out this beautiful float, shown here on the Boulevard (not yet Biscayne Boulevard). The Royal Palm Hotel stands in the background at right.

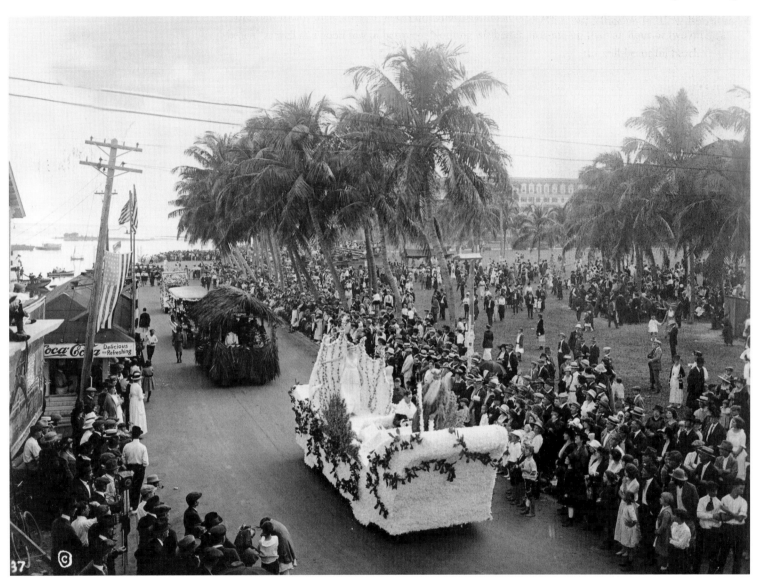

As the tempo of the 20s increased, it became necessary for Miami to station police officers on several downtown corners to control the traffic. Here an unnamed officer directs the flow at Northeast First Street and First Avenue.

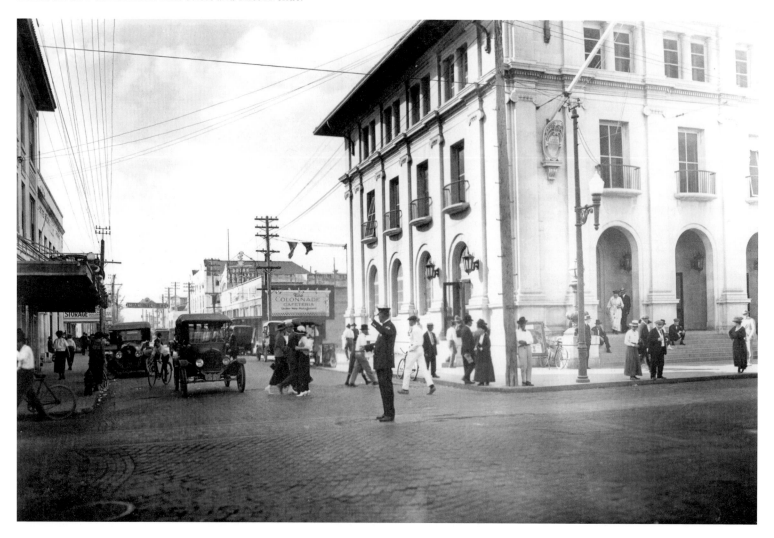

This very early 1920s view looks south on Northeast First Avenue. Complete with trolley tracks, the city was bustling. The Royal Palm Hotel is visible at center in the distance.

This Fishbaugh image shows Northeast First Avenue at night. There was—and still is—something "magic" about Miami.

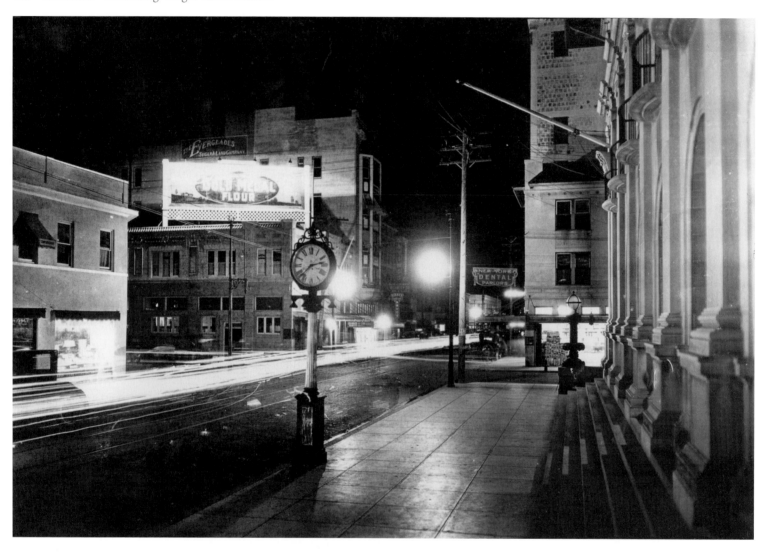

In the 1930s one of the most exciting things one could do was to take an airplane ride. This group is boarding Pan Am's new Commodore seaplane, the first of the full-sized passenger-carrying amphibians, at Miami's Dinner Key Pan Am seaplane base.

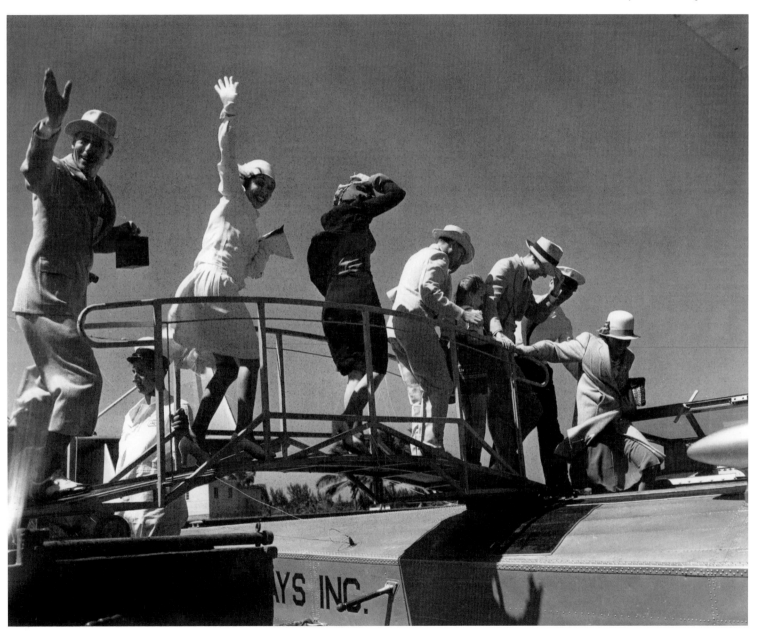

In this view north on Northeast First Avenue from First Street, are the Paramount Hotel on the left, Mr. Foster's Store on the right, and one of Miami's never-should-have-been-destroyed trolley cars in the center. The streetcar, an electrically powered, pollutant-free, near-noiseless vehicle, is making a comeback throughout the nation. In Miami, a light rail line (the new name for the streetcar) is planned.

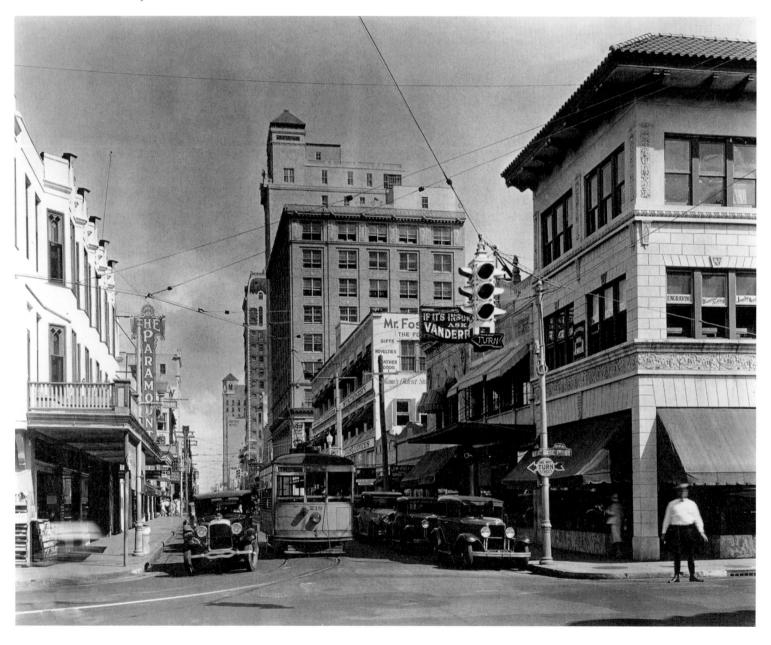

When George Merrick and partner John McEntee Bowman opened the Miami Biltmore Hotel, Merrick's dream for Coral Gables was fulfilled. Almost every newspaper in the country carried a Coral Gables by-line as reporters waxed eloquent and gushed over the grandiose structure. It remains today a magnificent centerpiece of the Gables, still known as "the City Beautiful."

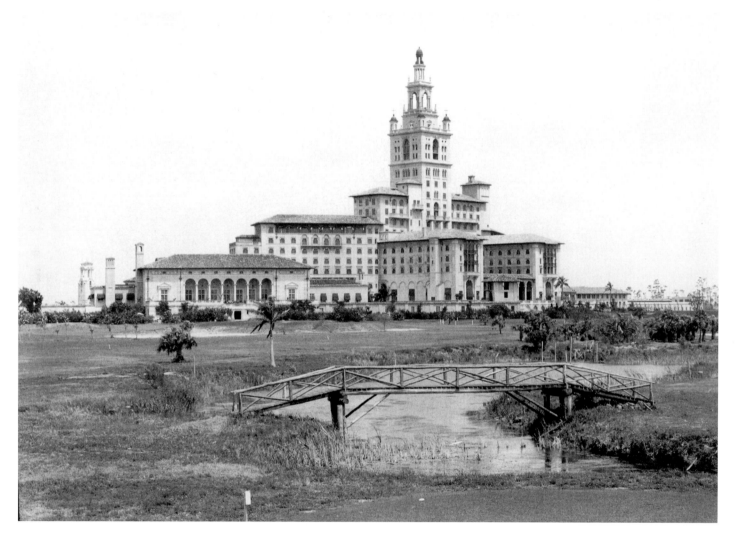

This May 1, 1930, photo commemorates the historic moment when Colonel Charles Lindbergh (fourth from left) piloted a Pan American airmail flight from Cristobal, South America, to Miami. Among the other famous pilots in the photo are Shorty Clark (one of the men to Lindbergh's right) and Dinty Moore, at far right.

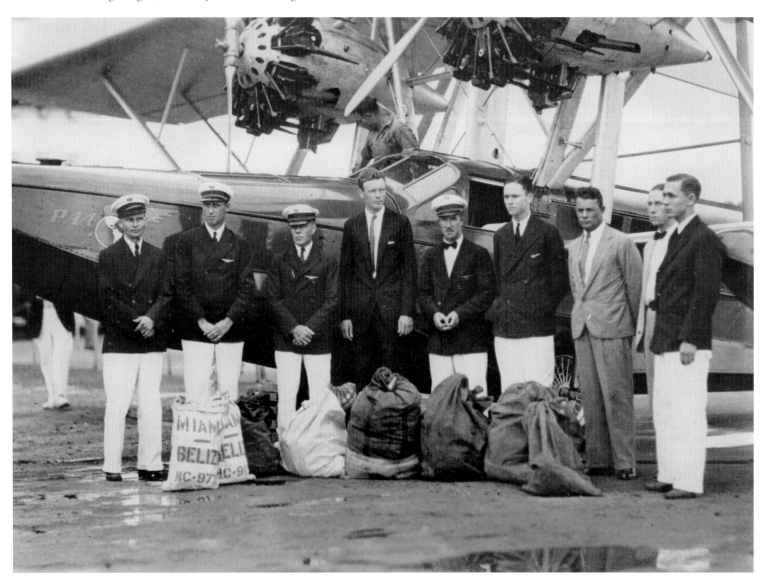

Carl Fisher had worked long and hard to make Miami Beach "the world's playground." The promenade, which ran north from behind the Roney Plaza Hotel for a full block, was just another of Fisher's visions for "the beach." It became the place to see and to be seen, and no few romances began along this broad walkway.

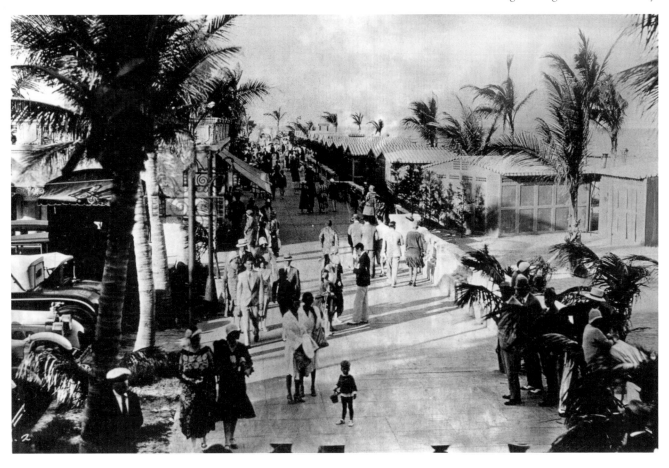

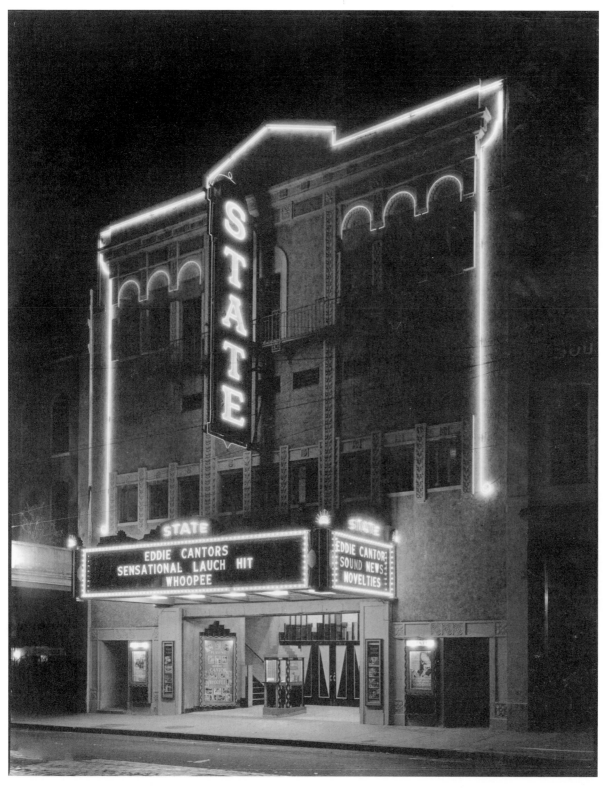

The State Theater was one of Miami's grandest early movie houses. Tonight, November 13, 1930, the feature film is Eddie Cantor's hit *Whoopee*. Moviegoers, 20 years before television, will also enjoy "sound news" and novelties, likely cartoons.

With the construction of the Venetian Causeway, which replaced the aging Collins Bridge, the Venetian Islands Company brought in a fleet of gondolas (complete with singing gondoliers) from Venice. Shown here March 20, 1930, the boats, which could be rented for $5 an hour (an enormous sum then), were doomed by the Depression and the last of them would disappear within just a few years.

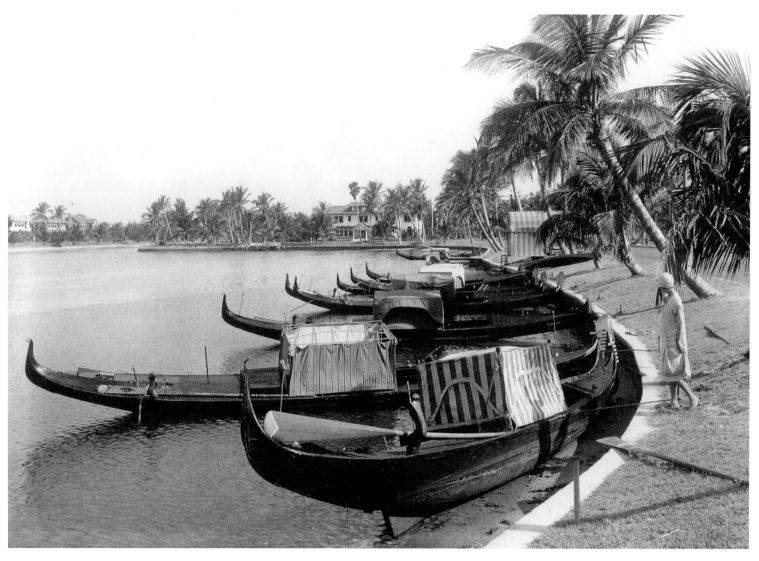

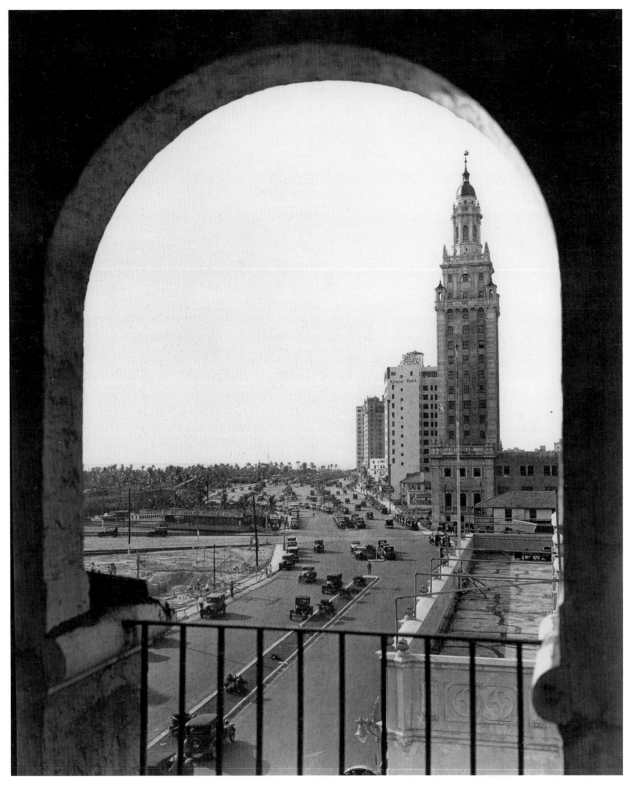

On February 13, 1930, photographer William A. Fishbaugh positioned himself so that he could see the construction on Biscayne Boulevard south of Fifth Street. The tall, stately building immediately in front of the camera is the Miami News building, which would serve as the headquarters of the James A. Cox–owned newspaper until a move to Northwest Seventh Street in the late 1960s.

What is Miami Beach—if not beach? Although numerous hotels and apartment houses clutter the view today, there are still blocks of public beaches at both the north and south ends of "the beach" as well as a good few in between. Nothing is a better pick-me-up than an hour or two on the still-beautiful beach.

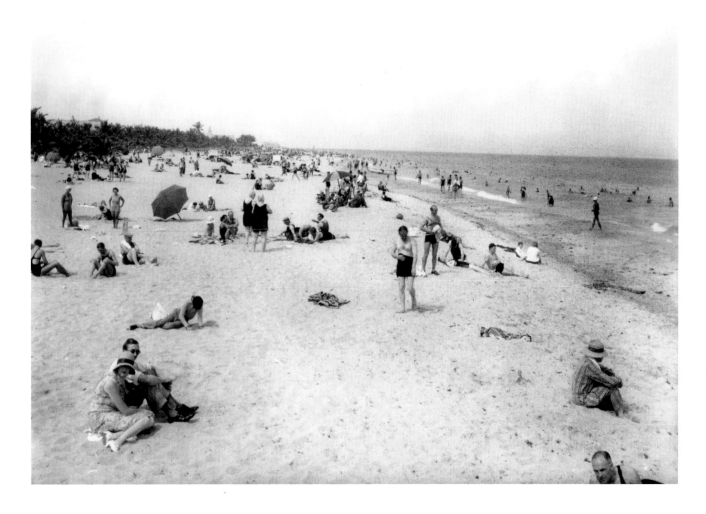

Want publicity? Add pretty girls to the campaign. Here Miami postmaster
O. W. Pitman, far right, welcomes the arrival—with assistance from several
beautiful young women—of a load of mail from Central America, delivered
by Captain Edward G. Schultz, who stands in the plane, ably assisted by his
faithful terrier.

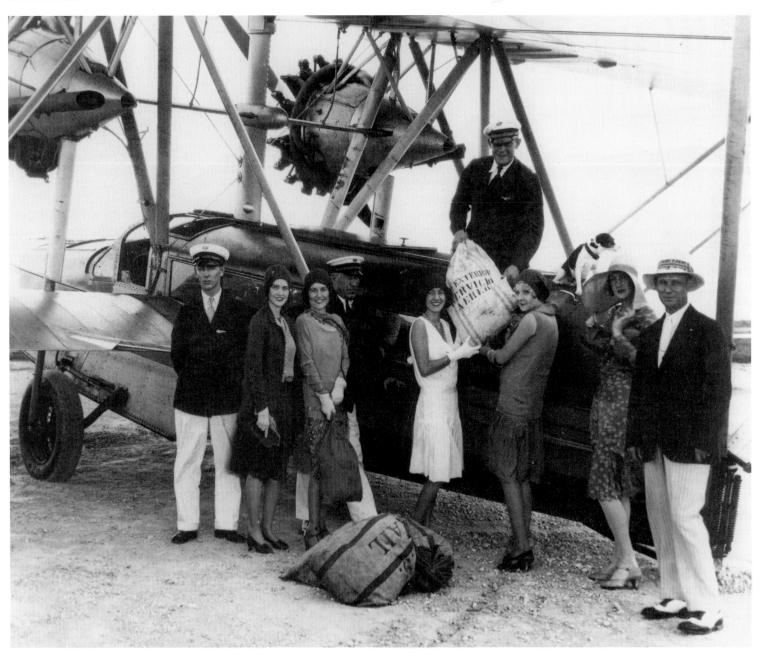

When it was built on Miami Beach, the Roney Plaza was nothing short of spectacular. The largest of the Miami Beach hotels, it would remain the city's grande dame until the 1954 opening of the Fontainebleau. The striking entrance to the Roney is displayed in this June 6, 1930, Fishbaugh portrait.

The Seminole tribe was invited to greet the first of the new four-engined Sikorsky seaplanes when it arrived at Dinner Key. Prior to the construction of the terminal building, which would later become Miami's city hall, the seaplanes used a floating barge in Biscayne Bay as their departure point. Passengers were brought to the barge in small boats.

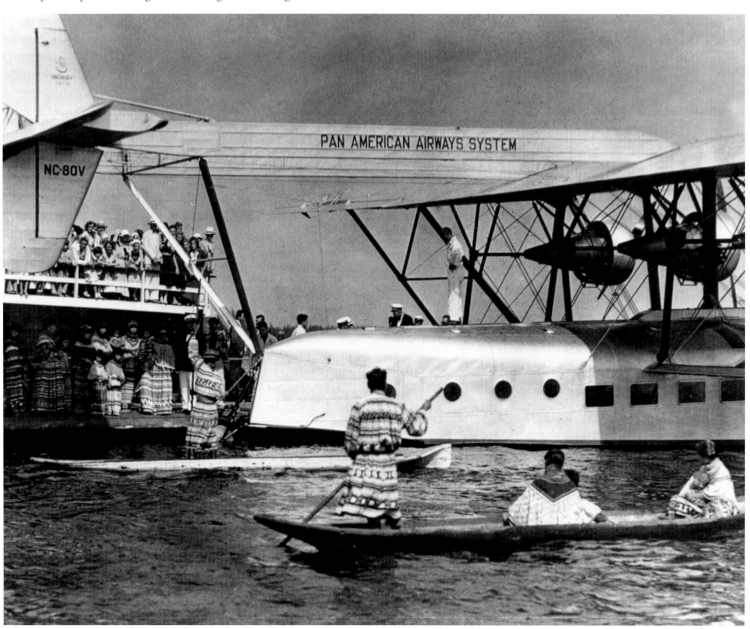

Before its name was changed to South Miami, this community was known as "Larkins," honoring the town's founder. Although the name of the town was changed in the 1920s, "Larkins" Public School, on Sunset Road in South Miami, retained its name. William A. Fishbaugh captured this image February 18, 1930.

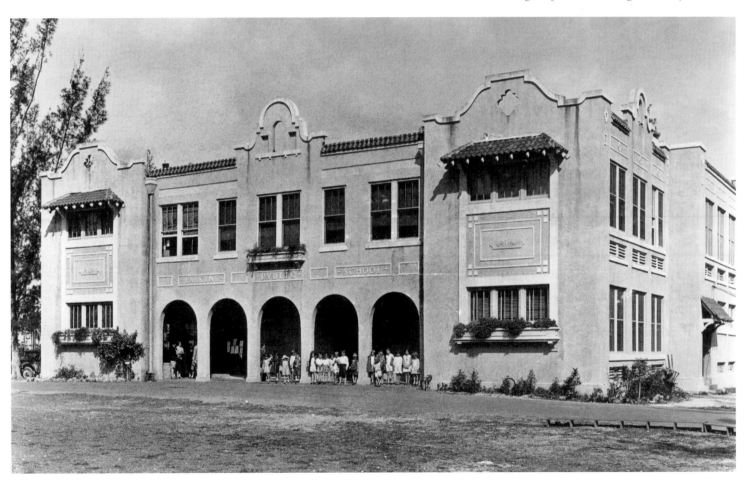

On April 14, 1931, almost 35 years after Miami was founded, four of the city's pioneers stand for their picture on the site of the Royal Palm Hotel, closed after the 1926 hurricane and razed in 1930. From the left are J. E. Lummus, John Sewell, T. L. Townley, and Ev Sewell. As Miami mayor, the latter was on the reviewing stand with President Roosevelt in 1933 when Guiseppe Zangara shot and killed Chicago mayor Anton J. Cermak just a few feet from the president.

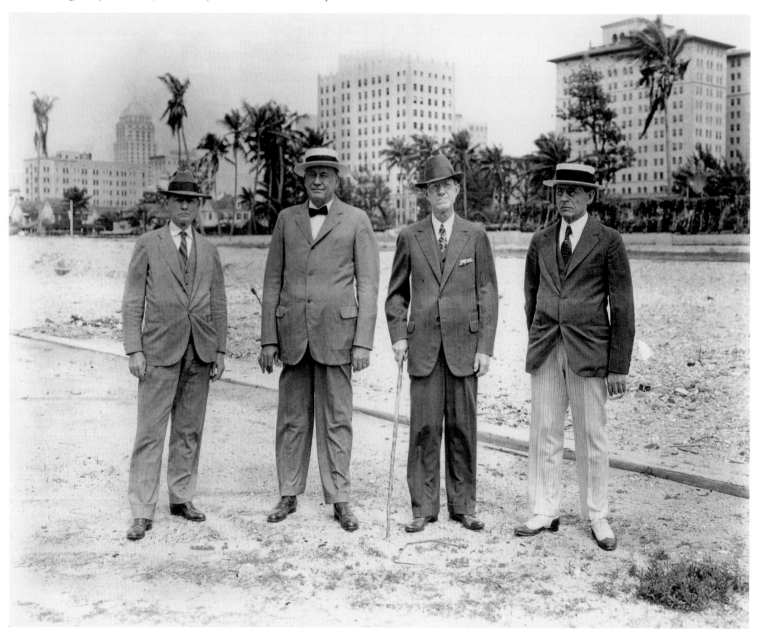

The elegant interior of a Pan American four-engined Sikorsky S-40 at Dinner Key. The S-40 was the first four-engined airplane regularly used in commercial air service in the country.

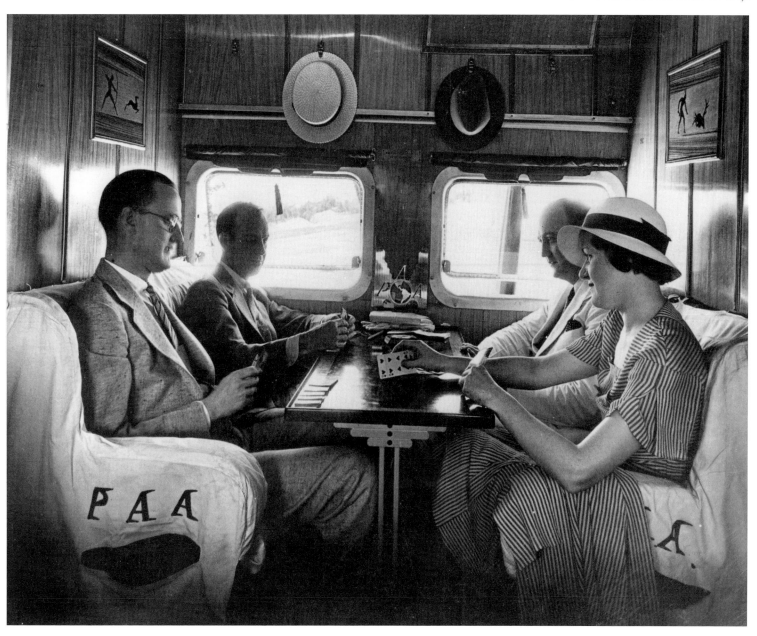

On February 11, 1931, William Fishbaugh photographed the interior of
"the Shadows," the home of Mr. and Mrs. Carl Fisher, on Miami Beach.
The grand staircase is shown here.

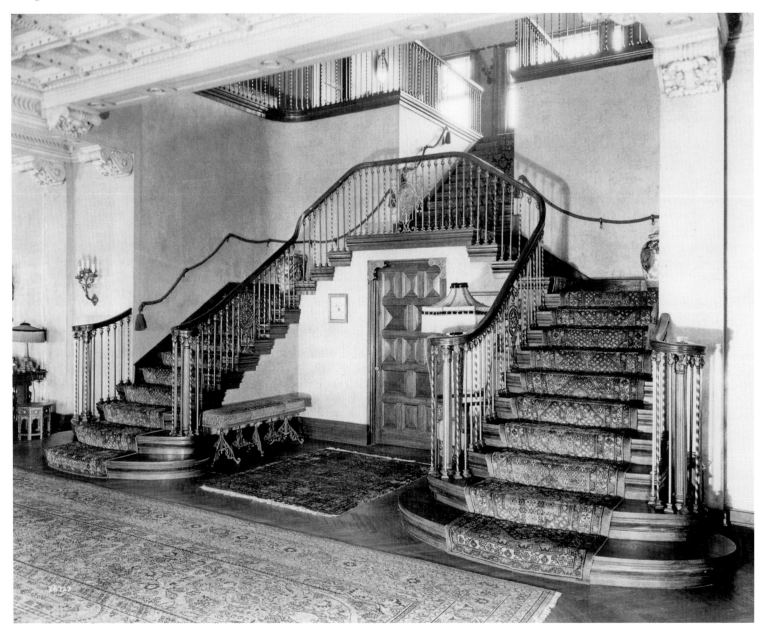

Standing outside Miami's first Ford dealership a
couple prepares to leave the dealership, excited
about owning a brand-new Model A.

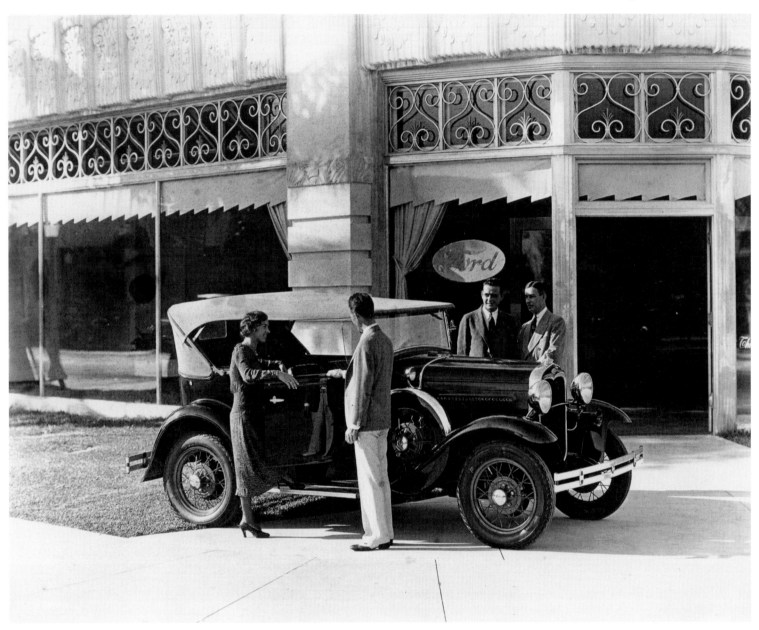

The Gralynn Hotel was, for many years, a gathering spot for business people after work. In this September 2, 1931, view north on Southeast First Avenue, the hotel is on the left.

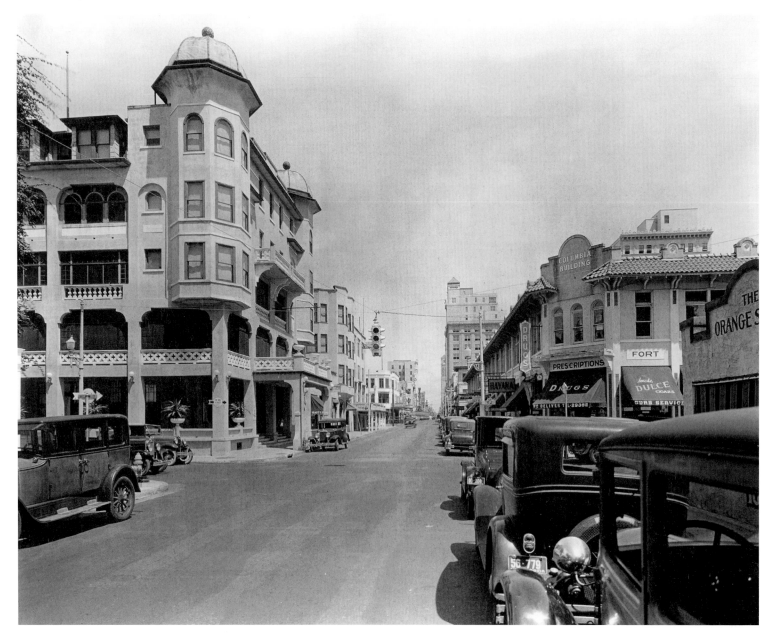

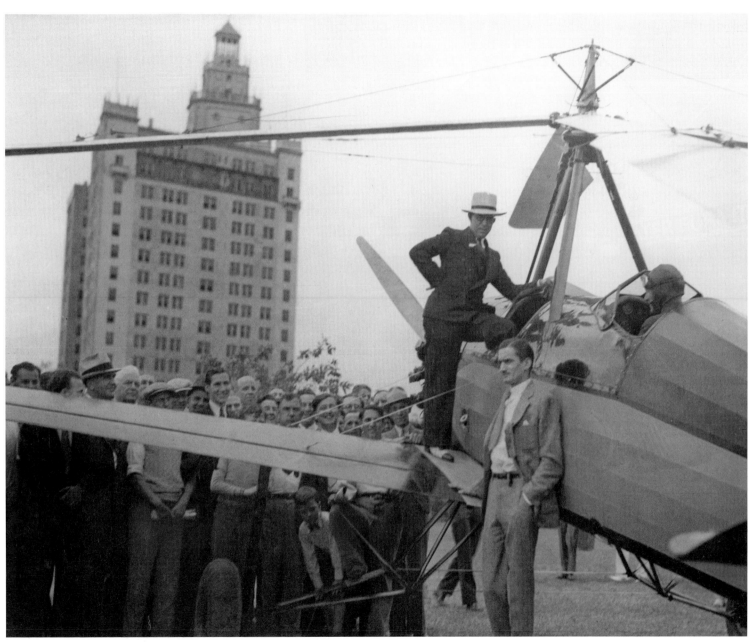

Shown in Bayfront Park shortly after its completion, this experimental plane was the subject of awe and admiration by numerous onlookers.

Miamians, for years, shopped downtown at Jackson's, Byron's, Richard's, the Mark Store, Kress's, and the Red Cross Pharmacy, which is shown here on October 1, 1932. White-coated pharmacists busily prepare customer prescriptions.

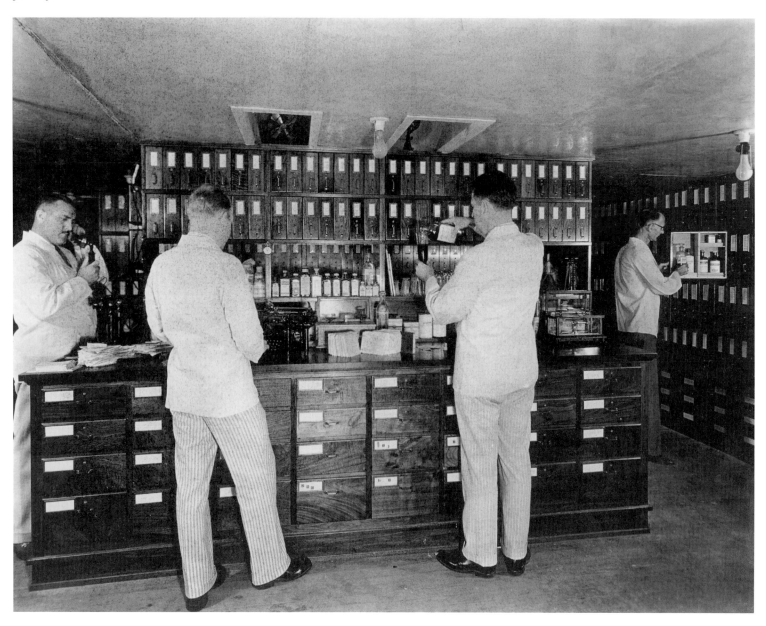

Human memory is often short. The Cuban "exile" experience is *not* "new" to Miami. In 1933, following a regime change, a group of Cuban civilian and military leaders surround Major General Mario G. Menocal, former Cuban president and then-leader of the Miami exiles. Today, only the names and faces have changed.

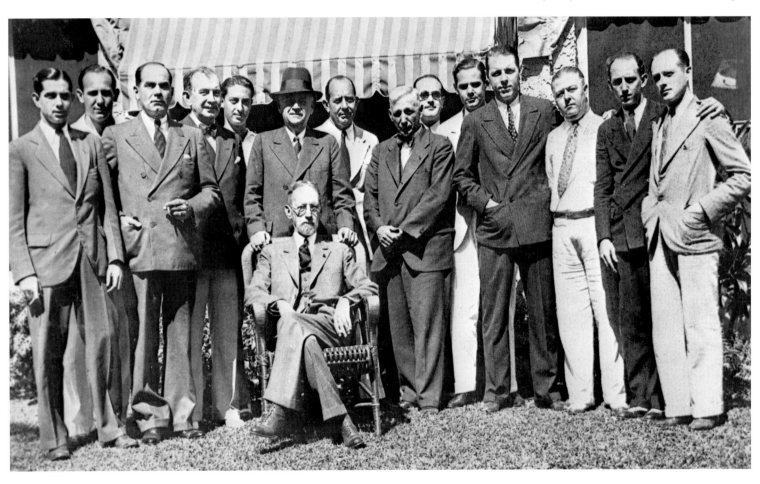

On July 13, 1933, Miami's brand-new hook and ladder truck gleams in front of the North Miami Avenue fire station, at that time department headquarters.

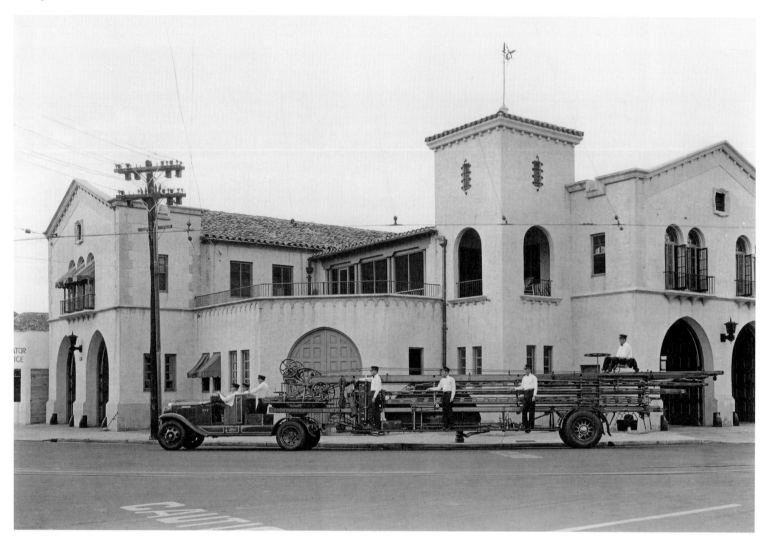

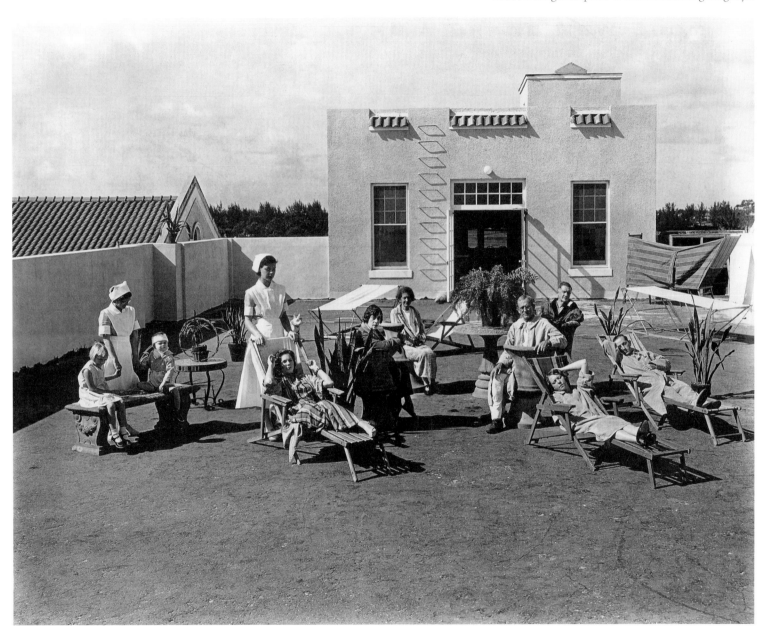

Unrecognizable today, the solarium at Jackson Memorial Hospital was, in 1933, a delightful place to soak in health-giving rays.

In 1933, the new U.S. Army Air Force bomber *City of Miami, Fla.* was christened. The one male in the photo may be Army Air Force commander "Hap" Arnold.

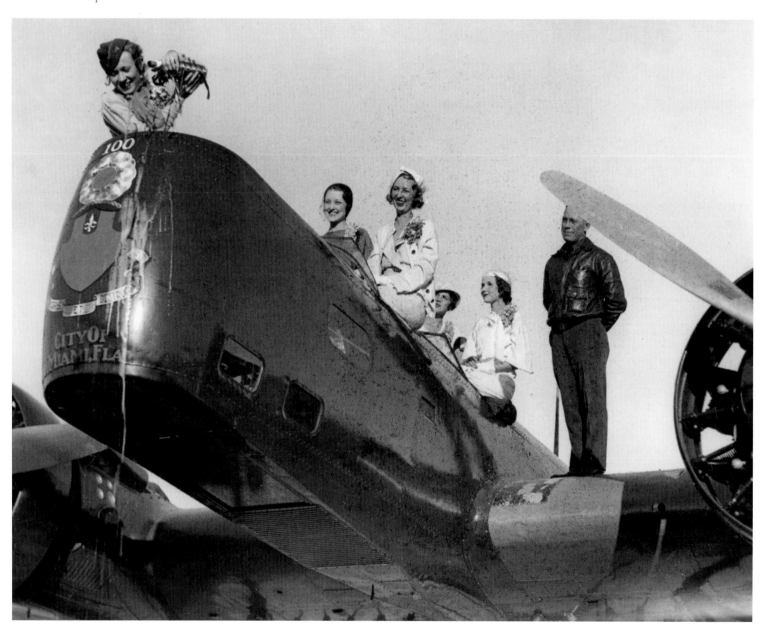

By the early 1930s the Biscayne Bay Islands Company had filled in Palm, Star, and Hibiscus islands, all located on the County (later MacArthur) Causeway. Palm and Hibiscus, the latter still mostly undeveloped, are shown here, the County Causeway at left.

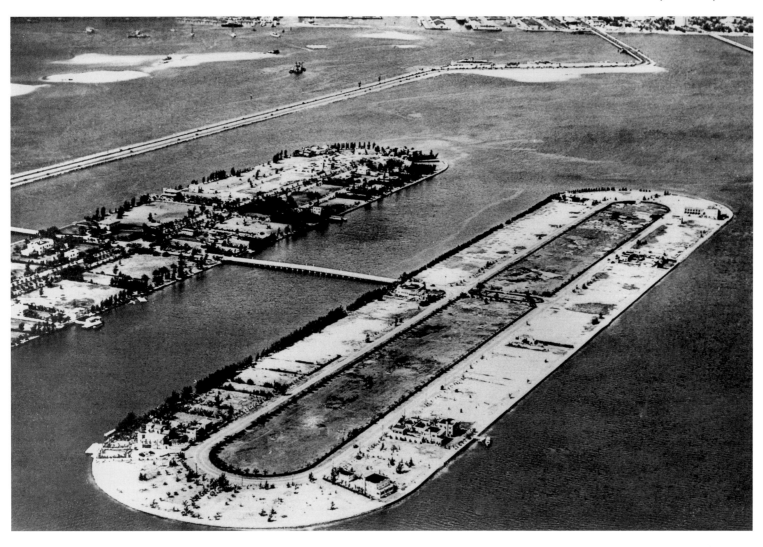

The Venetian Hotel was on Northeast 15th Street just west of the entrance to the causeway of the same name. Shown here on March 10, 1934, the hotel, about a mile north of downtown, was not only quite fashionable but was also the closest hotel to Miami Beach.

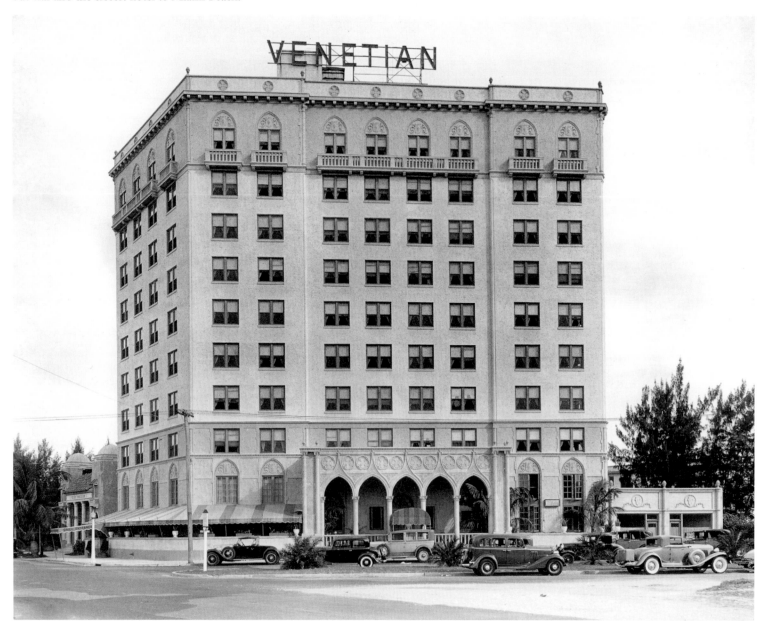

It was *de rigueur* to be photographed after returning from a deep sea fishing trip, especially if one had a catch to display. Here, sometime in 1934, the Weinkle family—Barney, Staney, and Milton, all seated, from the left—proudly display the two swordfish they have caught on the fishing boat *Sport*. Captain Roy Stuart and his mate are the two men standing at left and right.

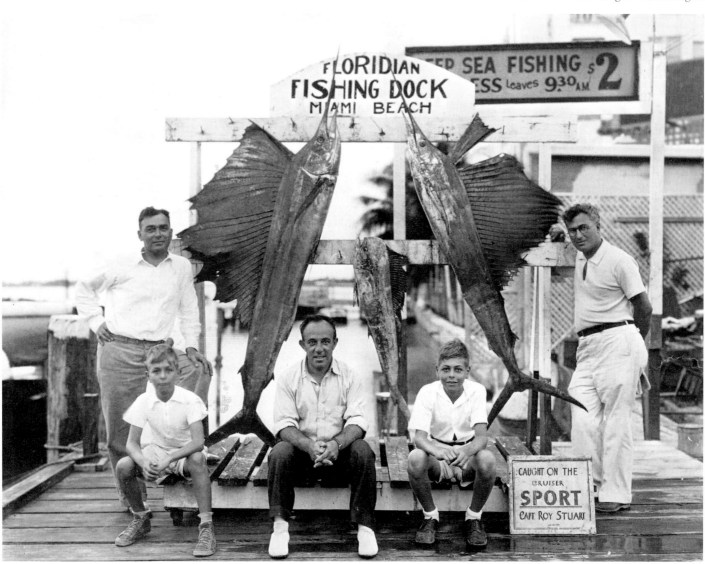

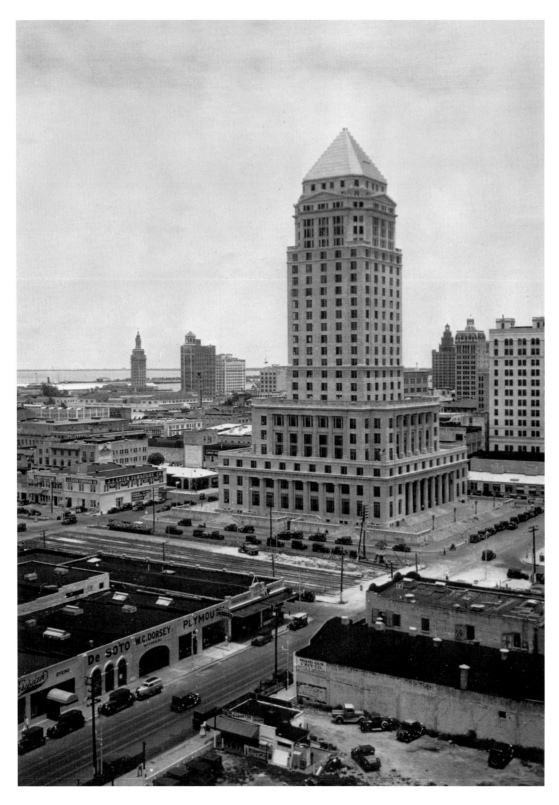

A familiar Miami sight even today, the Dade County Courthouse was, in 1935, also the Miami City Hall. This view looks east by northeast, Flagler Street immediately below the camera and the Florida East Coast Railway tracks just west—on this side—of the courthouse. The downtown depot is just a few hundred feet farther north, but out of view.

Mayor Everest (Ev) Sewell stands next to one of the pre–Orange Bowl Parade Palm Fest floats—a car festooned with flowers. Both Ev and his brother John were an important part of early Miami history.

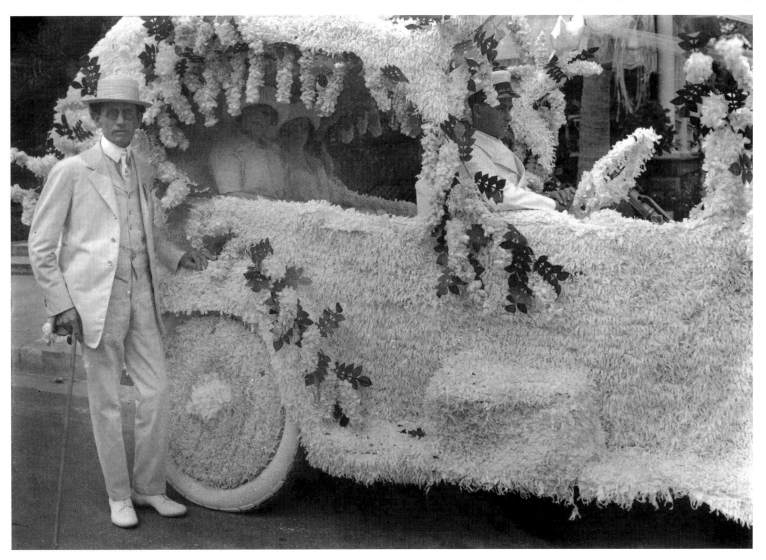

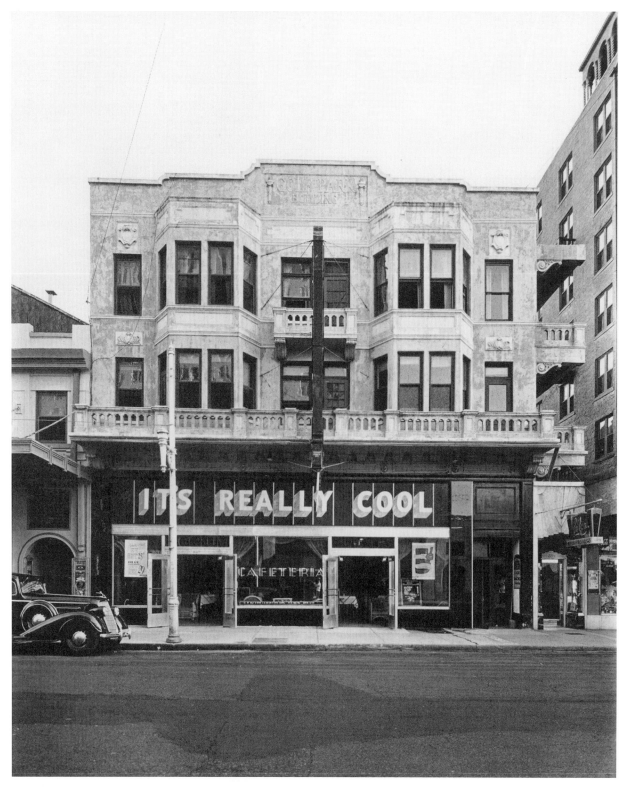

Contrary to current opinion heard or spoken, summers in the 20s and 30s in Miami, before air conditioning, were hot! Here, the Golf Park Building cafeteria in downtown Miami boldly advertises its early attempts at air conditioning. Less conspicuous, wide-open doors suggest this as one of those days when the primitive unit was not functioning.

This is one of the great, high-speed, steam-powered passenger locomotives of the fabled and still extant Florida East Coast Railway. Photographed in January 1935, the engine, with a 4-8-2 wheel arrangement and known as a Mountain type, pulled the FEC's fast passenger trains between Jacksonville and Miami. Engine 446, built in 1926, is being inspected prior to departure from the Magic City.

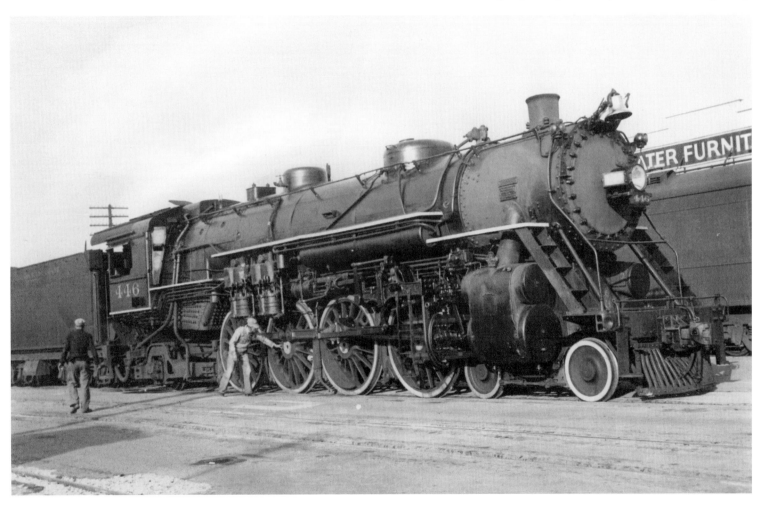

Other storms have killed more people, but the Labor Day 1935 hurricane was otherwise the most horrific ever to hit the U.S., with the lowest barometer readings in history and wind gusts topping 200 miles per hour. Hitting the middle of the Florida Keys, the storm destroyed more than 40 miles of the FEC's Key West Extension and killed more than 800 people, most of them World War I veterans working at the WPA camp at Matecumbe Key. Here, on September 8, 1935, a number of them are buried in Miami with full military honors.

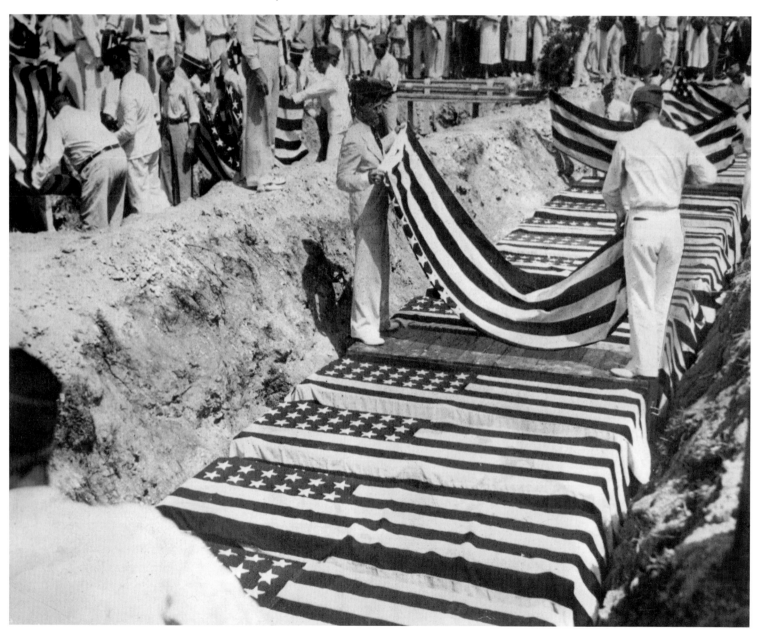

For many years Miami's Coca-Cola bottling plant was on Northwest 20th Street. It is shown here in 1935, shortly after opening.

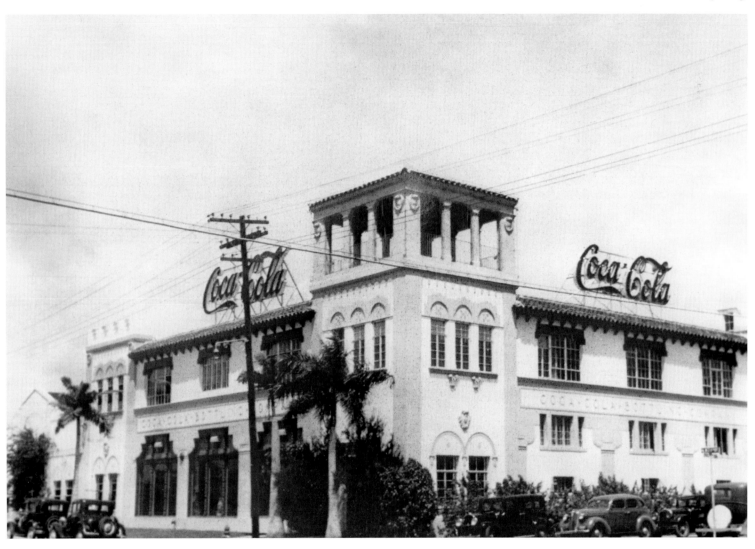

When it first opened the Coca-Cola plant could boast having the most modern bottle-cleaning and bottling equipment in the nation. Shown here are the interior of the building, complete with bottling works running at full capacity, and at far right, J. B. Monk, bottling department supervisor.

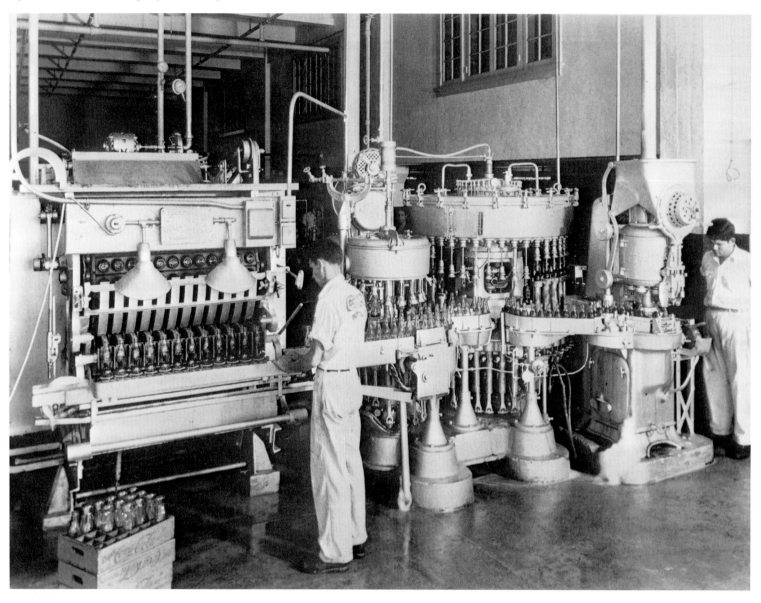

Miami Business College was on the corner of Miami Avenue and First Street. Offering courses in the city for many years, this fine secretarial and accounting school succumbed to the advent of community colleges and regionally accredited trade schools.

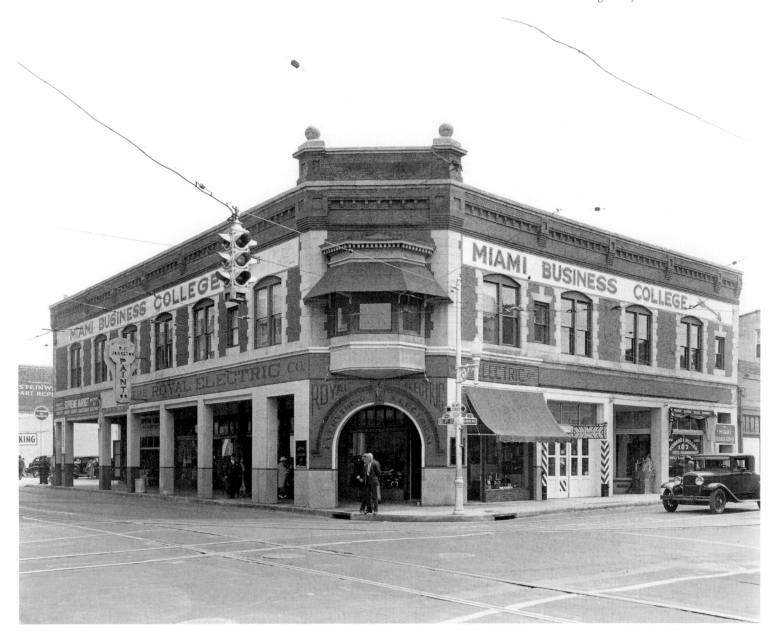

For many years, the *only* way to travel between New York and Miami was on the all-Pullman sleeping car "Florida Special." For the 1935-36 season, the train's 50th anniversary year, each "section" (train) carried a recreation car, a swimming pool (the only one ever operated on an American passenger train), a hostess, and a band. Depicted here is the scene just prior to a December 1935 departure from the Florida East Coast downtown Miami depot. The Dade County Courthouse, in the background, was sometimes portrayed (though not identified) by the railroad as its Miami station.

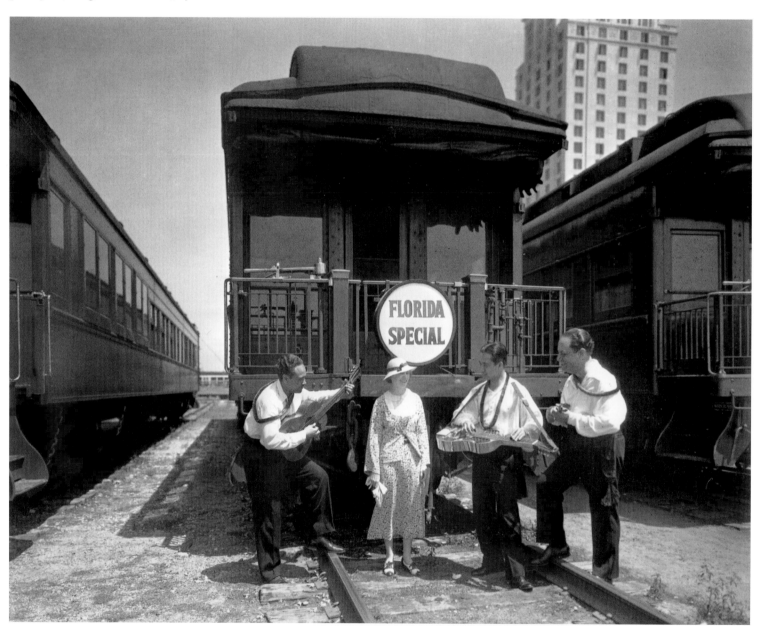

President Franklin Roosevelt enjoyed the warmth of Miami and came as often as he could. He is shown here at left with Florida senator Claude Pepper and Miami mayor Williams at far right as he is driven from the Florida East Coast station to the Miami docks, to board the yacht *Potomac* for a fishing trip.

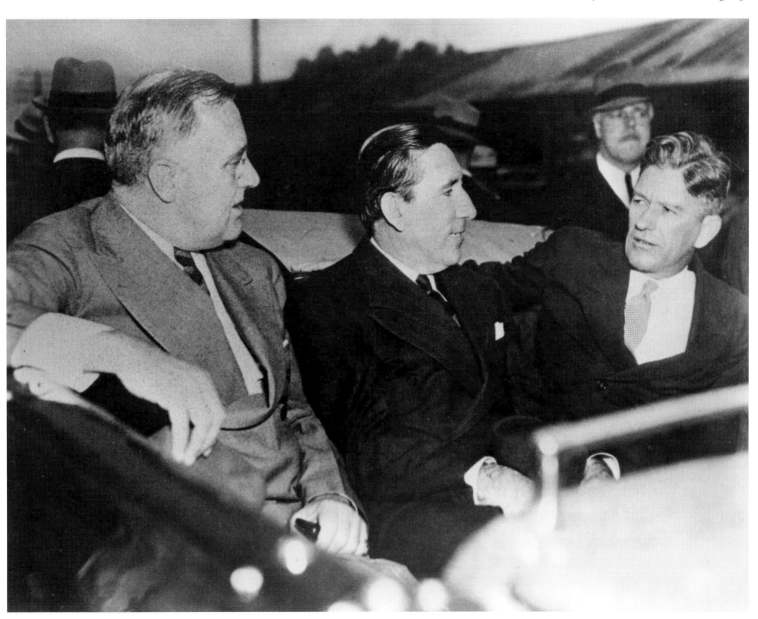

The great Miami Beach publicist, Steve Hanagan, invented "cheesecake." During the winter of 1937 this bevy of beauties strolling on the beach made Greater Miami and its weather even more desirable to those stuck in "the frozen north."

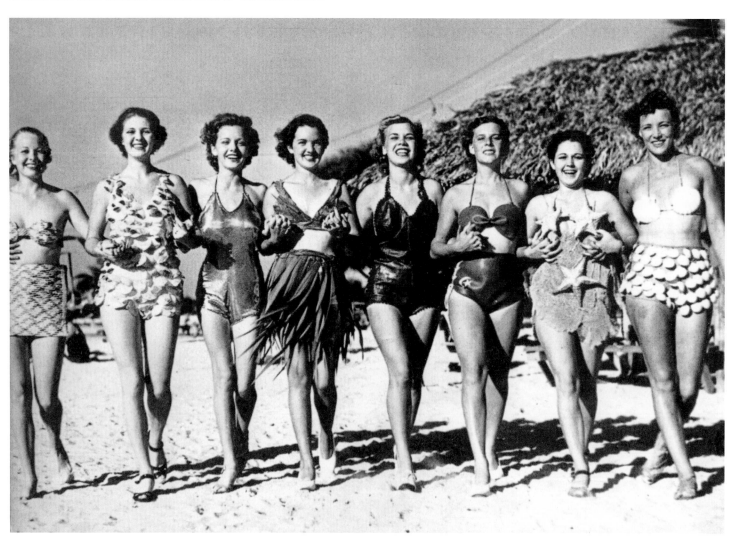

Along with the Royal Palm and the Roney Plaza, the Halcyon was among the most revered of Miami's tourism and hospitality palaces. The Halcyon was demolished in 1938 to make way for the Alfred I. DuPont building. This unique view was taken from the roof of the Olympia Theater building and looks northwest over the demolition site.

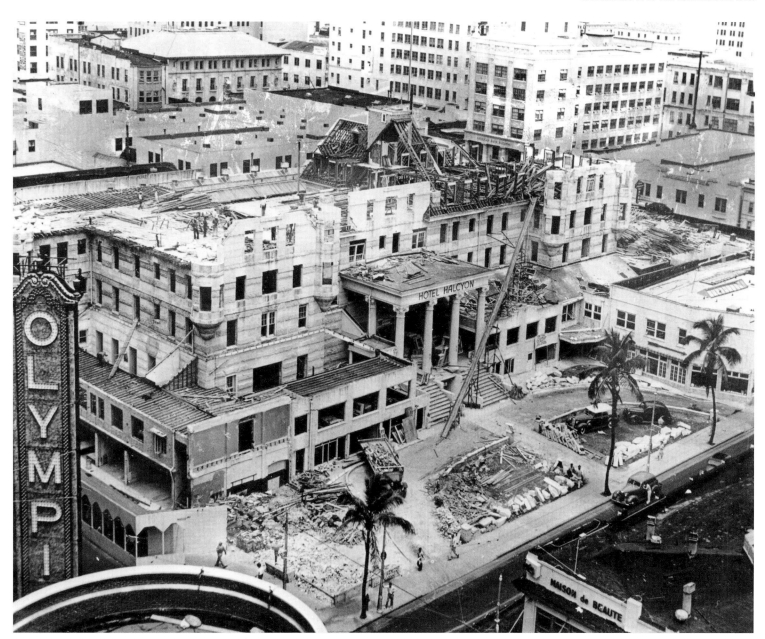

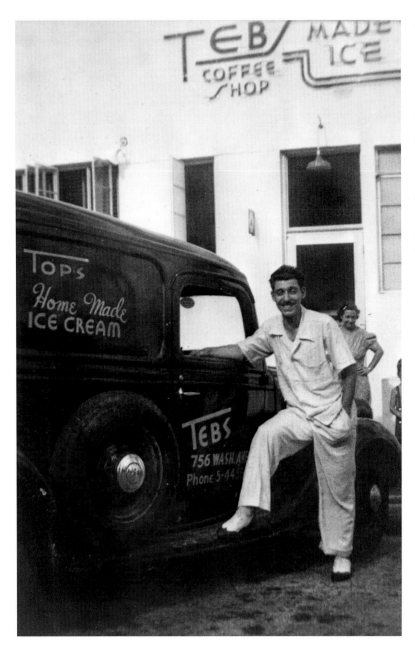

One of the greatest and most famous names in American architecture, Norman Giller, A. I. A., grew up and raised his family in Miami Beach. A writer and innovator, Norman is shown here as a young man, in 1939, delivering for Tebs Coffee Shop, then at 756 Washington Avenue on Miami Beach. The truck and the coffee shop are long gone; Giller, happily, is still with us.

Ready to leave Buena Vista for downtown Miami via Northeast Second Avenue, City of Miami streetcar 219 sits for its portrait by an unknown photographer. The days of the trolley were far too brief; its ultimate return could prove of inestimable worth to the people of Miami and other cities.

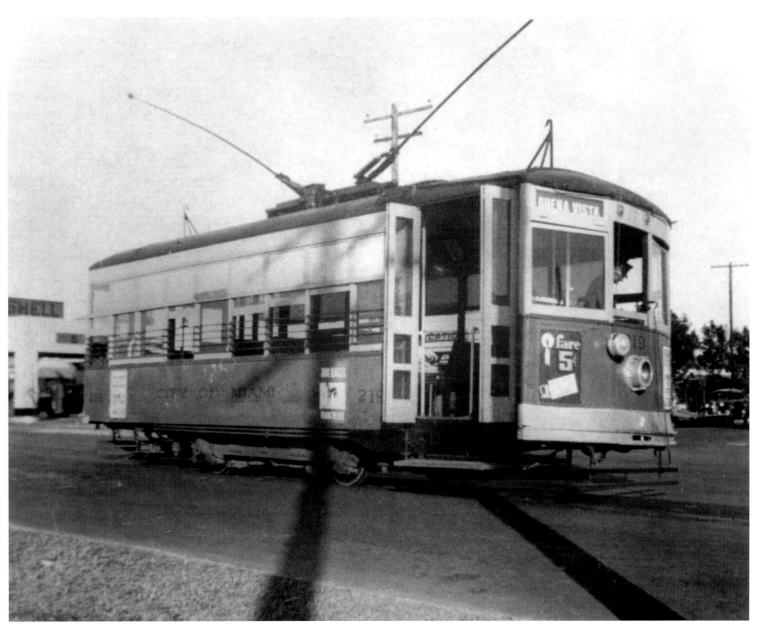

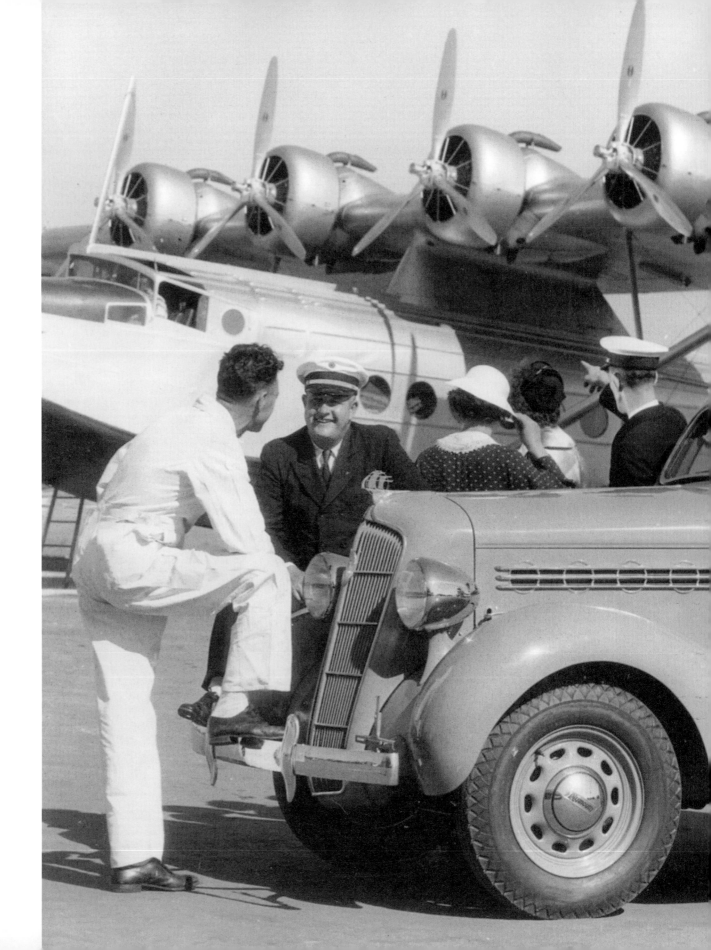

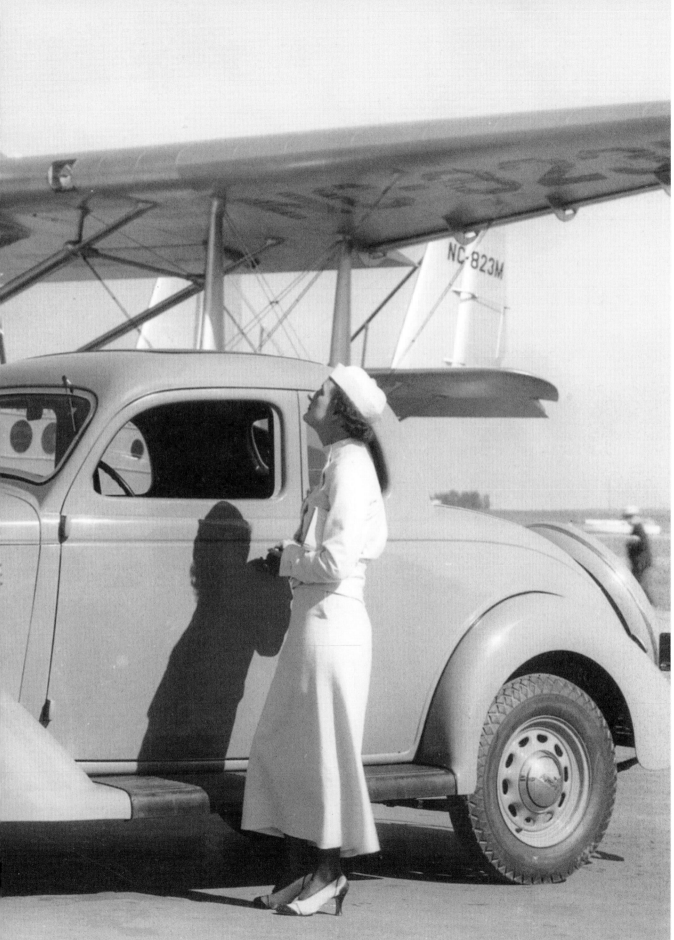

Which is more fascinating in this 1938 photograph? The four-engined Sikorsky clipper getting ready to leave for Buenos Aires, the Plymouth or Dodge Coupe, or the Pan Am employees preparing to board before the ship is towed into the water off Dinner Key for takeoff?

Chez Marie Beauty Shop was the "smart" place for women to have their hair and nails done, especially before a "special" evening. On August 7, 1939, Mr. Fishbaugh photographed this group of ladies in various stages of beautification.

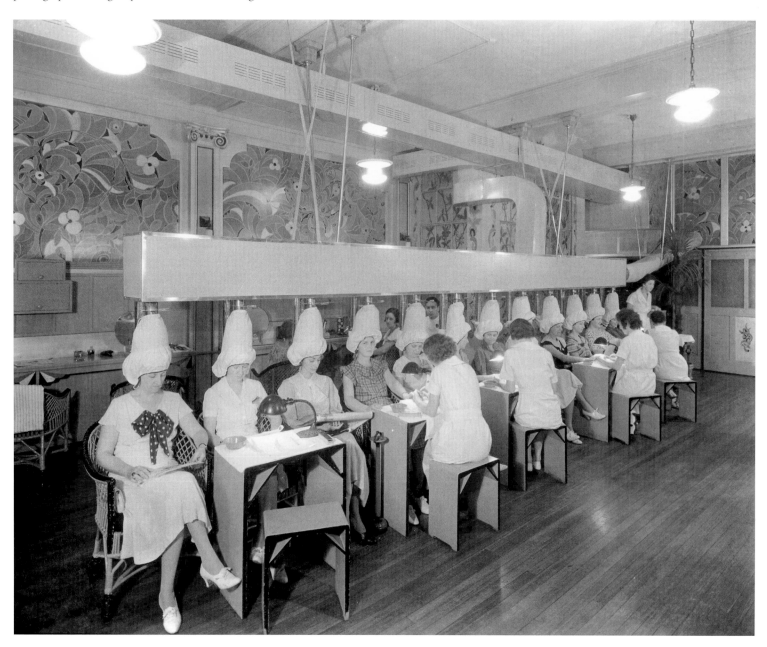

Backgammon is still played on Miami Beach but mostly in the condos rather than at the hotel. In 1939, it was all the rage. This group of fellows is certainly enjoying both the game and the sun as they sit in front of one of the cabanas at the Roney Plaza Hotel.

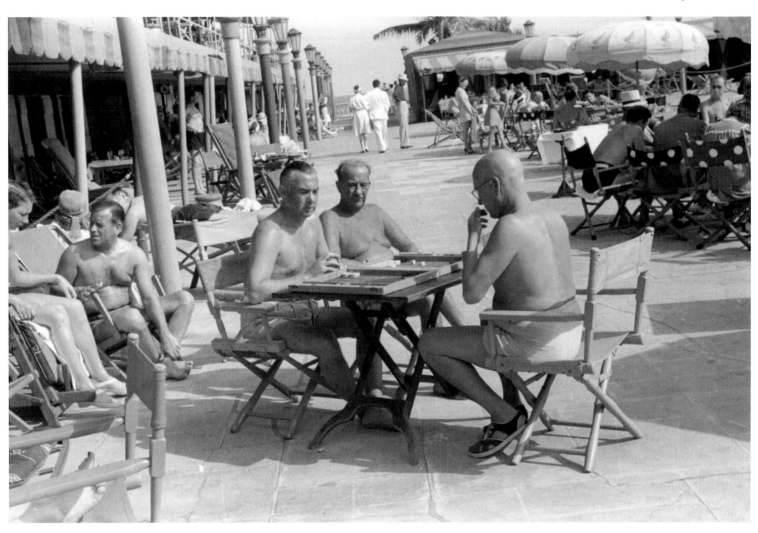

By the 1940s, downtown Miami's skyline would be set for almost the next 35 years. This scene, taken at Northeast Fifth Street shows the conditions of the old Miami fishing and private boat piers with, in the upper right corner of the photo, the Miami Aquarium located in the old *Prinz Valdemar,* which sank at the entrance to the harbor in early 1926. The pier at far left is the famous "Pier Five," for many years one of the world's most famous deep sea fishing boat departure points. Nothing identifiable in this scene with the exception of Biscayne Boulevard (the main street in the photo, running from left to right) is visible today.

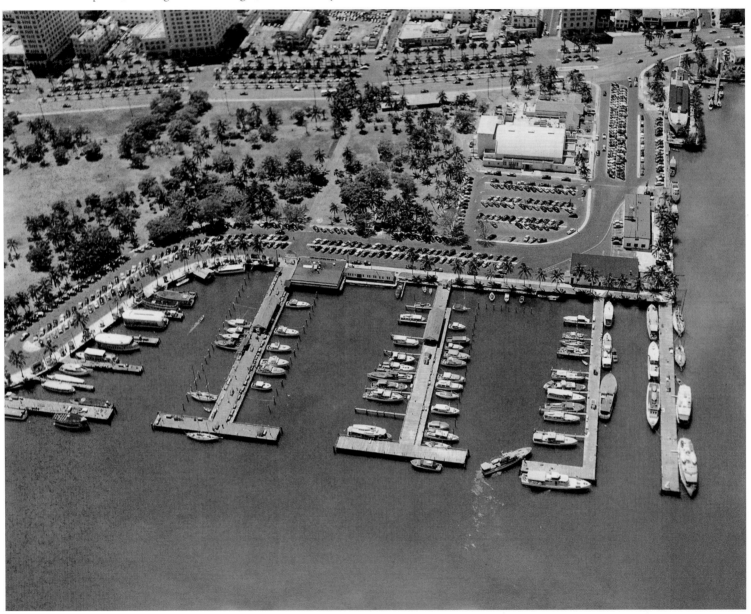

TRAINING AN ARMY AND A BRAND NEW BOOM

(1940–1949)

The 1930s would end on an up-note as the tempo of business quickened and both the Florida East Coast and Seaboard railways added passenger trains to serve the increasing number of visitors. Eastern Airlines did the same with its flights, and several interstate bus lines added luxury services including porters and snacks. Newcomers continued to swell Miami's visitor and population counts.

With war on the horizon, and Pearl Harbor on December 7, 1941, the area was turned into an armed camp. The war gets credit for saving the University of Miami. Airmen, soldiers, and navy personnel attended classes on the Coral Gables campuses and lived in the dormitories. The Navy and the Coast Guard also relied heavily on Miami, with the Dupont Building serving as naval headquarters for the south Atlantic and the Caribbean basin.

On Miami Beach, the Army leased most of the hotels and began training fliers. More than 60 percent of all U.S. Army Air Force flying personnel received their training on Miami Beach. Troops marched along Washington Avenue, Lincoln Road, Collins Avenue, and on the golf courses. Graduation ceremonies for most of the classes were held in Flamingo Park, but upon leaving, many if not most of the men and women had sand in their shoes and vowed to return when the war was over.

With the ceasing of hostilities and the return of the hotels to commercial operations, a new wave of construction began, and hotels marched farther and farther north up Collins Avenue. Though several of the hotels attempted to continue restricting clientele, the fact was that the army's large presence had essentially put an end to anti-semitic practices. At the end of the decade the City of Miami Beach adopted a policy of non-discrimination in and for the hotels.

The entire area bustled with wonderful new restaurants. Even though some of the old standards had closed, nightclubs such as the Clover Club, the Vagabond Club, the Beachcomber, and the Latin Quarter, and restaurants such as the Hickory House, Ruby Foo's, Old Scandia in Opa Locka, the Mayflower on Biscayne Boulevard, Parham's, and many others brought an aura of elegance and sophistication to Greater Miami. A new boom was just beginning.

On the sands of Miami Beach's Lummus Park, no clue is visible that a nation and the world were just emerging from the worst depression in history. Looking north from the Shoreham-Norman Hotel on February 10, 1940, it is evident that everybody who could afford to escape the brutal northern winters would, if they were able, come to Miami Beach.

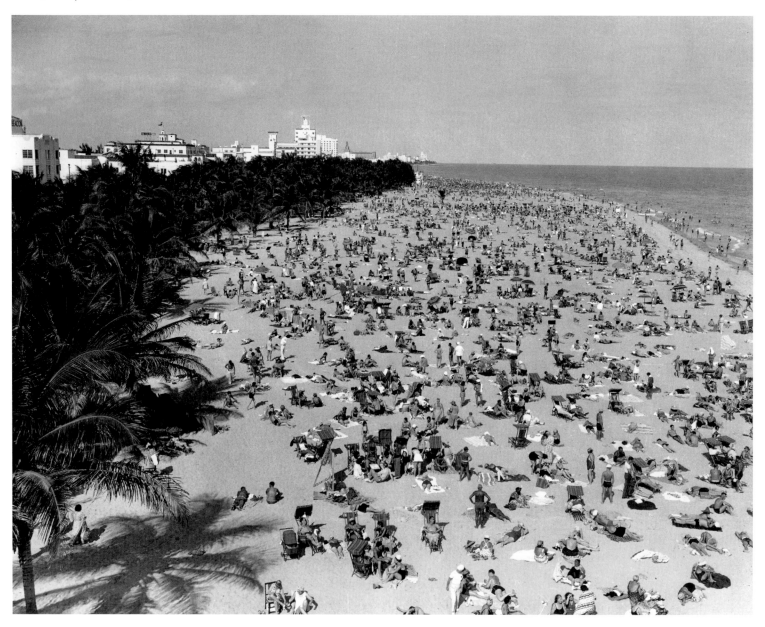

Standing in the backyard of this house on Grand Avenue in Coconut Grove, a visitor would not know that he was, in 1940, looking at the remnants of Miami's very first school, used originally as a Sunday school beginning in 1887 but then as a regular public school from 1889–1894. Although a building is preserved today that is reputed to be Miami's first school, it is unlikely to be this one.

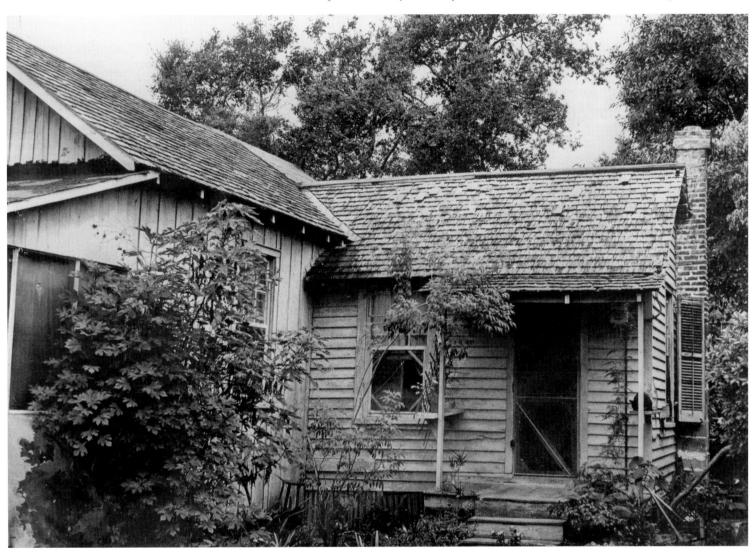

In the absence of a large public auditorium, the band shell at Bayfront Park was the site of concerts by the famed musicians Mana Zuca, Cesar LaMonaca, and others, and of important meetings. Chicago mayor Anton Cermak was shot here in 1933. And on April 14, 1940, G. W. Romer recorded the presentation of "the Townsend Plan" by Dr. Francis E. Townsend, an event that, lo these many years later, is no longer in the city's collective memory.

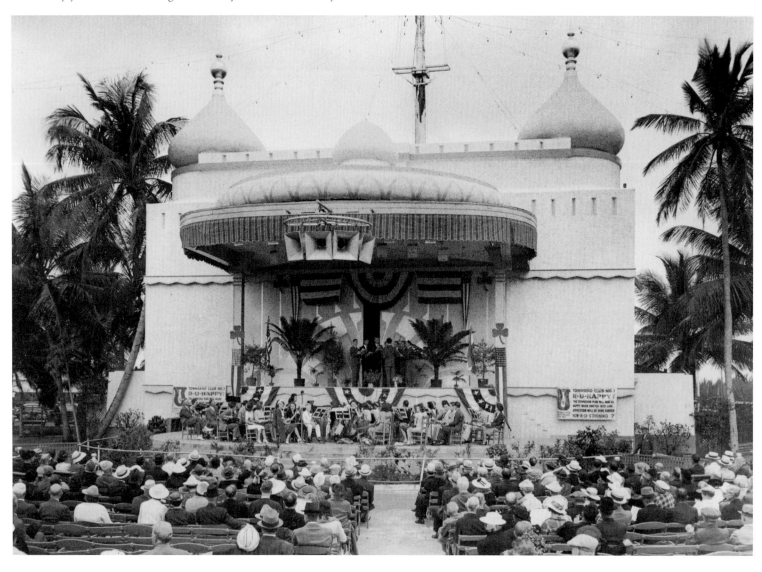

Sometime in 1940 Miami Beach City Council members—from the left, Harry Hice, Baron deHirsch Meyer, John Levi, Mayor Mitchell Wolfson, and Herbert A. Frink—destroy the slot machines at Carter's gambling house in an effort to clamp down on gambling as a vice.

The downtown postoffice and federal building soon became too small for the growing city and moved to new quarters, leaving the building vacant and a perfect location for the new home of the Miami Public Library, which would occupy the building until 1950, when the new library would open in Bayfront Park at the foot of Flagler Street.

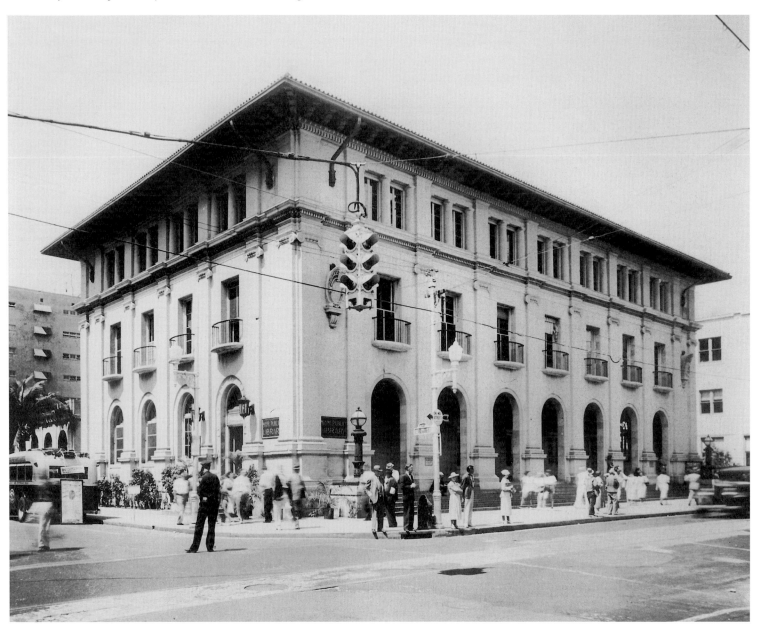

Lincoln Road is now a mall but in the 1940s the street was the "Fifth Avenue of the South," complete with Bonwit Teller, Burdine's, a Cadillac dealership, Sak's Fifth Avenue, and many other famous stores. This photograph, from the collection of the late James P. Wendler, looks west on Lincoln, the first cross street being Washington Avenue. The building across Washington on the left is the Mercantile Bank Building, which replaced the Lincoln Hotel. The low building on the right with the dome-style roof is the old Miami Beach Federal Building, replaced with a high rise bank building in the early 1960s. The large buildings farther up Lincoln on both left and right survive today.

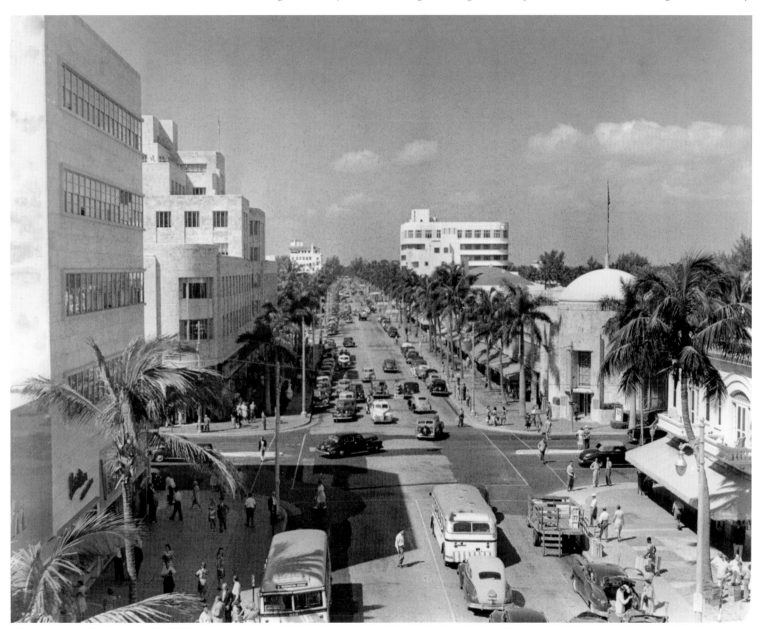

This beautiful edifice is the Pepper home on Miami Beach. It is unclear whether this was the home of U.S. senator (later congressman) Claude Pepper or the Pepper who was the land and real estate manager for the Model Land Company, the land sales arm of the Flagler System.

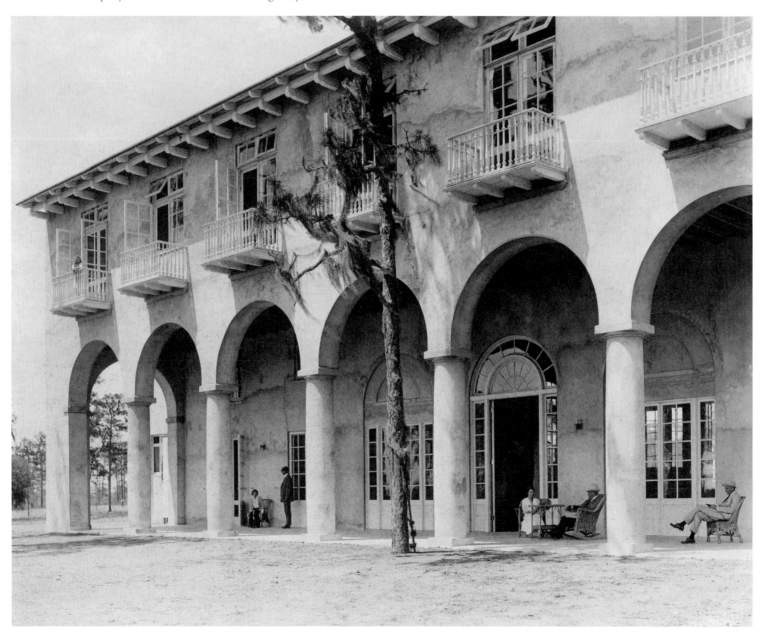

Although Key West had telegraph service with the arrival of the Florida East Coast Railway in 1912, telephone service was spotty and unreliable until this crew, with Roy A. Estes at center, strung the new line from Miami to the island city in 1941.

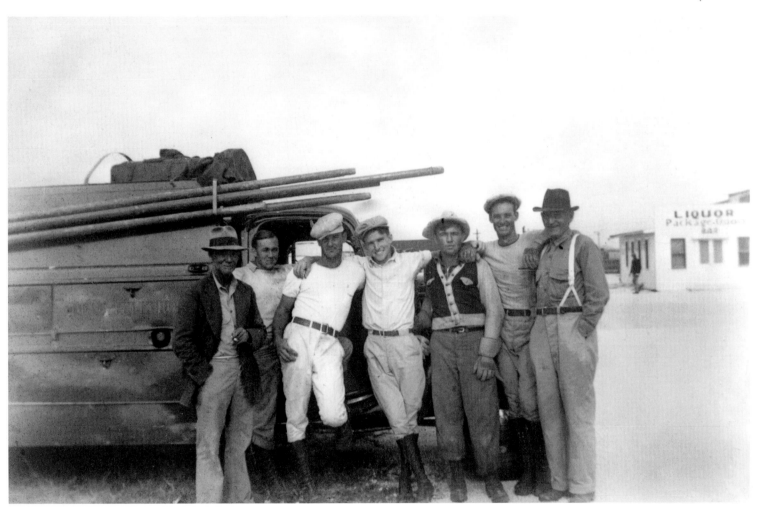

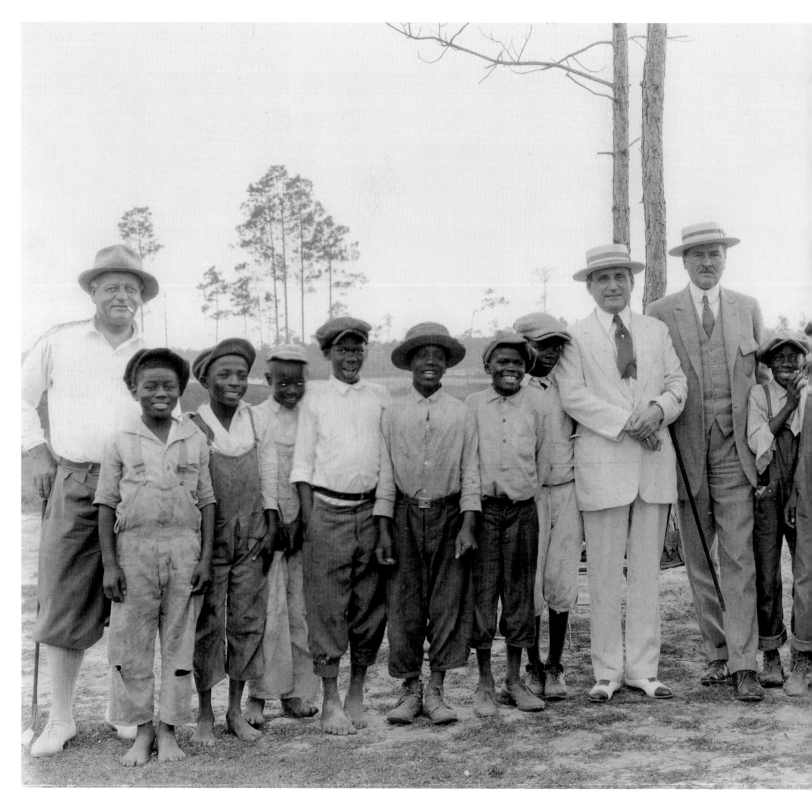

142

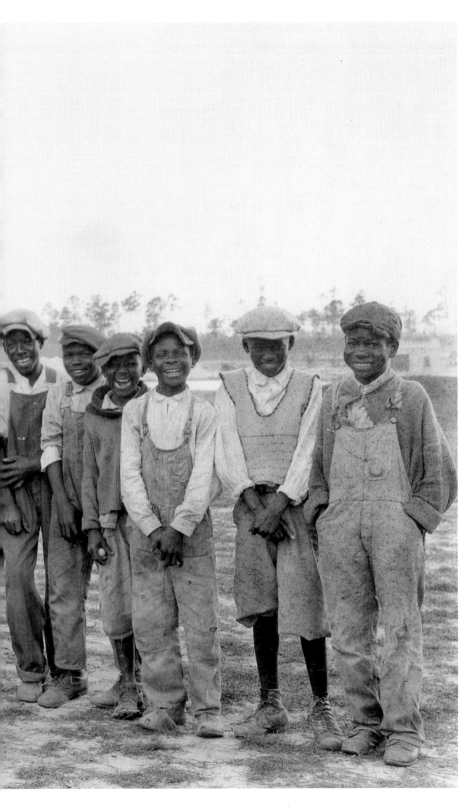

Photographed during summer vacation in the 1940s, this group of children earned a good bit of money as caddies, at the then quite new Miami Shores Country Club. The club had been built as a WPA project during the Depression. With the children is, at far left, golf pro Alec Smith, among others.

Even with World War II in full sway, tourists came to the Magic City. Servicemen and women also needed things to do on their days off. The *Seminole Queen,* with the spires of downtown Miami in the background, left the piers daily for the Miami River and a visit to Musa Isle, where wide-eyed visitors could see Seminoles and their "chickees" (semi-portable homes), young braves wrestling alligators, and a variety of tropical flora and fauna including uncaged monkeys. It was a trip worthwhile in those tense days before the tide of war turned in America's favor.

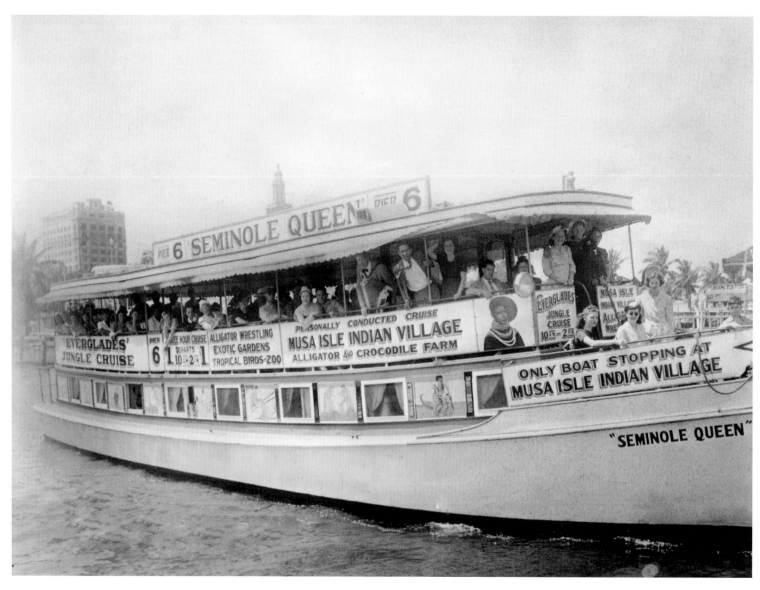

By early 1943 the various branches of the armed forces were actively recruiting young Americans for the service, enabling them to "sign up" before being drafted. Here a U.S. Navy Recruiting Cruiser, complete with induction trailer, stops downtown to sign up would-be seamen.

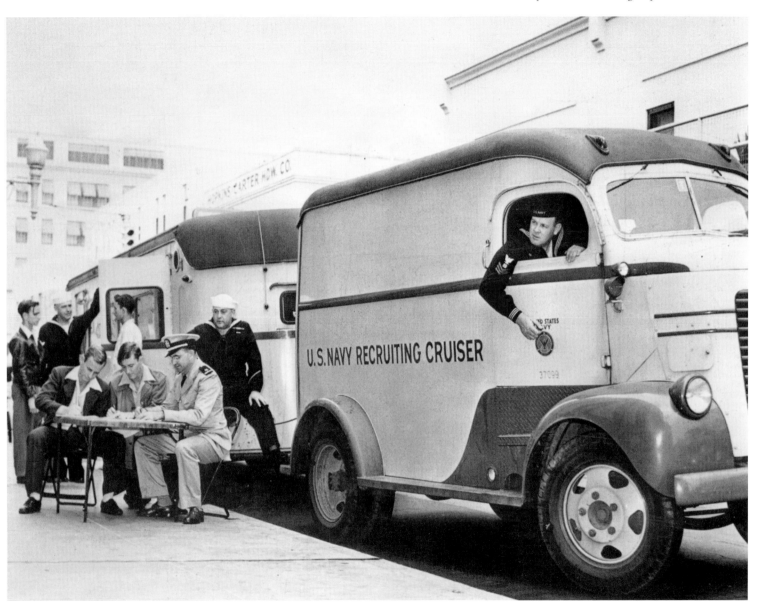

While Miami Beach was the home of Army Air Force training, the Navy was based in Miami. Seven days a week Navy fighters and bombers put budding aviators through their practice paces.

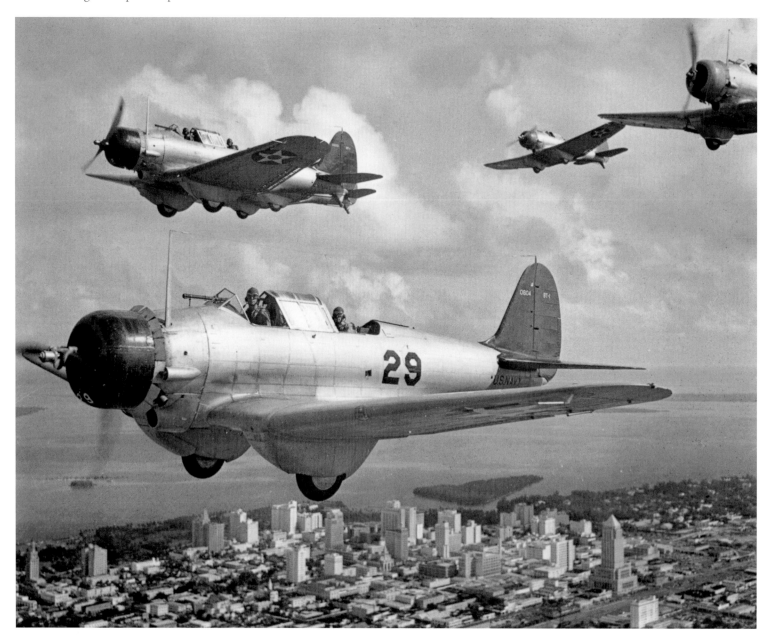

Two platoons of military police (MP's) pass in review under the palms of Miami Beach's Collins Park on Collins Avenue, between 21st and 22nd streets. In the background the tower of the Roney Plaza looms over the scene.

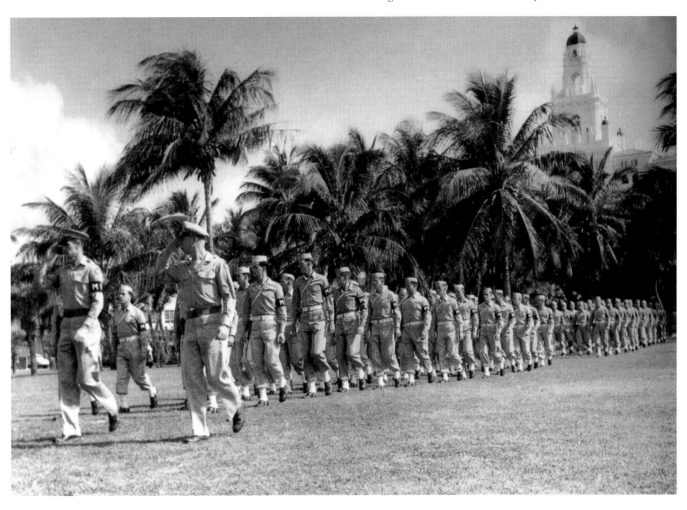

Beautiful movie starlet Veronica Lake broadcasts over Florida's first radio station, WQAM, now the home of Miami radio icon Neil Rogers, promoting war bonds. In 1942 the outcome of the war and the fate of the free world were still unknown. Stars such as Miss Lake were an integral part of the war effort.

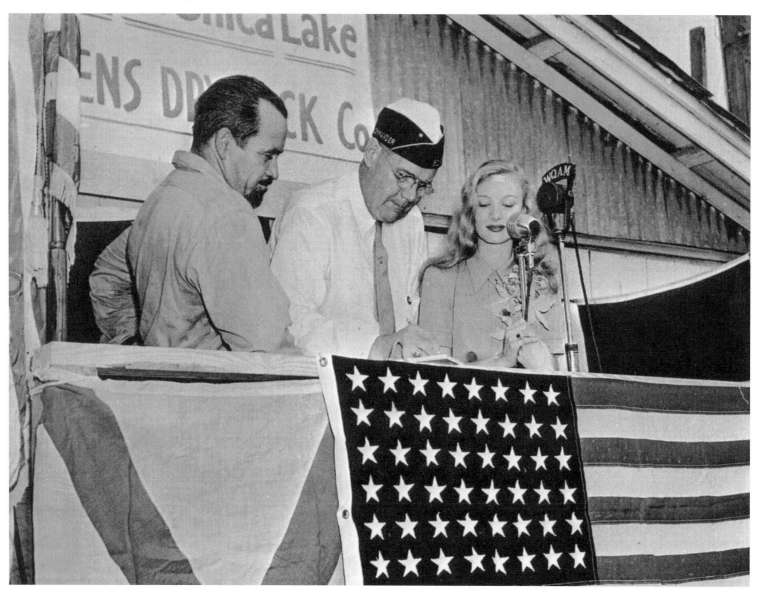

The sandy beach at Miami Beach was an ideal practice ground for thousands of Army Air Force trainees, as they prepared themselves for combat. Fitted out with gas masks, trainees took their calisthenics and physical training seriously.

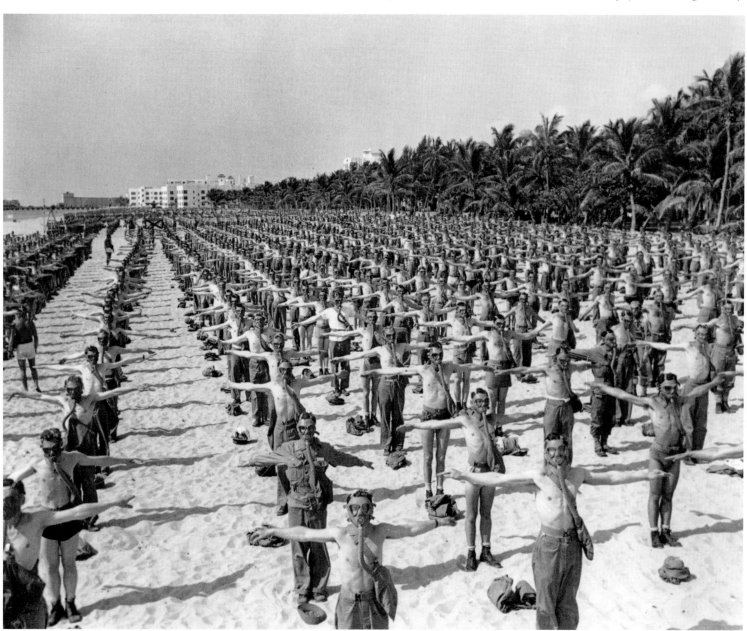

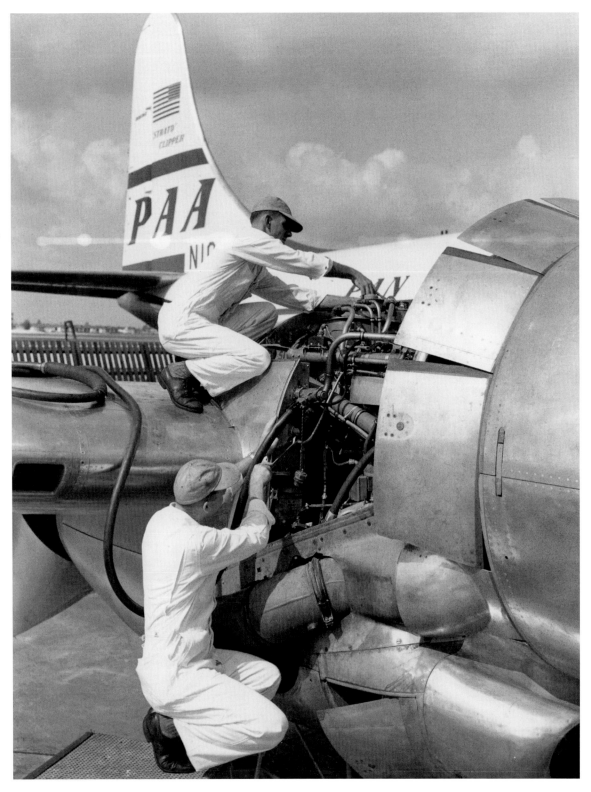

With the beginning of hostilities, Pan Am's flying clipper (seaplane) service from Dinner Key ended and all operations shifted to Miami's 36th Street Airport. Two Pan Am mechanics are hard at work maintaining one of the engines of a DC-6 prior to its departure for Caribbean or South American destinations.

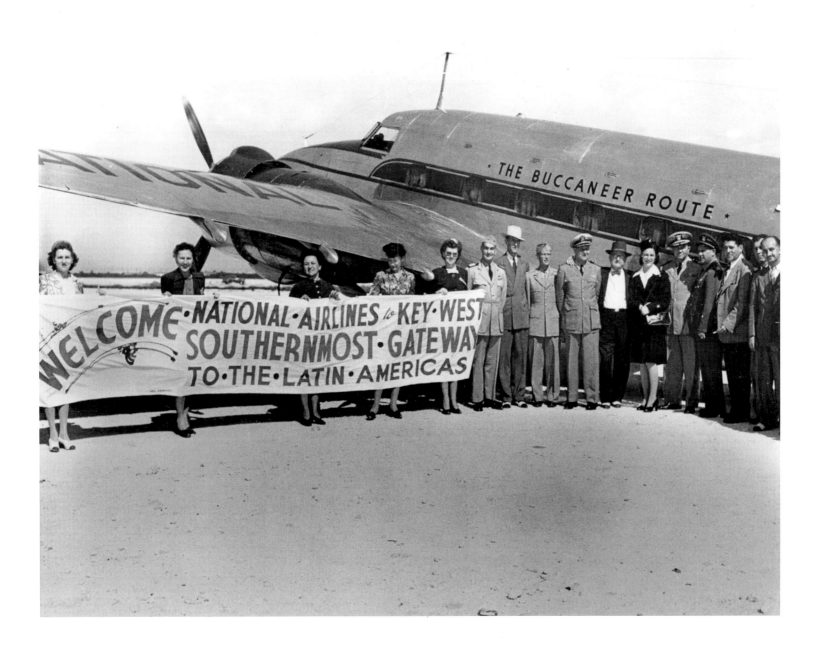

On February 10, 1944, National Airlines began service between Miami and Key West with civic officials, navy representatives, airline employees, and enthusiastic residents welcoming the flight.

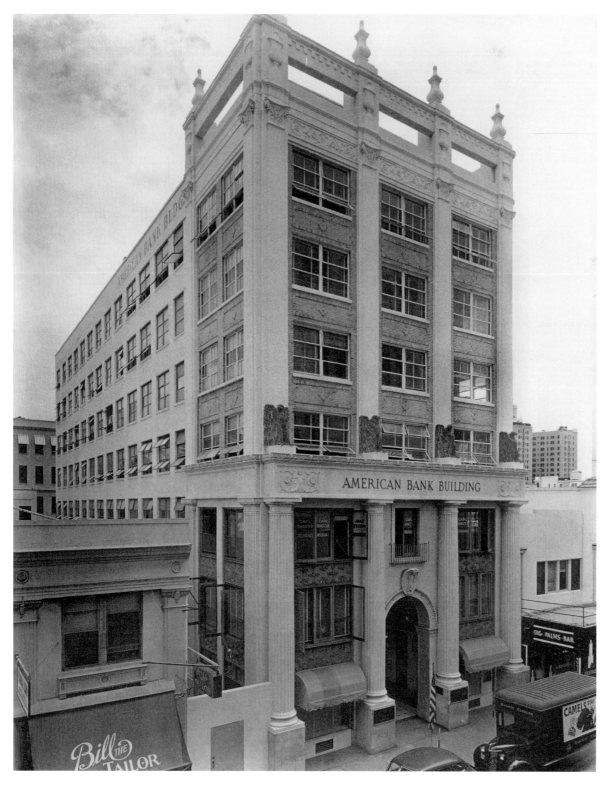

One of the most severely
damaged of the buildings in
the 1926 hurricane was the
Meyer-Kiser Bank Building.
With several damaged floors
removed, the building was
restored and eventually
became the American Bank
Building. On June 6, 1944,
with news yet to come out of
Normandy, a Railway Express
Agency truck makes a pick-up
or delivery in the days before
UPS and FedEx.

One of the later and larger art deco hotels, the Versailles, on Collins Avenue, not in today's Art Deco District, was one of the most striking of the then-new Miami Beach hostelries.

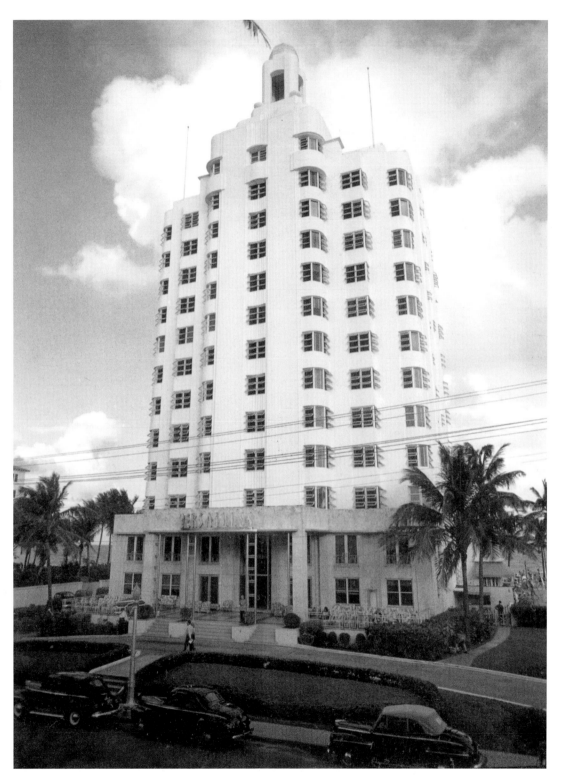

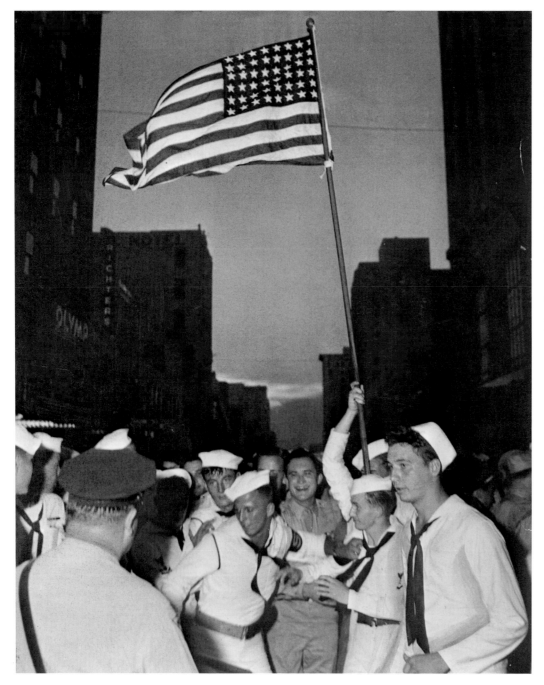

Victory over Japan (VJ) Day was celebrated as lustily in Miami as it was in New York. Here an excited and enthusiastic bunch of sailors are right in the middle of Flagler Street at Northeast Second Avenue, the Olympia Theater Building to the left and Richter's Jewelry prominent just to the west. The shore patrolman at center seems to be trying to keep the crowd calm, assisted by the well-known Miami native, Moishe Poopick, front right.

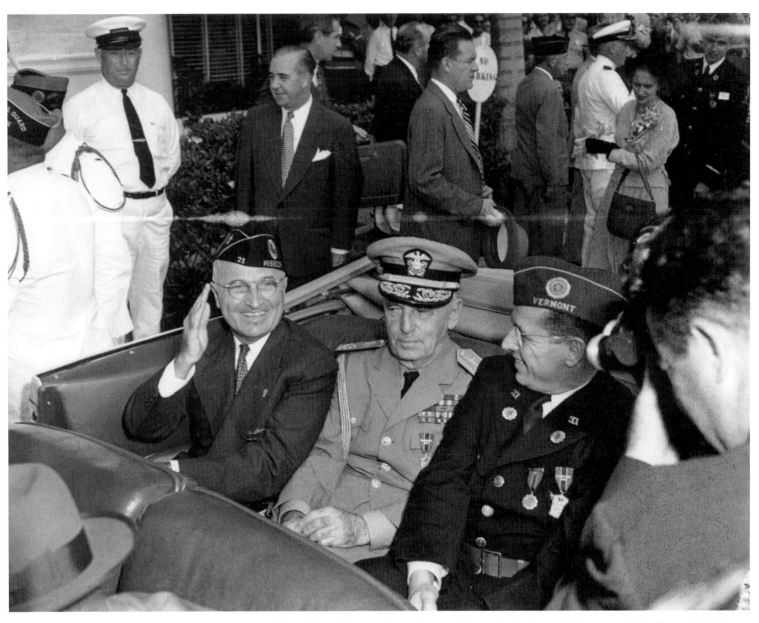

President Harry Truman salutes the crowd from the backseat of his convertible in front of the Roney Plaza Hotel shortly after the end of the war. Admiral William Leahy sits in the center with, it is believed, a U.S. senator from Vermont, at right. The event may have been the first American Legion convention held in Miami after World War II ended.

Like the rest of Miami, the Florida East Coast Railway was changing dramatically. With the arrival of the new diesel locomotives sporting the stunning red and yellow paint scheme, fewer and fewer steam locomotives were needed. FEC diesel 571 was equipped with a steam boiler and was equally at home handling passenger or freight trains. In this view, the engine rests at Miami's Buena Vista Yard awaiting her next assignment.

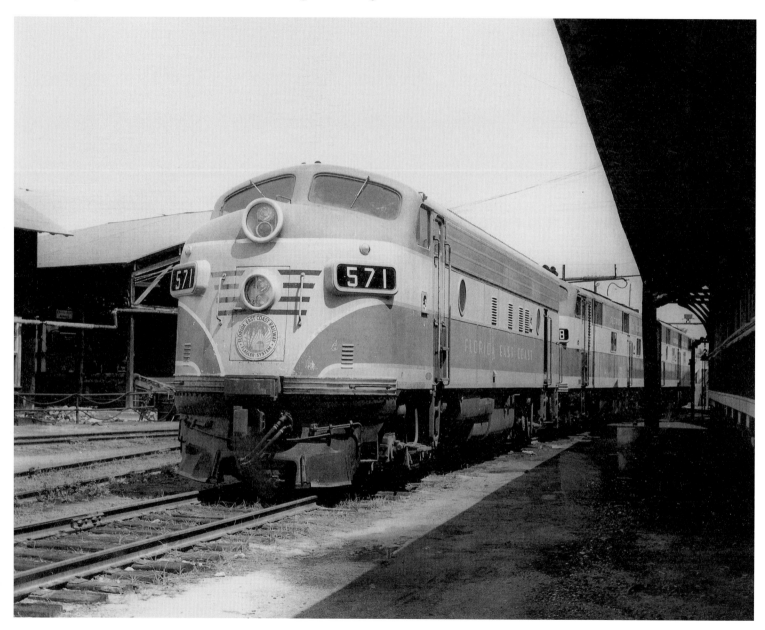

A view of Miami Beach Presbyterian Church, as it looked in 1946. This beautiful building would be replaced with a new structure in the 1950s.

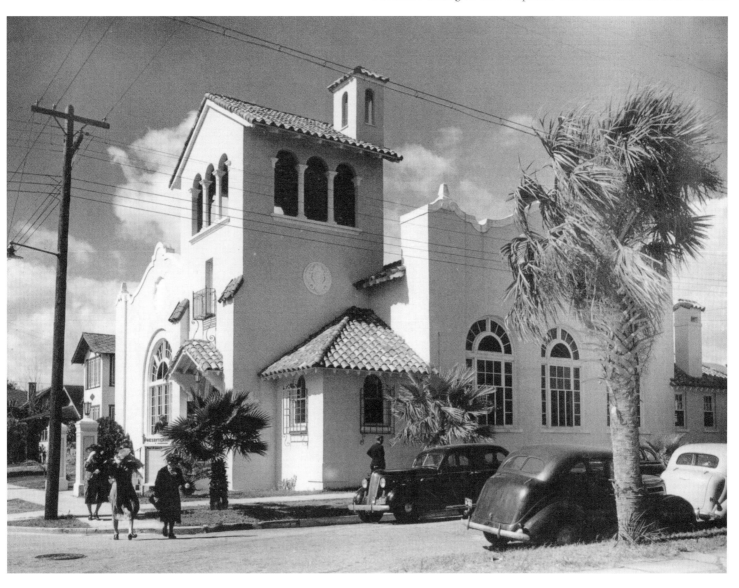

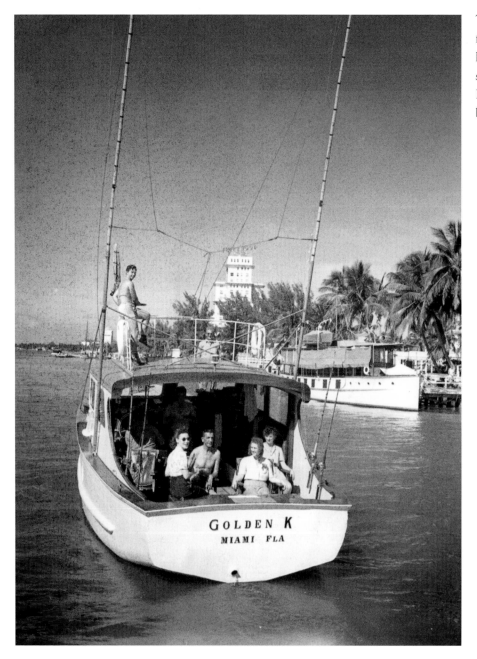

The *Golden K,* a trim fishing cruiser, slowly heads north along the west side of Miami Beach, the Fleetwood Hotel in the background.

Watershows, originating in Atlantic City, were also a staple at Miami Beach hotels. As a part of guest entertainment, the shows were generally held every Sunday. In 1946, with a bevy of bathing beauties watching, one of the Vanderbilt Hotel beach boys does a clown dive from the three-meter board.

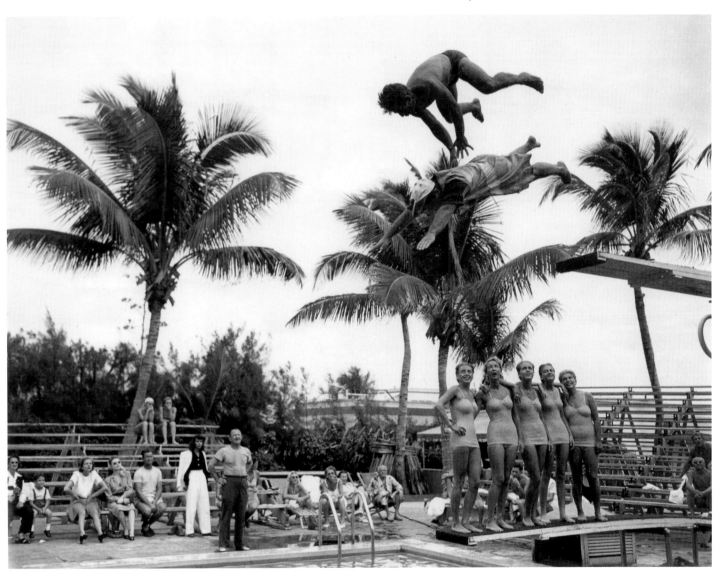

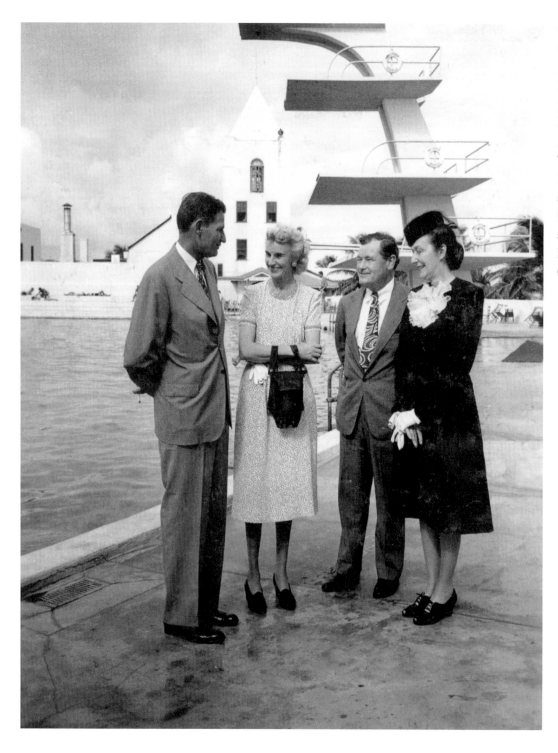

Governor and Mrs. Millard Caldwell (far left and far right) are joined at the MacFadden Deauville Hotel pool, 67th and Collins, in Miami Beach, by Mr. and Mrs. John H. Phipps, center. The hotel boasted Miami Beach's highest diving board and the pool was the largest in the city, exceeded in size only by the pool at the Miami Biltmore Hotel in Coral Gables.

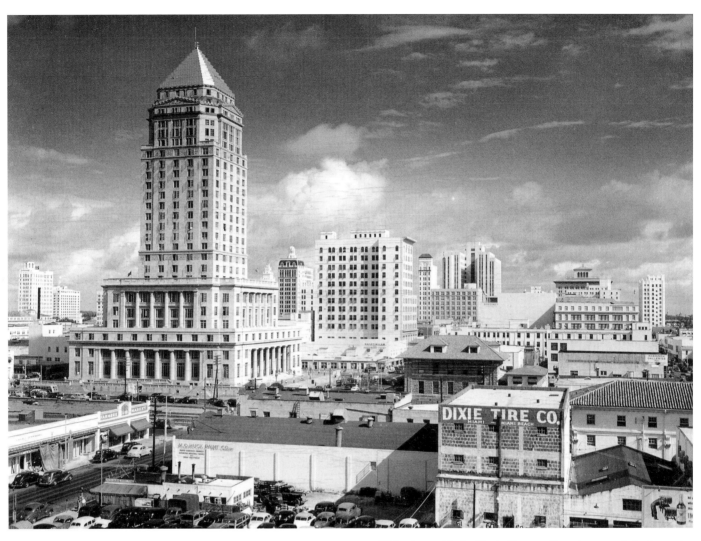

This view, with the Dade County Courthouse at left, shows the expanding city. The DuPont Building, at Flagler Street and Northeast Second Avenue, is the large building at center in the background.

The publicity staff at Miami Beach didn't hesitate to put pictures of beautiful women enjoying the city's sun and surf into national circulation. These two, both of New York City, certainly make a pretty picture on Miami Beach's oceanfront.

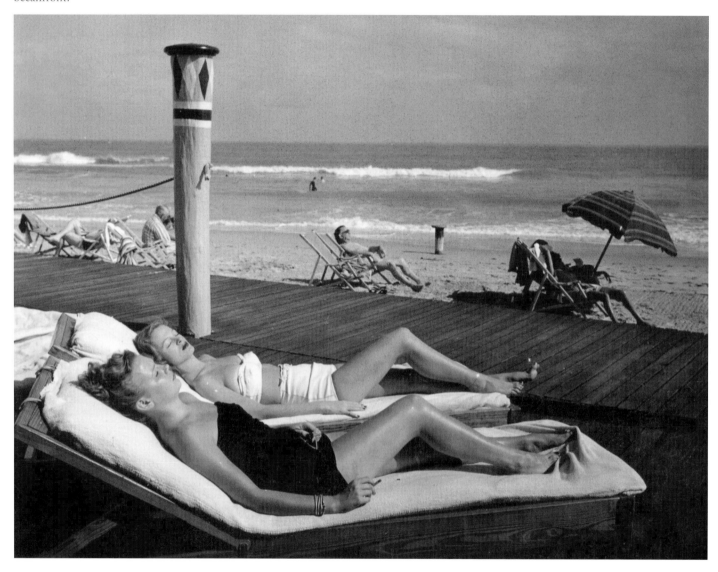

Liberty Avenue and 23rd Street on Miami Beach was the epicenter of some of America's finest night clubs and restaurants, the tenderloin extending from 20th to 24th Streets on Collins Avenue and west to Park and Liberty Avenues. While Trocadero, shown here, did not last long, many of its neighbor establishments survived for decades.

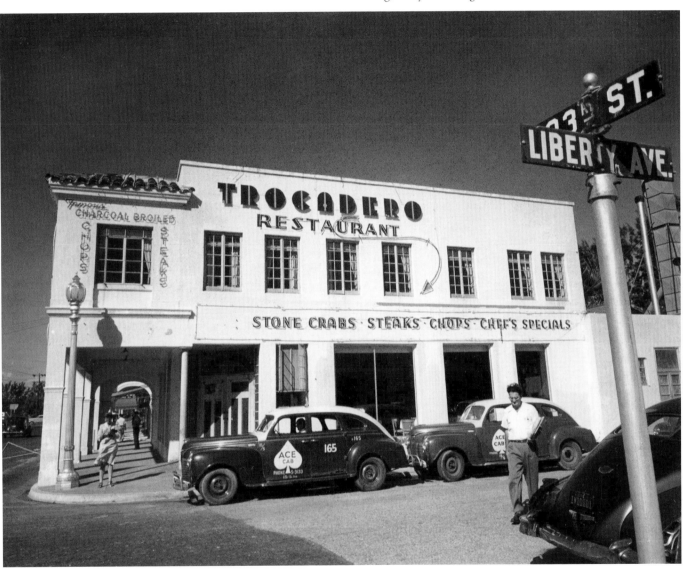

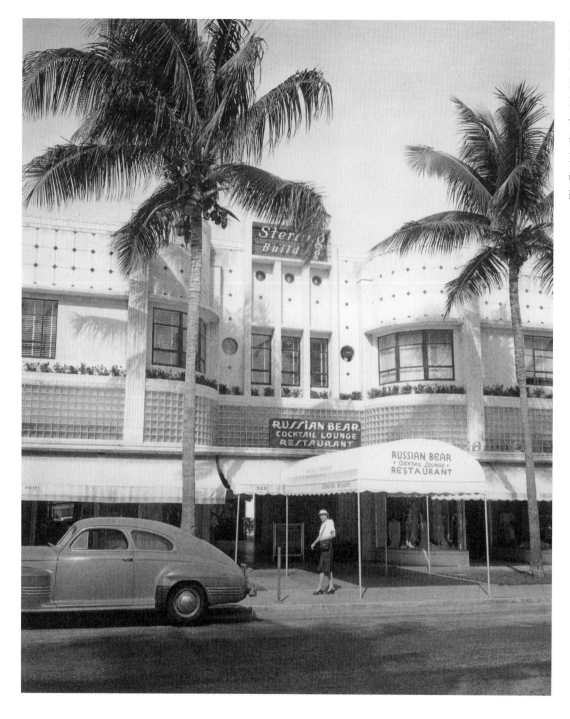

Miami Beach's Lincoln Road was elegant, indeed. The Russian Bear Restaurant, in the Sterling Building at 940 Lincoln, was, for many years, one of the city's top restaurants. Here a passerby smiles for the camera before going inside.

The Miami Colonial Hotel, along with others like the Alcazar, Columbus, Everglades, and Biscayne, fronted Biscayne Boulevard between Northeast First and Fifth streets. Though all are now gone, their names bring warm memories to innumerable Miamians and visitors. At left is the Clover Club, a night club famous for great food and extravagant stage shows. The headline entertainer the day this photograph was taken was the great burlesque performer Gypsy Rose Lee, memorialized through the Broadway show "Gypsy."

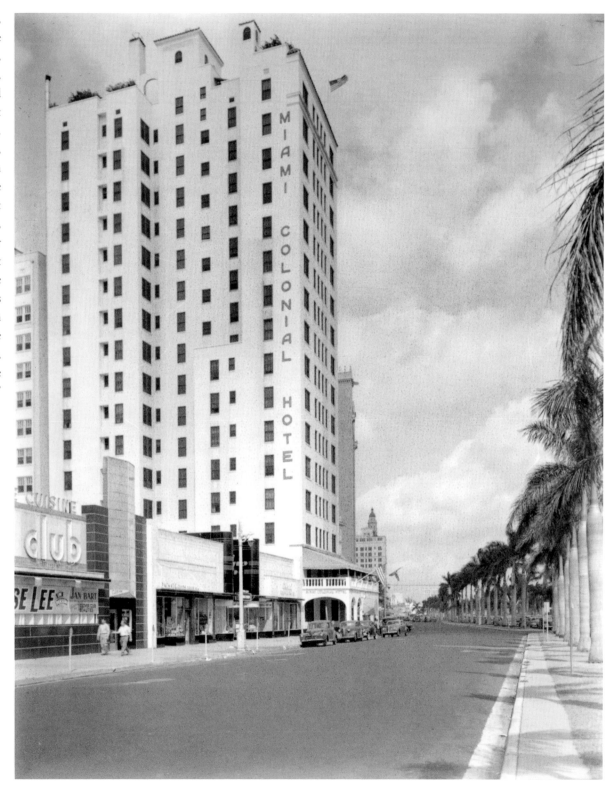

In 1947 University of Miami students Thomas Baker (not in the photo) and Dick Hall (with sunglasses, far right), purchased this 1928 Studebaker Dictator touring sedan, which they named "Bessie," for approximately $60. Here, Hall, in the driver's seat, and a group of friends, are leaving campus for "chow" before getting back to their studies.

The home of the *Miami Herald,* from 1941 until the new building facing the bay between Northeast 13th and 15th streets opened in 1960, was at 200 South Miami Avenue. Owned for many years by the Knight Brothers, John and James, the publication declined markedly, according to *Time* magazine, under Knight-Ridder stewardship. The paper is now owned by the McClatchey group, and residents and employees are looking to them to return the paper to its Knight-owned greatness.

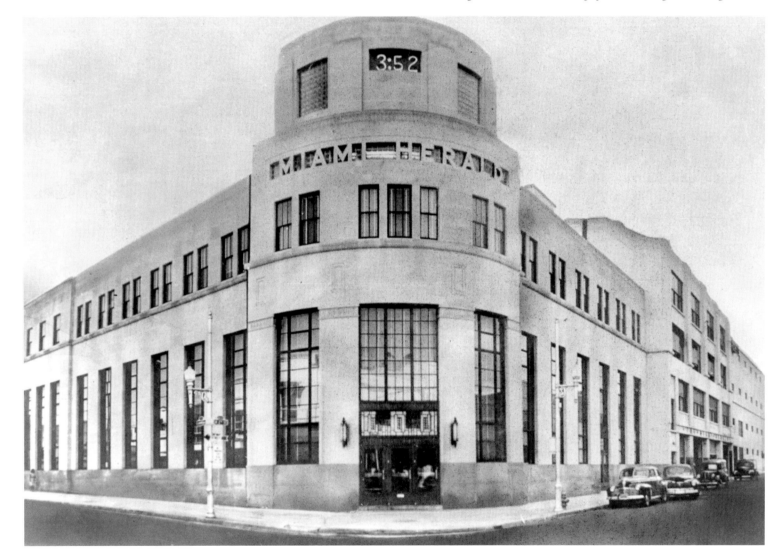

Biscayne Bay, with six causeways crossing from Miami to Key Biscayne and Miami Beach, has its share of traffic delays as drawbridges are raised twice an hour almost around the clock. Here several boats pass through the open MacArthur Causeway west (Miami side) draw, the open Venetian Causeway bridge in the background.

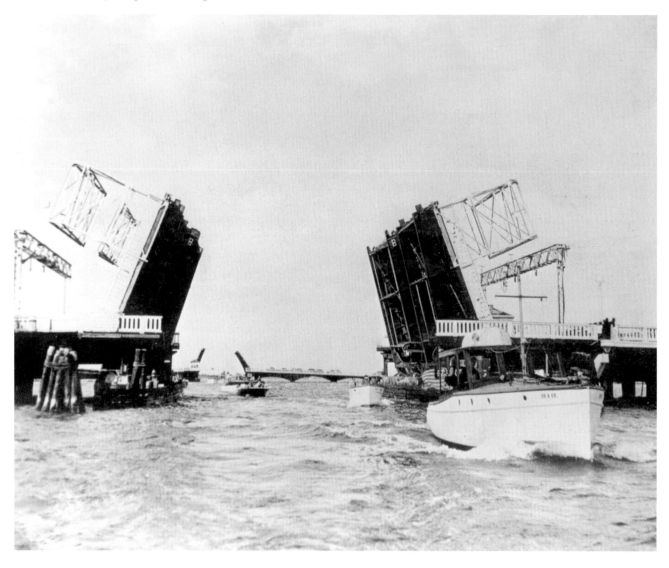

The Beachcomber was another of Miami Beach's glamorous night clubs. Located on Park Avenue just south of 23rd Street, it was the showcase of innumerable stars, not the least of them Henny Youngman and Alan King. A victim of the Modified American Plan, which gave hotel guests two meals a day, the Beachcomber, along with the rest of the great clubs and restaurants in the area, would close by the early 60s.

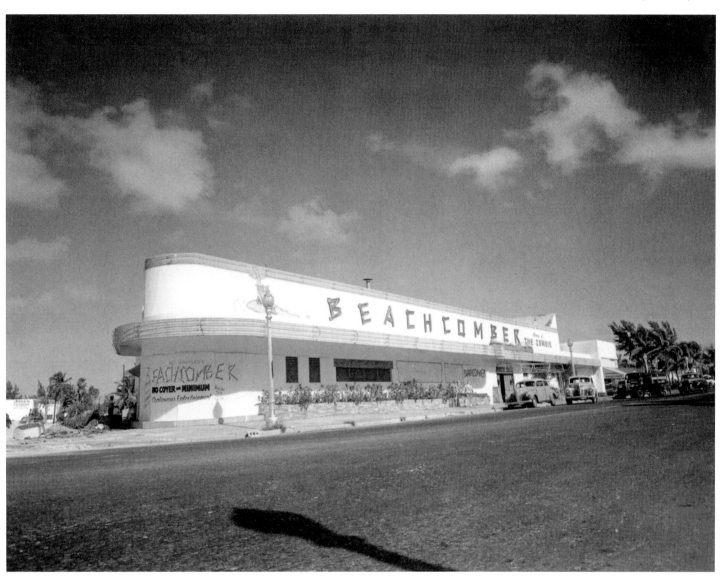

Miami's Three Score and Ten Club, long gone, served as a wonderful meeting spot for Miami's senior citizens. Founded January 23, 1929, by Thomas Meeks, the club thrived, at one time boasting more than 4,000 members. Photographed here on January 8, 1947, it would not last through the 1960s.

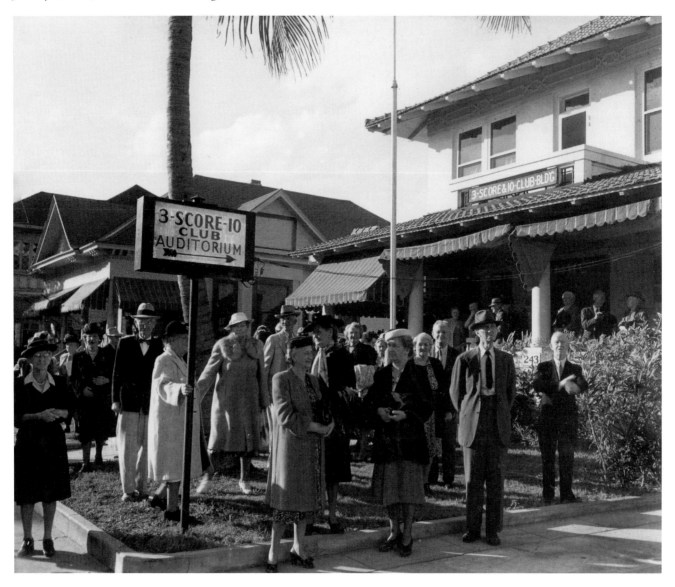

The Glorifried Steak House was another Miami Beach favorite, but with changing times and newer restaurants opening, it too would close prematurely.

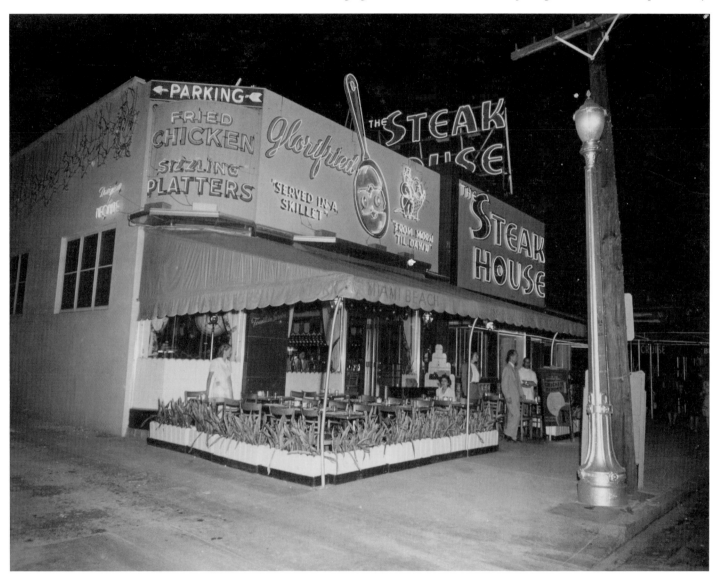

There was—and still is—something magical about Miami Beach. At the Raleigh Hotel, now one of the revitalized art deco district properties, the memories shine bright. It is evident, in this 1948 scene of guests dining at poolside, that the Raleigh was a special place.

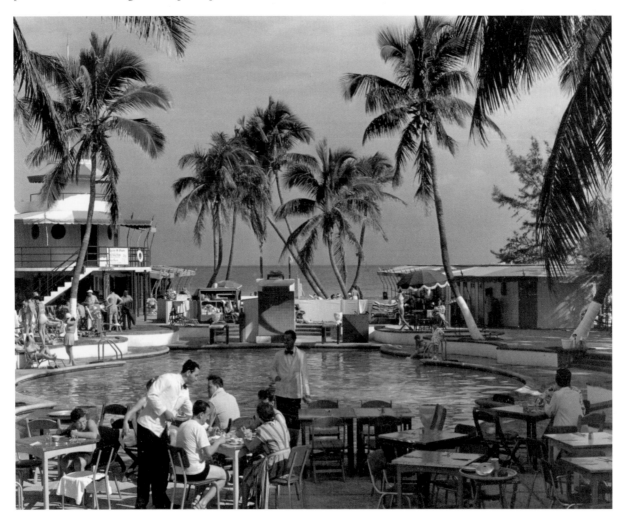

ROBUST RAILS TO STRAPPING SKIES

(1950s)

The 1950s began with great promise and excitement, as hotel after hotel, including the Allison, Lombardy, Casablanca, Saxony, Sans Souci, Sherry Frontenac, Deauville (which replaced the old MacFadden Deauville), Carillon, Fontainebleau, Eden Roc, and Doral opened along Collins Avenue.

The end of the era of the great night clubs and restaurants was signaled, however, by the introduction of the modified American plan dining arrangement, whereby breakfast and dinner were included in the beach hotels' room rates. A campaign against casinos also, in the opinion of some, curbed tourism, sending would-be visitors to gaming-friendly destinations like Nevada. Maimi and Miami Beach now needed to rely on the art deco district and the trendy clubs that remained to bring in a relatively smaller number of visitors.

Miami remained in a period of quiescence and almost no new buildings were added to the skyline. From 1927 until the early 1960s, Miami's skyline remained essentially unchanged.

The 1950s would also see the beginnings of change, however, as Miami's airport became the hub of all Latin American air traffic and construction began on the Julia Tuttle Causeway, connecting the Miami side at Northeast 36th Street with Miami Beach at 41st Street and planning for a new port of Miami began.

Rail passenger service, though not as robust as it had once been, remained strong, and in the early years of the decade the Florida East Coast Railway operated as many as nine trains daily in each direction between Jacksonville and Miami (most of them through-trains from New York and the Northeast and Chicago and the Midwest) while the Seaboard scheduled as many as six each way, those also going on to northern and midwestern points.

It was, in the view of some, the most pivotal decade in Miami's history.

This 1954 aerial view of Miami Beach looks south from 44th Street. Indian Creek is the waterway between the hotel strip and the ocean, and the bridge shown near the center is the 41st Street bridge over to that street's shopping area and to residential areas farther west on the beach.

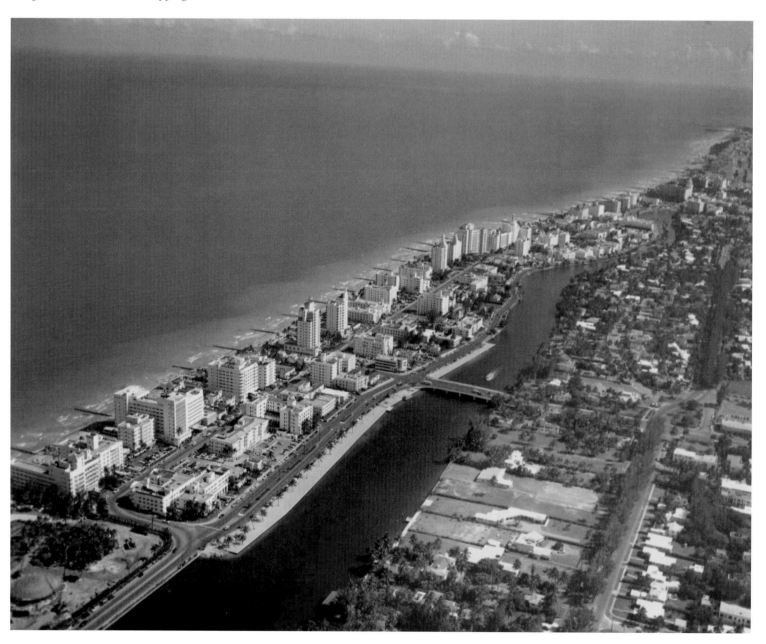

The southwest corner of Lincoln Road at Pennsylvania Avenue, two blocks west of Washington Avenue and four blocks west of Collins Avenue looking east. The Lincoln Theater is on the immediate left and the Albion Hotel is the several-story building on Lincoln farther down on the left. The curve of the west end of the Mercantile Bank Building is on the right on the east side of Drexel Avenue. When this photo was taken in 1954, Lincoln Road was in its heyday; the concept of a mall not even a pipe dream.

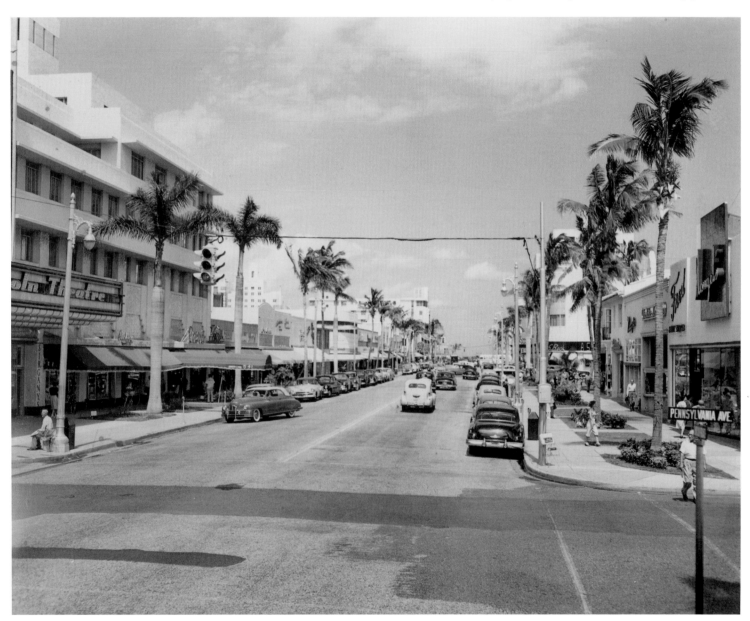

In 1950 the Sovereign Hotel, at 43rd and Collins, later just one of the smaller residential hotels, was still a swank and upscale location. Dancing on the outdoor patio with a live band was one of the main draws, a pastime that guests took to enthusiastically.

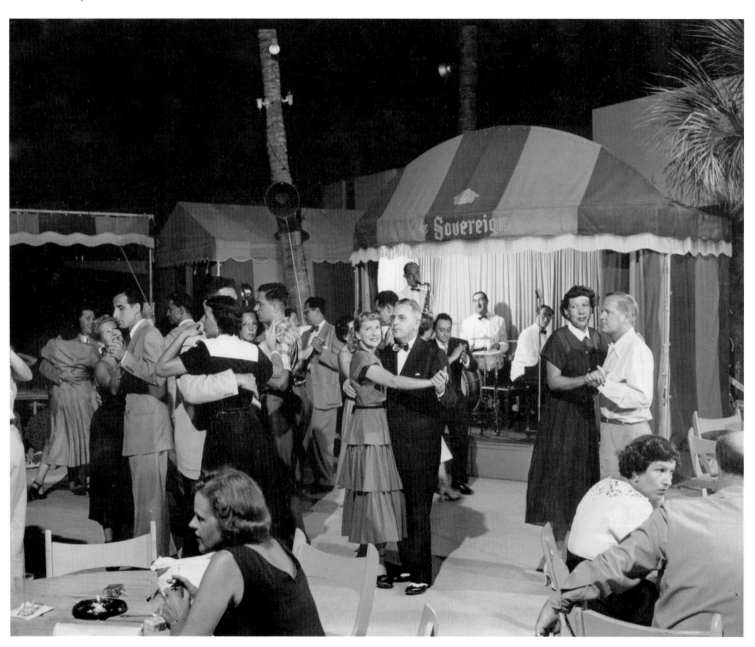

The Orange Bowl game and parade, up to 2004 when the parade was eliminated, has always been one of Miami's greatest draws, both for residents and visitors. For the 1950 game, movie starlet Colleen Townsend, who played in movies with actors such as John Wayne, presents the game ball to the referee prior to kickoff.

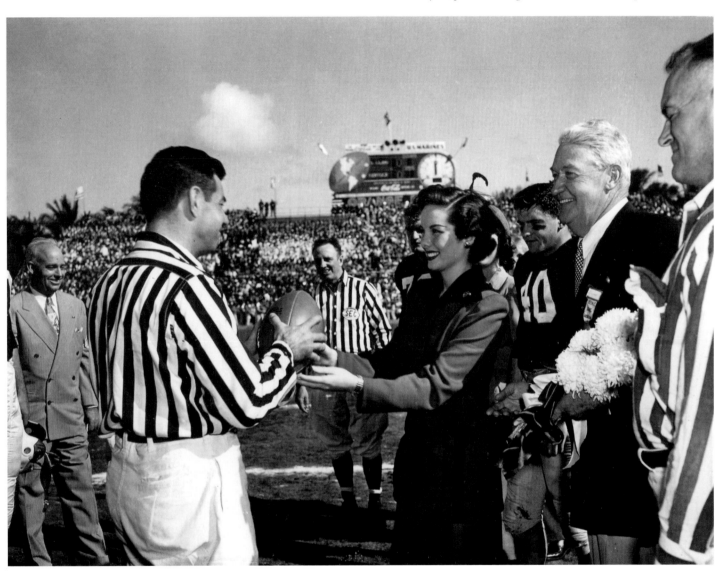

Another marvelous view of Miami Beach shows Washington Avenue looking south from Lincoln Road in July 1950. On the right (west) side is Liggett's Drug Store, its doors opening at the corner of Lincoln and Washington. Next to Liggett's is Woolworth's, and next to Woolworth's was formerly the beloved Ambassador Cafeteria, one of Miami Beach's several Jewish-style cafeterias, open for breakfast, lunch, and dinner, with huge sandwiches and terrific food in general.

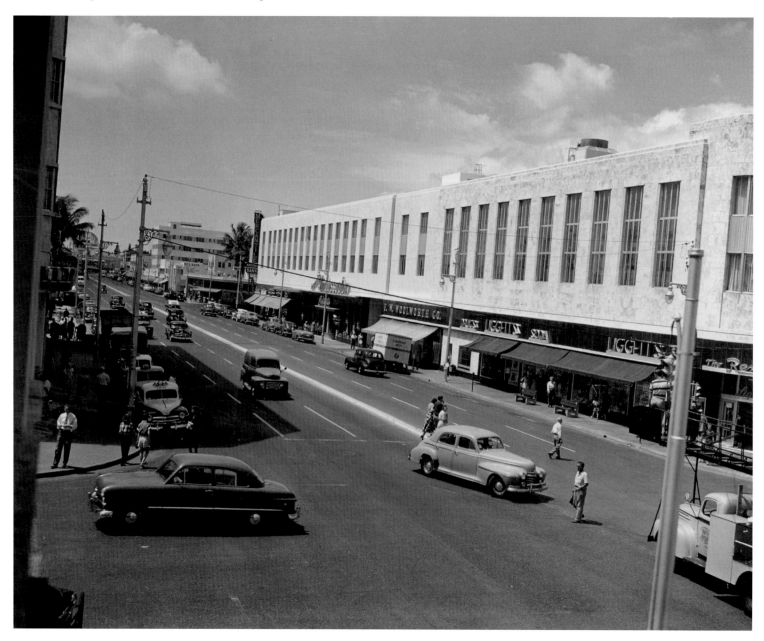

High above the Magic City on January 2, 1955, the Northwest Seventh Street bridge over the Miami River is directly below the camera, which is looking southeast toward the Rickenbacker Causeway, Virginia Key (the island to the left), and Key Biscayne. Downtown Miami is at left, the County Courthouse the most prominent building on the skyline, today almost completely surrounded and obscured by taller high-rises.

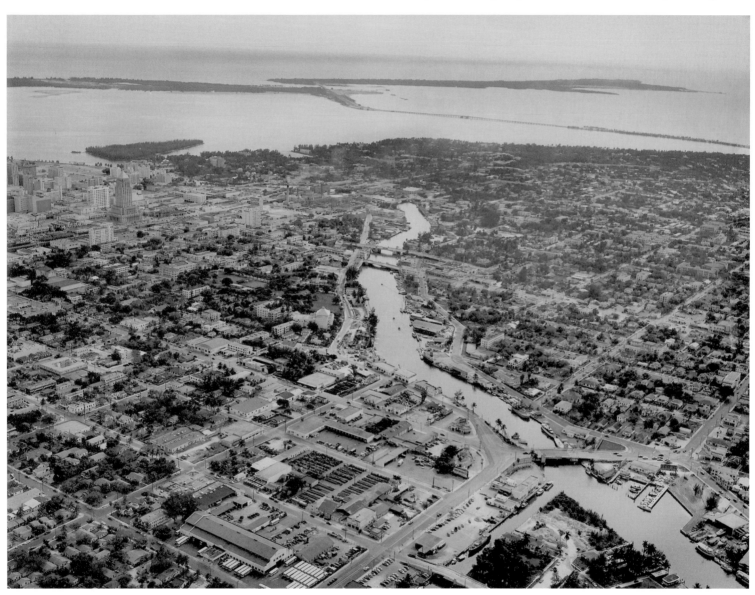

They liked Ike and in early 1952 his campaign stops included Miami.
Behind a large blowup of the man who would be president, local and
Republican party dignitaries listen intently to the speaker.

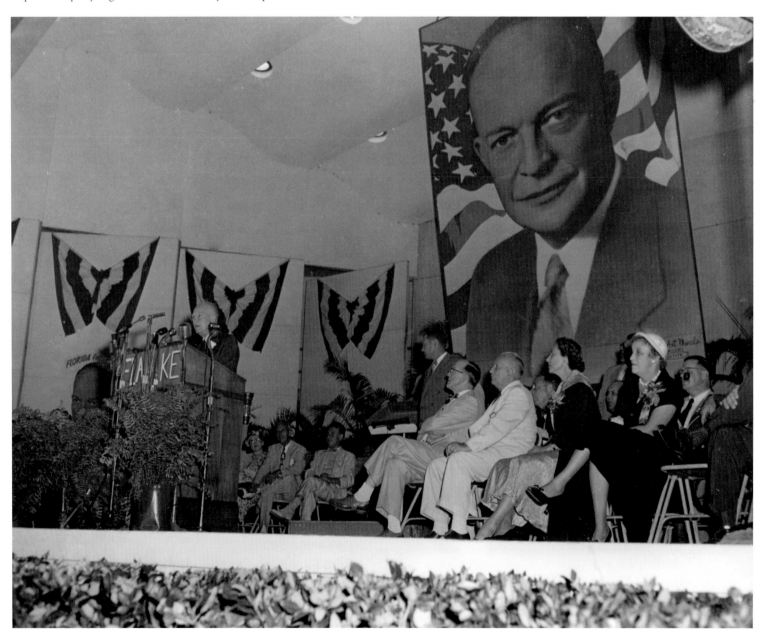

Famous for its "motel row," Sunny Isles, with the word "Beach" added to its name, would be incorporated as a city in 1997, and will celebrate its tenth anniversary in 2007 with the publication of a history of the city and area, *From Sandbar to Sophistication: The Story of Sunny Isles Beach*. The Golden Gate, at the north end of Collins Avenue, was one of the row's larger motels and was a choice destination for a large number of travelers and tourists. Unique to Sunny Isles, the Golden Gate, which had facilities on both sides of Collins, actually had a tunnel under the busy road for the use of its guests.

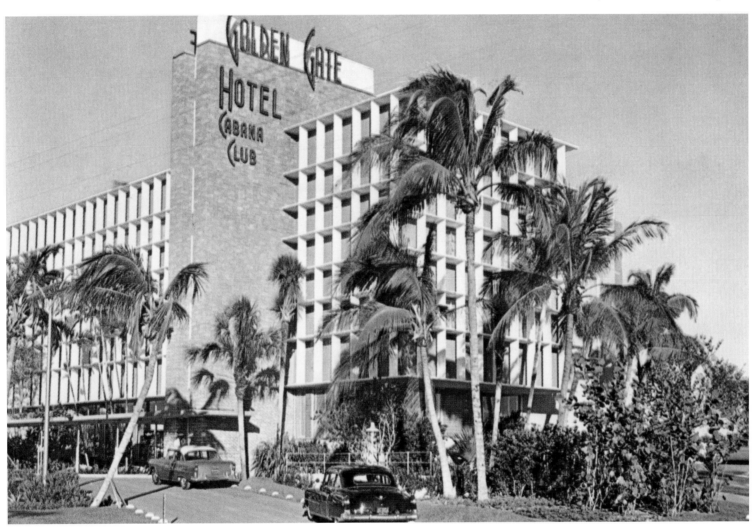

The Miami Outboard Club was a boater's group, one of a good few in the Greater Miami area. Here, several members gas up for an outing in 1953.

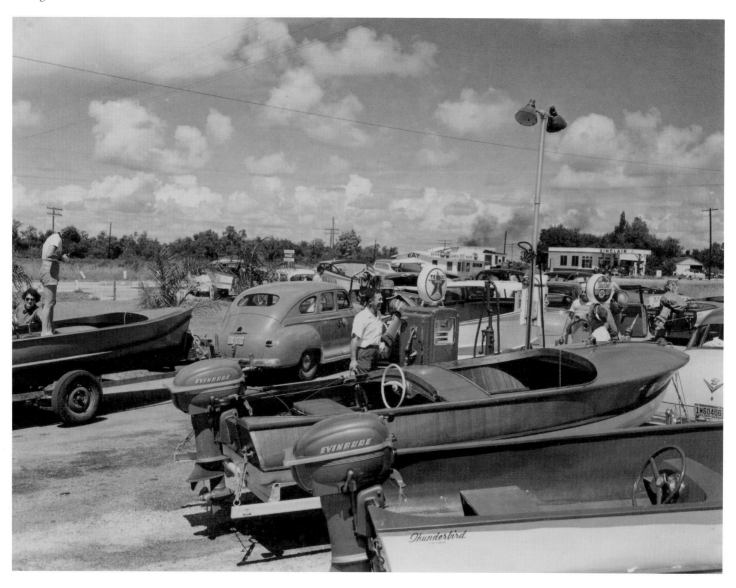

In 1952, Pan American's seaplane flights to the Caribbean and South America were commemorated with a historical plaque, placed near the site of the original Pan Am landing field at today's Miami International Airport. A group of dignitaries participated in that ceremony, a moment captured in this photograph.

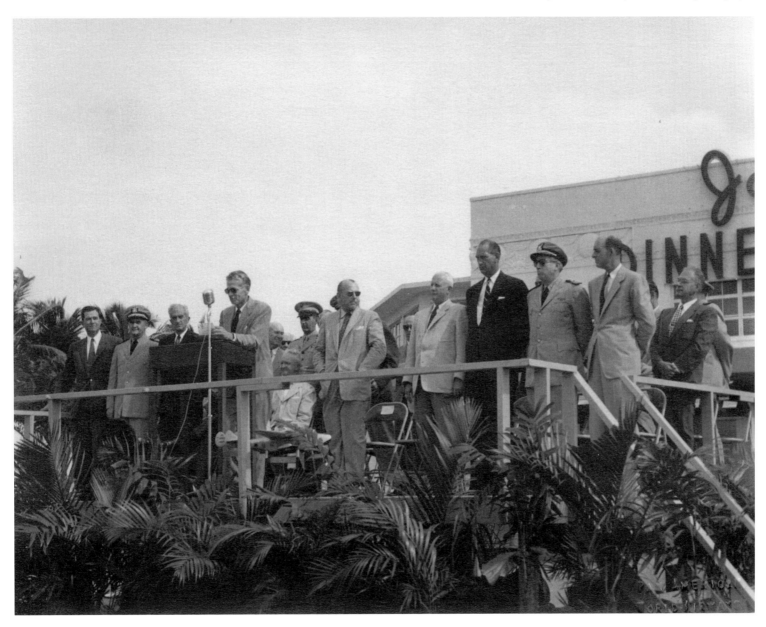

Few things say "Miami" as much as sunshine and water. It was those two elements that led the Florida East Coast Railway and later the city and its chamber of commerce to refer to Miami as "the Magic City," a term that has been in the public domain since at least 1913, when it appeared in an FEC descriptive booklet. Here, on February 1, 1955, Francis P. Johnson is participating in the Miami-Nassau sailboat race, the city in the background.

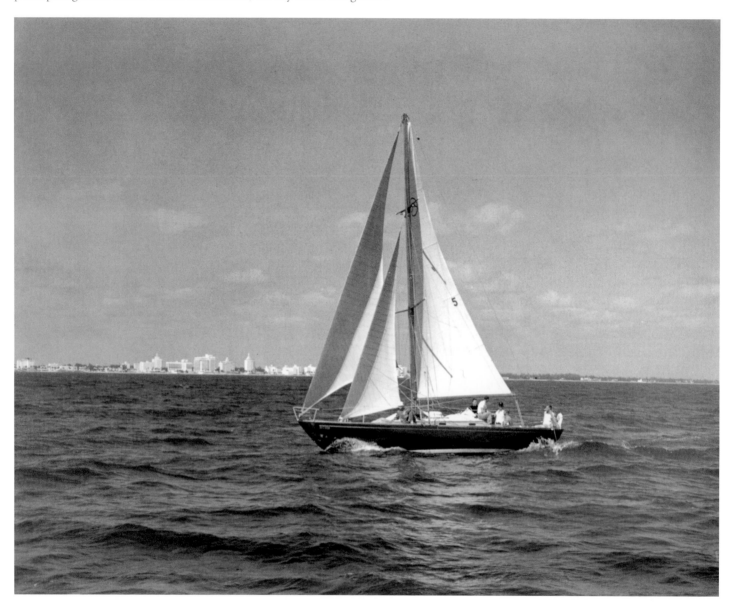

It is October 1958 and the winds of change are stirring. Looking east on Flagler Street from Biscayne Boulevard, the Pan Am ticket office is on the left with the Ingraham Building behind it, the majestic DuPont Building two blocks west on the north (right) side of Flagler.

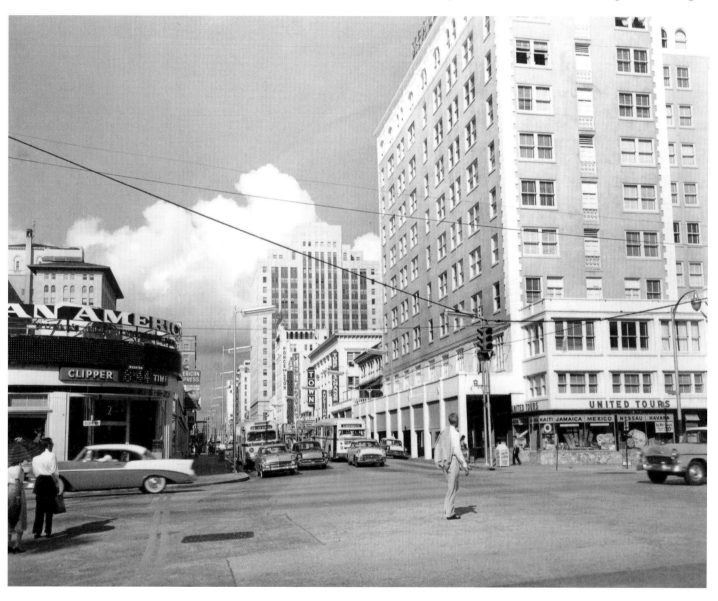

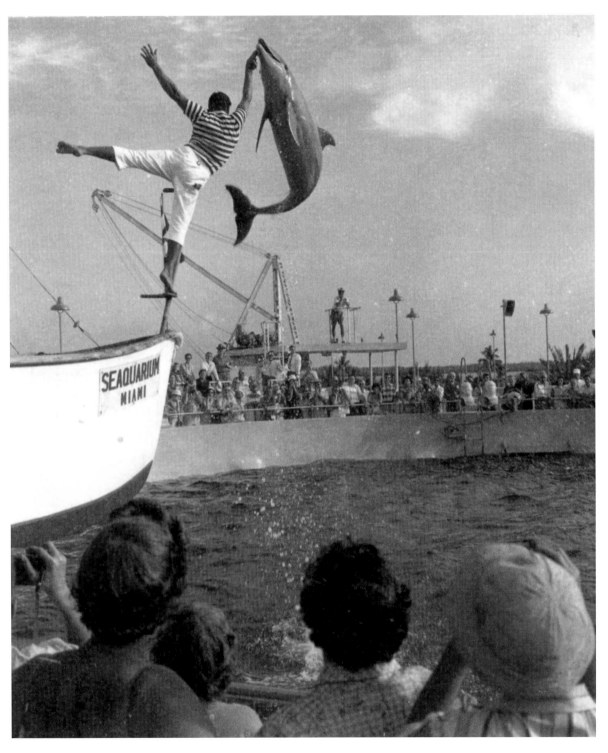

Opening in the late 1950s, Miami Seaquarium was one of the nation's first combination aquariums, marine research centers, and water-based entertainment venues. Here, in 1958, one of the performing dolphins leaps high from the tank to enjoy a tasty fish treat being proffered by its trainer.

Matheson Hammock Park, in Coral Gables, was one of the mainland's answer to Miami Beach. At Matheson Hammock one could enjoy sports, fishing, swimming, and the convenience of a boat ramp. Sometime in the fall of 1959 a family group prepares to launch their runabout for a day on the water.

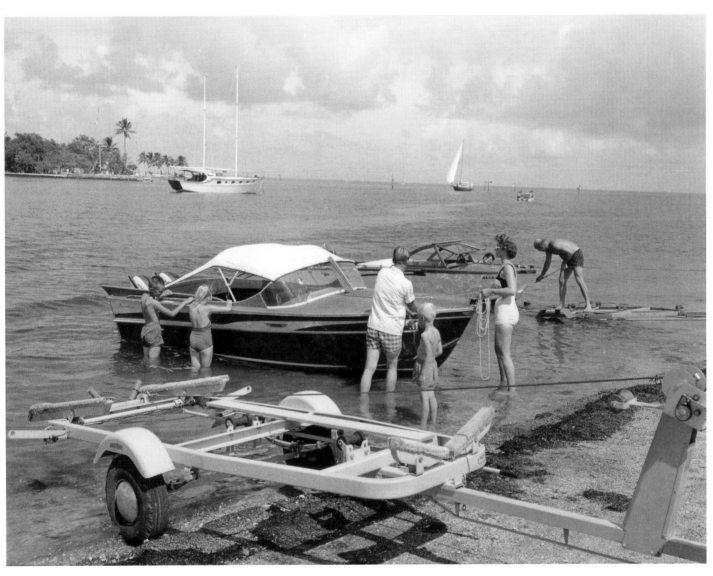

Built in 1912 as part of the Key West Extension project, the Florida East Coast Railway's downtown Miami station became a target of ridicule by the local press and politicians as they urged construction of a new depot on the site of the railroad's Buena Vista Yard. Shown here on September 11, 1959, it was razed between September and November of 1963. Local historians have come to realize the importance the station had and that it should have been preserved.

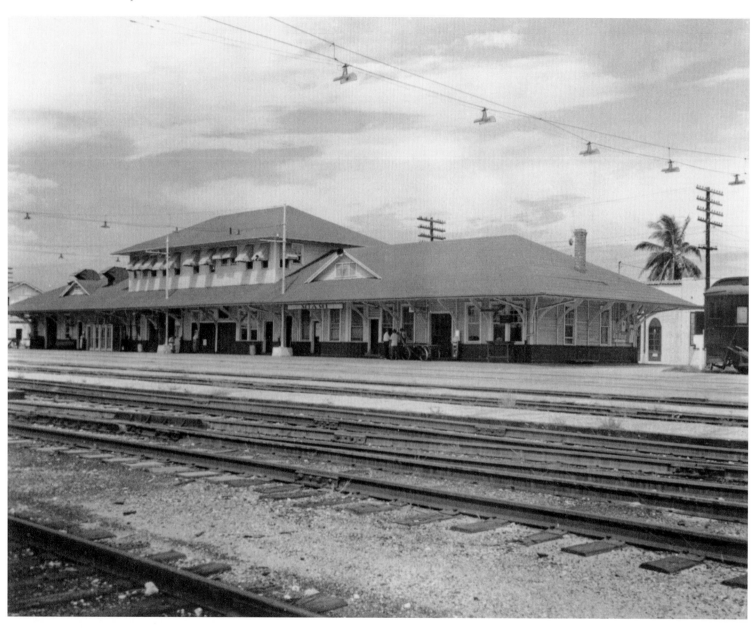

A City Looks Onward

(1960s)

"The times they are a'changin'," and, indeed, the 60s were a time of nothing if not change for Miami. The Julia Tuttle Causeway was completed, the new Port of Miami at Dodge Island was under construction, the First National Bank of Miami built Miami's first new skyscraper in more than 35 years, the county's population (nationally, anyplace in Dade County is and was thought of as "Miami" even though, at the time, there were 26 separate, incorporated municipalities in Dade County) reached one million people, the county's experiment with home rule seemed to be working well, and Fidel Castro's takeover of Cuba resulted in the first of several huge influxes of Cubans to the U.S., primarily in Miami.

Miami-Dade Community College came into existence and plans were finally begun for a state university in Miami, today's Florida International University.

The Miami Beach city council decided to allow the building of apartment houses on a section of Collins Avenue north of the Eden Roc that had previously been one of the most magnificent residential streets in the world. Today, like Brickell Avenue on the Miami side, which suffered the same fate, Collins Avenue is a blighted, concrete canyon.

Miami High and Coral Gables High School continued their dominance of the local sports scene, particularly football, between them winning numerous state and several national championships while Miami Beach High persevered (with the exception of Bronx High School of Science) as the nation's number-one rated academic public high school, sending as many as 95 percent of its graduates in any given year to college, with graduates including innumerable doctors, lawyers, accountants, college professors, authors, hoteliers, and restaurateurs.

The times, assuredly, were a'changin', but they were a mere prelude to the cataclysmic changes that would affect Miami—for better or worse—in the 70s, 80s, and 90s.

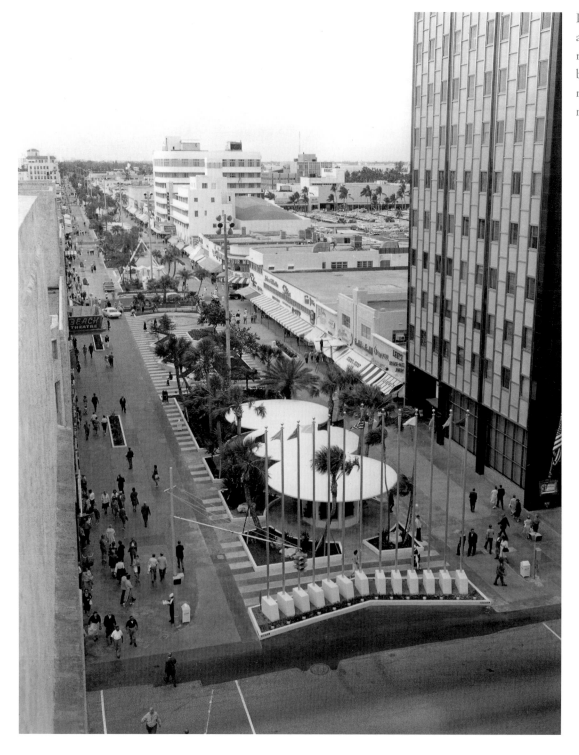

Lincoln Road Mall shortly after opening, with the new Miami Beach Federal building on the immediate right, the view west on the mall.

Dinner Key, once a small, separate island and then the site of the Pan Am Clipper seaplane base, became the site of Miami City Hall, center foreground, the building formerly the seaplane terminal. The large building to the left of City Hall and the buildings to the right were all once either Pan Am or Navy seaplane hangars. Photographed here in 1961, the only building of more than two stories is the Bank of Coconut Grove, behind and to the left of Dinner Key Auditorium, the former Pan Am hangar at left.

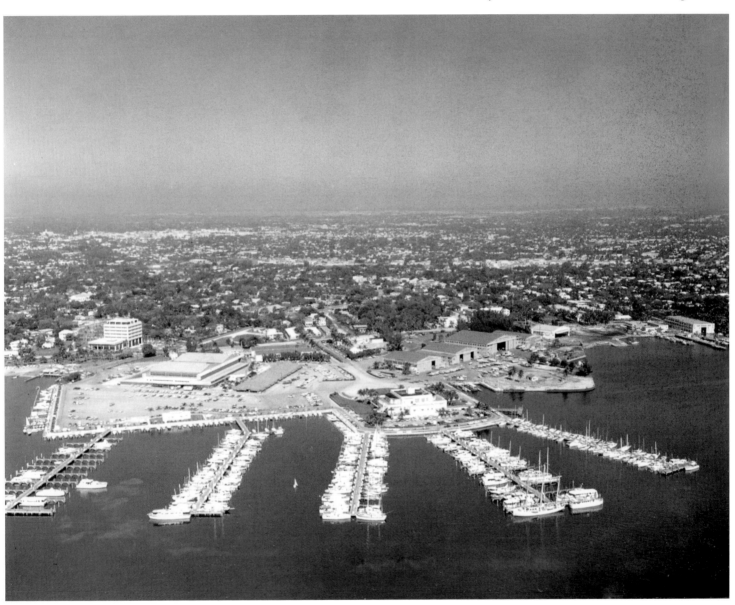

Miami's downtown piers housed fishing boats, private yachts, and sightseeing boat fleets, and there was activity there almost 24 hours a day. Shown here in 1961 are the *Melody* (closest to camera), the *Paraboots,* and the *Mary Lou,* all private yachts, with the sightseeing boat *Dreamboat* tied up at the end of the pier.

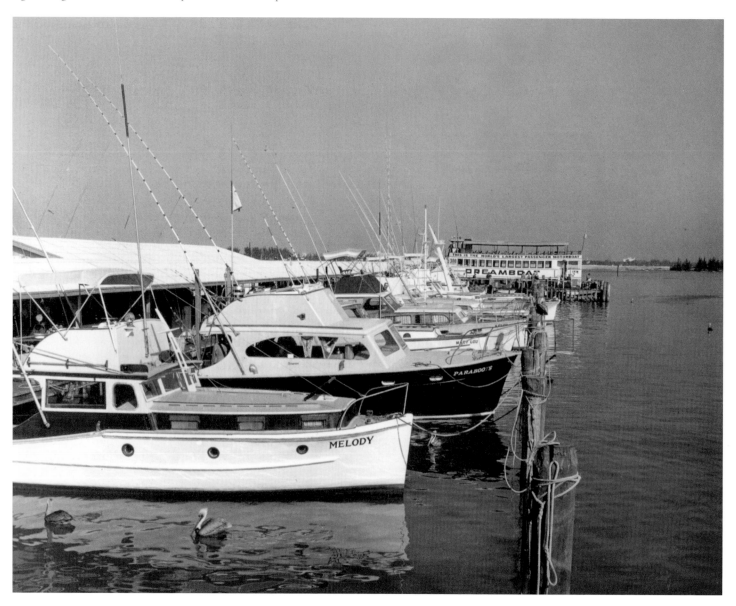

For many years, Miami Shores Country Club was the state's only municipally owned private club. A mixed foursome is shown here in 1961.

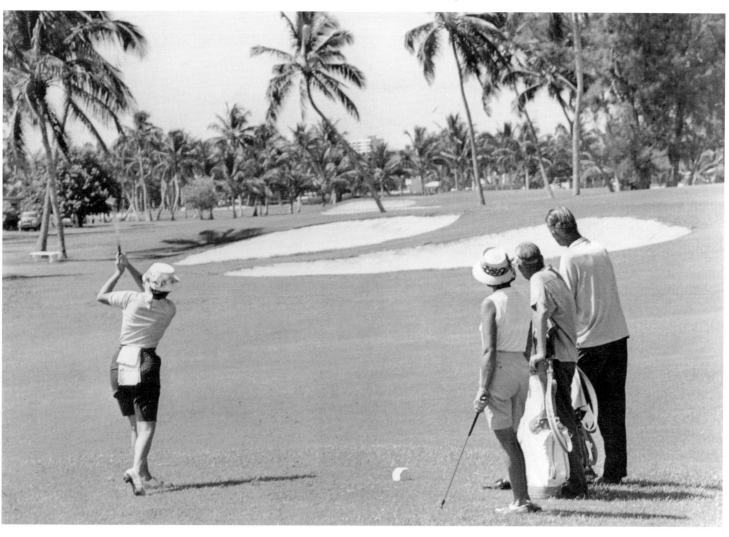

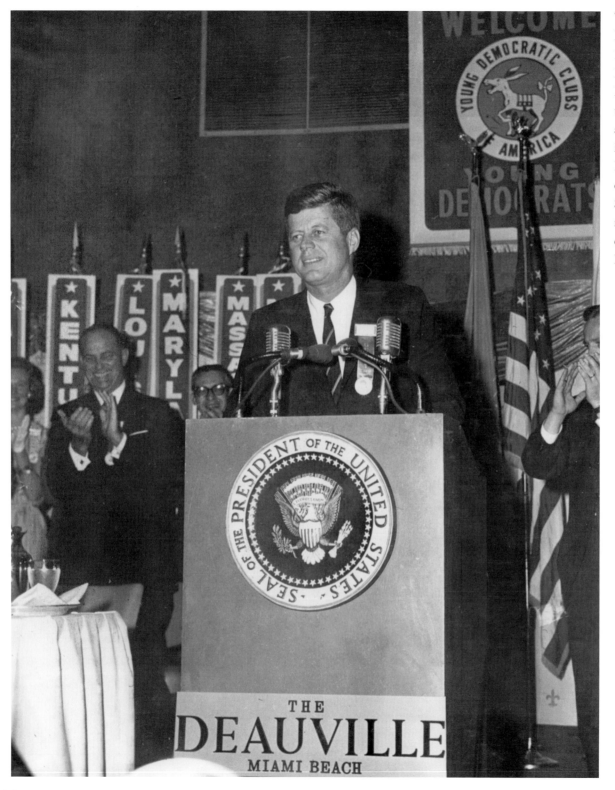

The week before his ill-fated trip to Dallas, President John F. Kennedy came to Miami. Speaking to the Young Democrats at the Deauville Hotel in November 1963, Kennedy received ovation after ovation. Shown to the president's right is Florida state comptroller Fred O. Dickinson.

Following one of the 1965 hurricanes, the City of Miami Beach had its crews out on the sand cleaning up the debris. The crew is shown here on far south beach, the pier in the background.

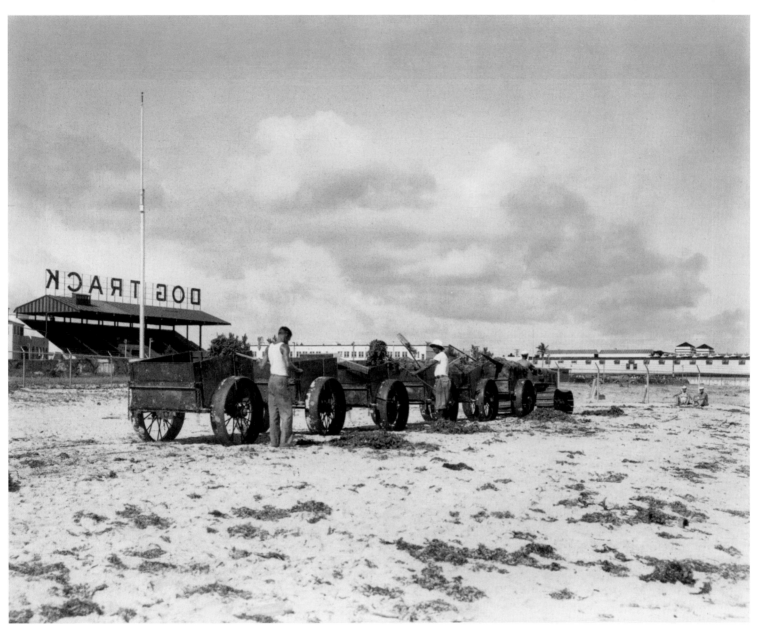

Miami Beach from 28th Street and Collins Avenue north shows the Seville Hotel (the building with a clock facing the camera), and, among others, the Saxony, Sans Souci, Sea Isle, Barcelona, Empress, and Fontainebleau (the curved building). Today the art deco hotels are Miami Beach's greatest attraction.

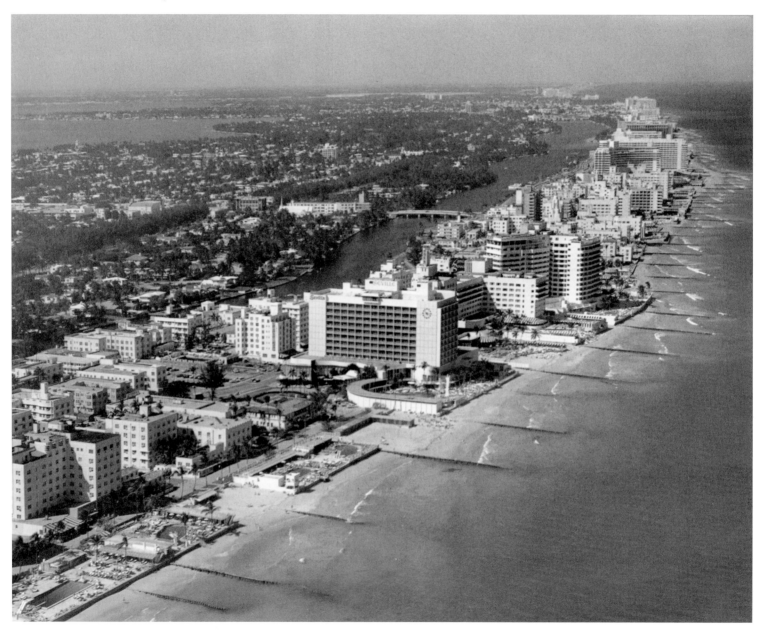

Miami was not shy about announcing its Pier 5 as home of the "World's Finest Fishing Fleet," with its great sailfish, ease of access, and convenient parking. Located at the foot of Northeast Fifth Street, the pier is now but a memory, replaced by a tourist attraction first known as Miamarina and today as Bayside.

They came by whatever means they could to escape the tyranny of communism, some by boat, some by plane, some by raft, but all with the same desire: to make a new life in a land of freedom. In 1962 this group of five Cubans joins the daily exodus from their island nation and here make landfall on Miami's shore.

Hurricane Cleo was anything but kind to Miami Beach in 1964, leaving flooded hotel lower lobbies, breaking the floor-to-ceiling glass of the Fontainebleau's lobby, ripping down signs, and causing damage that would take months to repair. In this view south on Collins Avenue from 67th Street, the Sherry Frontenac, Monte Carlo, Delmonico, Martinique, Casablanca, Lombardy, and Allison hotels are visible.

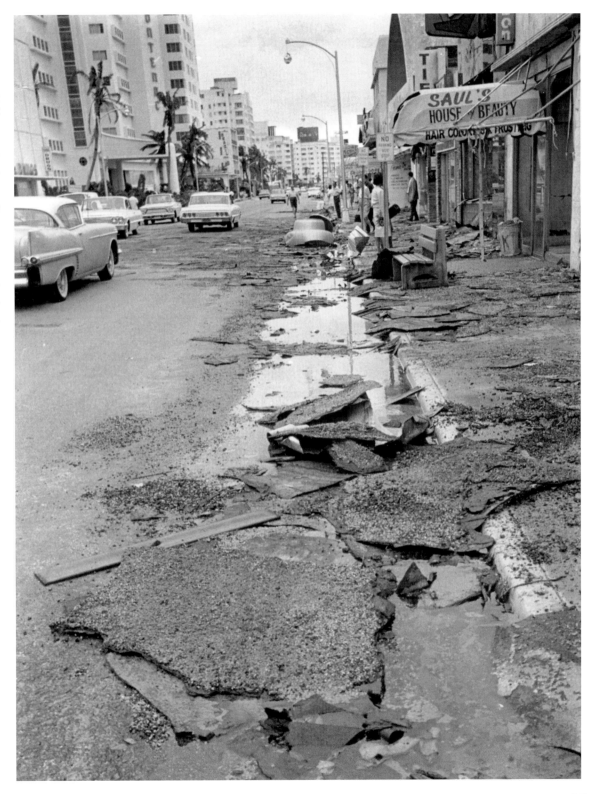

NOTES ON THE PHOTOGRAPHS

These notes, listed by page number, attempt to include all aspects known of the photographs. Each of the photographs is identified by the page number, photograph's title or description, photographer and collection, archive, and call or box number when applicable. Although every attempt was made to collect all available data, in some cases complete data was unavailable due to the age and condition of some of the photographs and records.

II **OCEAN FRONT**
Florida State Archives
we178

VI **ELSER PIER**
Florida State Archives
pr06912

X **MIAMI RIVER**
Florida State Archives
rc16665

2 **OLD FORT DALLAS**
Florida State Archives
rc16667

3 **STONEMAN FAMILY**
Florida State Archives
pr07046

4 **EARLY HOME**
Florida State Archives
rc08982

5 **BANK OF THE BAY**
Florida State Archives
rc02695

6 **ROYAL PALM BREAKING**
Florida State Archives
rc09522

7 **TUTTLE'S TENT GATHERING**
Florida State Archives
rc09242

8 **P. JOHN COATES**
Florida State Archives
rc00251

9 **COATES PROPERTY**
Florida State Archives
rc00246

10 **BLACKSMITH SHOP**
Florida State Archives
rc10725

11 **TUTTLE'S HOTEL**
Florida State Archives
pr06900

12 **FLAGLER STREET**
Florida State Archives
rc01811

13 **FLAGLER WORKMEN**
Florida State Archives
rc08898

14 **HOUSEBOATS**
Florida State Archives
rc00247

15 **POLLOCK FAMILY AT HOME**
Florida State Archives
rc09221

16 **11TH STREET**
Florida State Archives
rc19966

17 **SEWELL'S SHOE STORE**
Florida State Archives
rc01827

18 **COACHING PARTY**
Florida State Archives
rc19214

19 **S. S. MIAMI**
Florida State Archives
rc20015

20 **KINGSLEY REAL ESTATE**
Florida State Archives
rc09208

21 **ROYAL PALM HOTEL**
Florida State Archives
fr0519

22 **HOTEL LUNCH ROOM**
Florida State Archives
or06193

23 **ROYAL PALM PARK**
Florida State Archives
rc13560

24 **ROYAL PALM HOTEL**
Florida State Archives
no40491

25 **FEC COUNTRY CLUB**
Florida State Archives
rc08003

26 **TWELFTH STREET**
Florida State Archives
rc09691

27 **HALCYON HOTEL**
Florida State Archives
rc11512

28 **WILSON & FLYE GROCERY**
Florida State Archives
no35163

29 **BAY VIEW HOTEL**
Florida State Archives
fr0801

30 **SEMINOLE INDIANS**
Florida State Archives
no32167

31 NEWSBOYS
Florida State Archives
no355052

32 FIRST PRESBYTERIAN
Florida State Archives
rc19042

33 1902 FIRE
Florida State Archives
pr06903

34 HALCYON HOTEL
Florida State Archives
rc20625

35 WILSON & FLYE GROC.
Florida State Archives
rc10721

36 MRS. MANN
Florida State Archives
rc00054

37 DADE CNTY. COURTHOUSE
Florida State Archives
rc19575

38 LINCOLN RD. CLEARING
Florida State Archives
rc02079

39 AVENUE C
Florida State Archives
no35178

40 MIAMI RIVER DOCKS
Florida State Archives
no38917

41 ROYAL PALM HOTEL
Florida State Archives
rc-092

42 FEC HOTEL
Florida State Archives
rc09238

44 W & H
Florida State Archives
no40847

45 YOUNG MIAMI
Florida State Archives
rc19623

46 HALCYON HOTEL
Florida State Archives
rc14343

47 FORT DALLAS BUILDING
Bramson Archives
50

48 TRENCH DIGGERS
Florida State Archives
no46164

49 JACKSONVILLE TO MIAMI
Florida State Archives
rc09251

50 BRICKELL FAMILY HOME
Florida State Archives
rc05724

51 HENRY R. CHASE
Florida State Archives
rc05726

52 FULFORD SCHOOL
Florida State Archives
rc08121

53 OUT FOR A RIDE
Bramson Archives
56

54 TWELFTH STREET
Florida State Archives
rc08883

57 MIAMI RIVER
Florida State Archives
rc06387

58 CAR DALE TOWER
Florida State Archives
rc19026

59 CURTISS HYDROPLANE
Florida State Archives
pr00481

60 GLENN CURTISS
Florida State Archives
pr0454

61 PAGEANT DAY PARADE
Florida State Archives
rc10387

62 OCEAN BEACH REALTY
Florida State Archives
rc09225

63 BLANCK DEPARTMENT STORE
Florida State Archives
ms25404

64 MIAMI HIGH SCHOOL
Florida State Archives
no35018

65 CHICAGO TO MIAMI
Florida State Archives
rc14105

66 ROYAL PALM PARK
Florida State Archives
rc02516

67 CAPTAIN THOMPSON
Florida State Archives
rc09219

68 HIPPODROME
Florida State Archives
rc20648

69 CARL FISHER
Florida State Archives
rc03727

70 AVENUE D STUDIO
Florida State Archives
rc03707

71 EVERGLADES
Florida State Archives
rc00046

72 RANDALL HENDERSON
Florida State Archives
pr20185a

73 ELSER'S PIER
Florida State Archives
rc18698

74 AIRDOME
Florida State Archives
rc19049

75 ELEVENTH STREET
Florida State Archives
rc18608

76 DADE COUNTY SECURITY
Florida State Archives
no35166

77 WOODEN BLOCK STREET
Florida State Archives
rc01828

78 "SHINNECOCK"
Florida State Archives
rc13590

79 TWELFTH STREET
Florida State Archives
rc01792

80 VICTORY LOAN PARADE
Florida State Archives
rc01839

81 FLAGLER STREET
Florida State Archives
rc06687